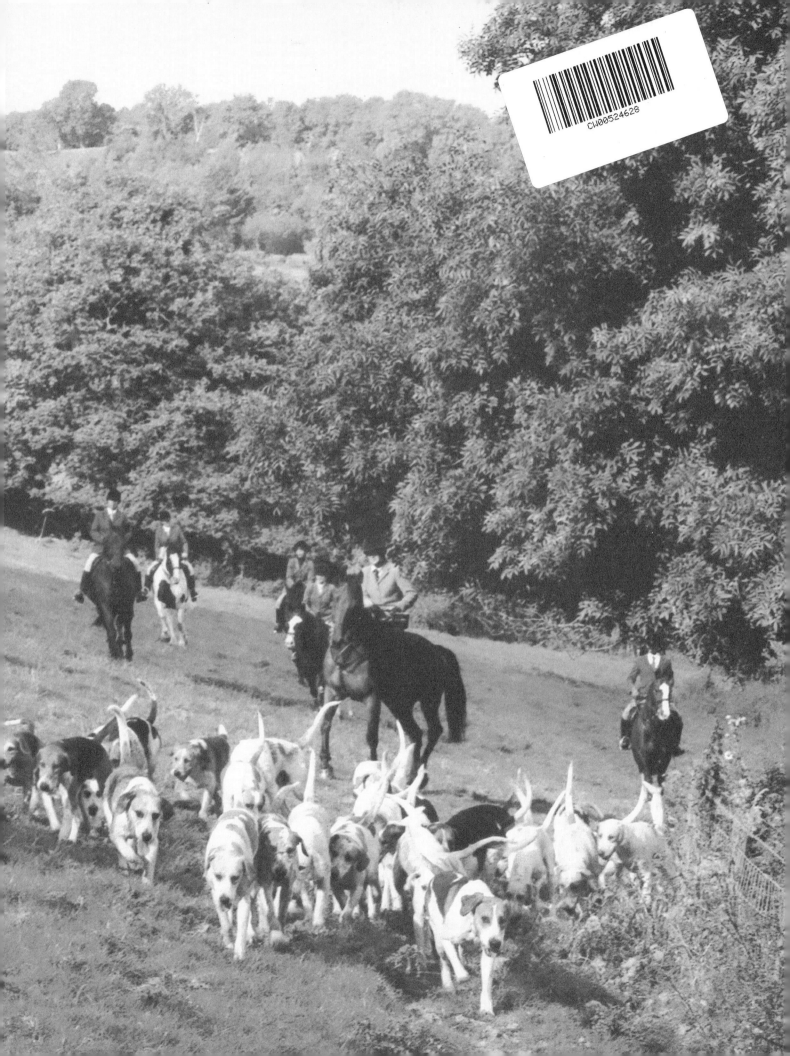

GOING HOME

JIM MEADS

Quiller

Copyright © 2008 Jim Meads

First published in the UK in 2008
by Quiller, an imprint of Quiller Publishing Ltd

British Library Cataloguing-in-Publication Data
A catalogue record for this book
is available from the British Library

ISBN 978 1 84689 041 3

Printed in China

Quiller

An imprint of Quiller Publishing Ltd
Wykey House, Wykey, Shrewsbury, SY4 1JA
Tel: 01939 261616 Fax: 01939 261606
E-mail: info@quillerbooks.com
Website: www.countrybooksdirect.com

Dedication

This book is dedicated to Marion Maggiolo, of 'Horse Country Store', Warrenton, Virginia and her staff of lovely ladies whose eagerly awaited newspaper ensures that my pictures and stories are regularly viewed in most parts of North America.

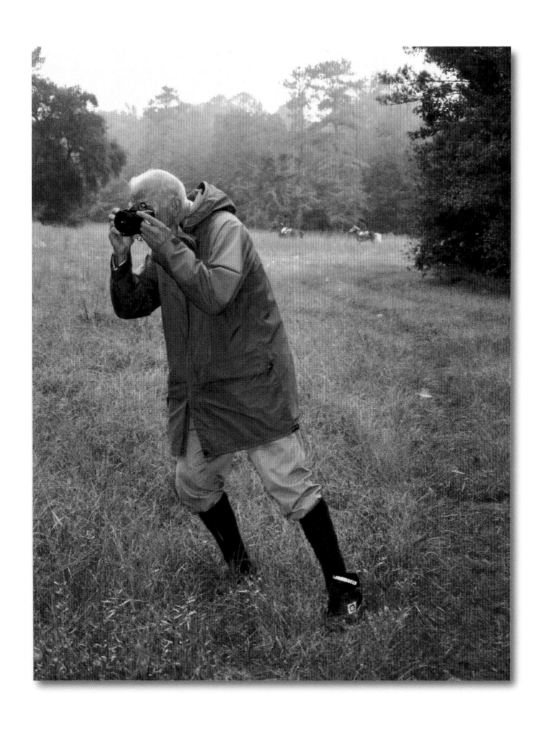

CLARENCE HOUSE

Jim Meads tells me that this is his last book of hunting photographs… at seventy-seven he is hanging up his boots, putting away his camera and "going home." No more will that familiar, jogging figure be seen slipping across country on foot; no more the strategically stationed camera beside some fearsome obstacle to catch you, hopefully, with no daylight between seat and saddle as your horse gracefully executes a brilliant manoeuvre.

Jim's magnificent library of hunting photographs is certainly the largest and most diverse that exists, and the latest of these are portrayed so well in this evocative book. So it is with a mixture of pleasure and great sadness that I write this foreword. It is wonderful to see how Jim has continued to capture an evocation of what is so unique about the hunting tradition; his great experience and real sensitivity mark him out in this regard.

Through these photographs it is possible to relive countless happy memories of our beautiful countryside: crisp early mornings in late Autumn with the young hounds; cold December days and the thrill of watching hounds stream out on a strong scent; the sheer terror, mingled with hope and a prayer as one heads for and clears a huge hedge; the shared companionship, wit and wisdom of genuine country people. All these things are part of a rich treasury of recollections that will remain precious to me, and to so many others, for the rest of our lives.

Safe home, Jim Meads.

Charles

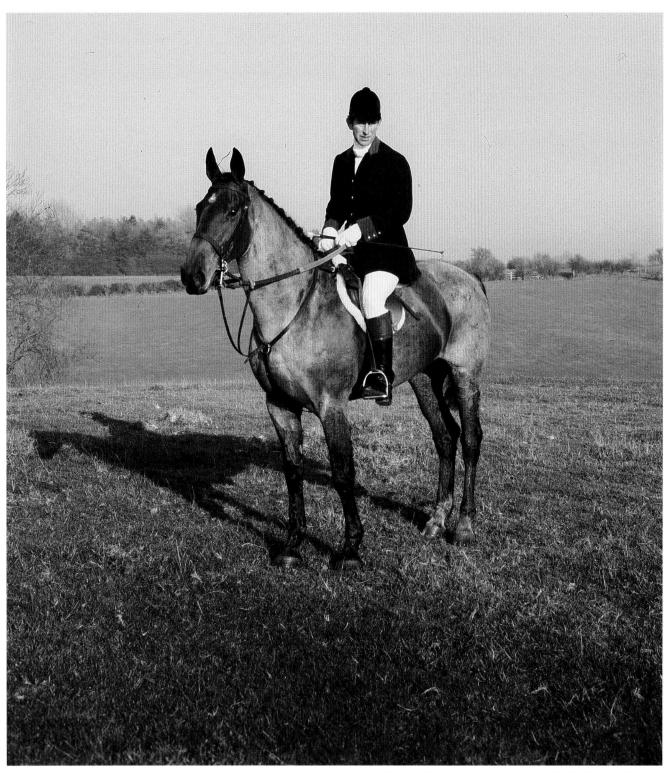

Prince Charles enjoying a day with the Belvoir Hounds.

Foreword by Mason H Lampton
President American MFHA 2005-2008

Often I would like to stop time to savour a magical moment. Just as I am ready to embrace that fleeting second, it is gone. I am left with an imperfect memory that blurs over time. The good Lord sent us Jim Meads to catch these times and capture them forever through his camera lens. He has a certain intuition that puts him in the right spot at the right time. As he has hunted with almost five hundred different packs over his long career, he has learned to read the mind of the hunted quarry whether red fox, grey fox, bobcat or coyote.

In Monticello, Florida, the Live Oak Hounds hosted the Board of the Masters of Fox Hounds Association of America for a hunt. The morning was pleasingly frosty with that august body chaffing for a day of sport. The hounds soon put up a lovely red fox and ran it across mown fields in front of all to see before darting in a covert. Jim Meads was waiting and soon he was on his knees capturing the fox for eternity as he charged directly towards Jim with the pack in hot pursuit. The whole field witnessed Jim clicking away with the fox, hounds, huntsman and field all captured in that instant.

My first encounter with Jim was in 1979 at the wedding of our mutual friends George Sloan and Jane Thorne. Jim took a picture of the groomsmen on the steps of John Thorne's home. Bob Champion, Josh Gifford, Macer Gifford, Jim Wilson, Dick Saunders, Anthony Webber and myself made up the group. Jim's picture caught us as young men with revelry in our eyes. It was a happy time.

Some of my greatest memories of hunting in America have been captured by Jim. On casts all over America, there would be Jim lightly clad in his signature green rain gear and running shoes. He was soon running through streams, mud and heavy underbrush. He always appeared out of nowhere coolly waiting for that special frame. We would be in shock to see this apparition after having galloped seemingly forever. There he would be grinning ready to catch that special moment. He would innocently inquire why we were late. 'Had we taken a wrong turn?'

This man has become an icon among foxhunters across America. His warm smile and pleasing praise has soothed a new Master with a young pack or a young ingénue in the field. They often were nervous before they were photographed by the famous Jim Meads. They knew their face would soon be there for the world to see in national magazines.

Many times a proud Master has informed his members that the occasion was special as the great Jim Meads would be there to take the picture. 'Look smart as we want to make a good impression.' Jim made each hunt feel special while he visited and later when he published their pictures. His efforts often launched them from obscurity to fame and fortune.

The Masters of Fox Hounds Association of America has just celebrated its one hundredth Anniversary. Not only was Jim there to memorialise the festivities, he has also donated his life's work in photography to the MFHA to use to further the cause of hunting in America and around the world. He has transcended the role of being a photographer and has become an ambassador for the cause of hunting by bringing people together no matter where they live or who they are. His generous gift will become an irreplaceable history of hunting that generations will enjoy in the future.

This book is said to be his last, but the quest to photograph the five hundredth pack seems to drive him on to new frontiers. At this writing, he is healthy with many friends in the world. I will look for him patiently waiting to catch that next spectacular moment for the future generations to see. I am grateful for his efforts. I have enjoyed his company. You will enjoy his book.

September, 2007

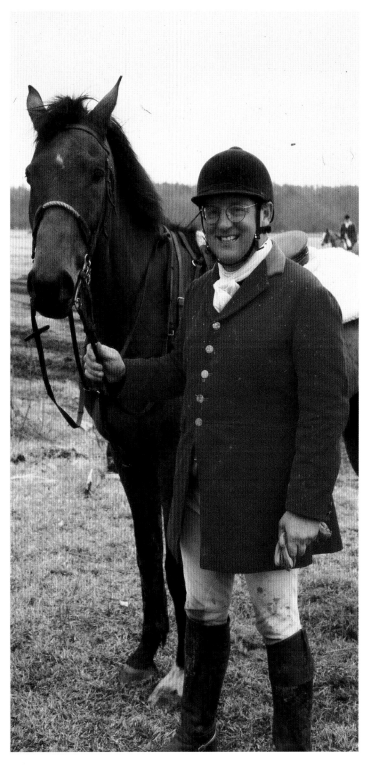

Introduction

When I left the Royal Air Force in May 1950, having served my King and Country for two years not as a pilot or photographer as I had hoped but as a lorry driver, little did I realise what the future held for me, as I began my career as a country sports photographer. Times were difficult financially, and for the first seven years I rode a motor cycle as I couldn't afford a car, travelling all over the country trying to make a name for myself as that 'crazy running photographer' who runs all day with hounds! My hard work and long hours began to pay off and gradually I became well known in the hunting world. Magazines like *Horse & Hound* and *The Field* began to publish my pictures with the latter commissioning me to take pictures on a regular basis, thus allowing me to change from two wheels to four and life began to take on a more rosy hue. Still working 'eight days a week' and visiting up to three hunts a day and attending all the major summer hound and horse shows I was then appointed *The Field's* Hunting Photographer in 1958, working closely with one of my all time heroes Sir Andrew Horsbrugh-Porter Bt., for the next thirteen seasons. Having also broadened my photographic expertise by encompassing game shooting, I was approached in 1970 by Philip Brown, Editor of *Shooting Times* to see if I would consider illustrating a weekly column for his magazine on hunting and shooting. When I asked who would be writing the stories, Philip smiled and said 'YOU'!

C N de Courcy-Parry, better known as 'Dalesman', pictured at Rydal Show in 1979 with two friends and Jim Meads.

Thus began my journalistic career which continues to this day, hand in hand with photography; this was pleasing to editors as it meant that they only had to send one person to an event instead of two. In 1973, my good friend and former BBC War Correspondent Michael Clayton and I were out on a commissioned job at the Old Surrey and Burstow Hunt with the meet being held at Horne Grange. This is the home of Joint Master Diana Barnato-Walker 1966–1979 another of my heroes as she flew fighter and bomber aircraft from factory to squadron right through World War II as a member of the Air Transport Auxiliary. Part way through a useful day's hunting in the pouring rain Michael said to me 'You won't believe it, but I'm to be the next Editor of *Horse& Hound*!' For the next twenty-five years we travelled the world

Toronto and North York Huntsman Mark Powell and the author with the Grand Champion cup at the Virginia Hound Show 2005 which was won by 'Sandford'.
(Courtesy of Emma Powell)

Out with the Moore County Hounds in North Carolina. (Courtesy of Jeanne Paine)

together, visiting such diverse countries as America, Canada, Ireland, Germany, France, Switzerland and Czechoslovakia and most exciting of all Australia in 1986 with a week's holiday in Bali on the way home. By the time we landed in Bali I was ready for some R & R as I'd run round the cross-country course at Gawler near Adelaide where the World Three Day Event Championships were held. For this event, I had two 35mm SLR cameras mounted on a metal bar, with one black and white film and the other with colour, which meant pressing two shutter releases at the same time. Two years later, most magazines turned over to full colour so the need for people like me to hump two cameras on a bar around a hilly cross-country course was gone forever.

Also in 1986 I had one of my most exciting trips of all and it had nothing to do with horses, hounds or shooting! I was approached by a representative of the Zimbabwe government, who had been impressed by my work, to see if I would be prepared to travel to his country for three weeks to take photos and write stories to encourage tourists to visit Zimbabwe. 'Do bears like honey?'!! It was an amazing experience and I became completely hooked on Africa especially after spending a week paddling a seventeen-foot canoe down the mighty Zambezi River with naturalist guide Ray Stoker. This entailed taking all our provisions in the canoe and really scary sleeping on sandbanks at night with crocodiles, hippos and elephants. Fortunately being brought up during the War and living through the Battle of Britain I have acquired the knack of sleeping anywhere at any time!

With Whipper-In Cindy Pagnotta at a meet of the Moore County Hounds in North Carolina.
(Courtesy of Jeanne Paine)

Probably one of the most important business and personal decisions of my life came in 1974 when, at the suggestion of various Americans I'd photographed hunting or shooting in the UK and Ireland, I plucked up courage and raided the 'piggy bank' and bought a return air ticket to the USA. There the first two foxhunts I photographed where the Amwell Valley in New Jersey and Mr Stewart's Cheshire in Unionville, Pennsylvania. I also went deer hunting in the Pocono Mountains, in deep snow and goose hunting on Chesapeake Bay around Chestertown where sitting in a 'Pit Blind' was like sitting in a refrigerator. Since then the good old USA has become my second home, having made something like one hundred and fifty return trips across the Atlantic Ocean.

During the years since my first visit I have made so many wonderful friends and had so much fun, otherwise I would not have kept on going, with all the hassle at airports since the ghastly events of 11 September 2001. Incidentally, I flew into New York City on day seven after the attack.

In 1978 Michael Clayton and I were working at the World Championship Three Day Event at the Horse Park in Lexington Kentucky and to extend our time in the US a certain MFH and huntsman from the Deep South whom we had both heard about, but never met, namely Ben Hardaway, arrived in his private jet to fly us down to Columbus, Georgia to hunt with 'MA Dawgs', our introduction to the Midland Foxhounds and 'The King of American Foxhunting'!

From 1950 to 1964 all my pictures, except for a few special ones, were taken in black and white on large and heavy cameras on 5x4" glass plates,

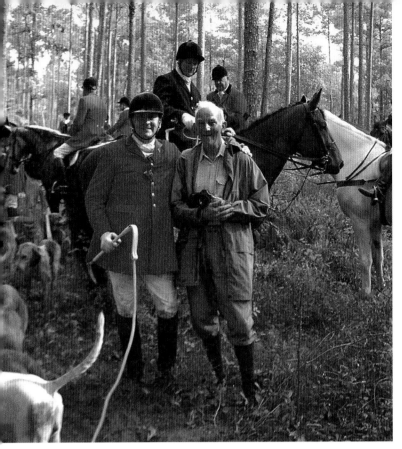

With Marty Wood MFH Live Oak Hounds at the end of a successful hunt in Florida. (Courtesy of Warner Ray)

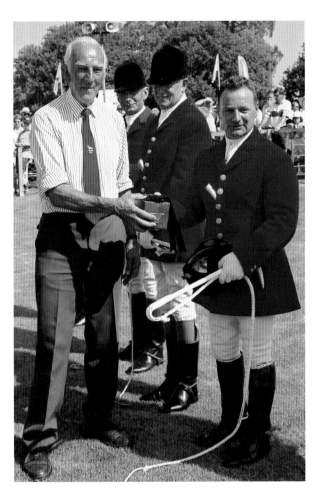

Jim Meads who judged the hunt staff turn out, presenting first prize to Holderness Huntsman Robert Howarth. The Lowther Hound Show, August 2003. (Courtesy of Ginni Beard)

fortunately in those days I was young and strong and took it all in my stride. Then from 1964 to 1980 I changed to my first single lens reflex camera, which used films and produced 2¼x2¼" negatives. My final change came in 1980, when I turned over to 35mm single lens Canon cameras, with interchangeable lenses but still mainly using black and white films to illustrate articles until, as mentioned, in 1988 most magazines turned over to full colour. During all these 'black and white years' and running endlessly across country in an effort to take that special shot, in a pocket of my green waterproof jacket lived a little folding camera loaded with a colour film. Whenever an opportunity presented itself, out would come this little folding camera and 'click' a colour picture was in the bag! Some of these shots can be seen in the 'Ireland Recalled' and the 'Nostalgia' sections of *Going Home* showing horses, hounds and people from an era back to 1957, when colour photos of hunting were few and far between.

There is one other feature of my life which I must touch upon, for without it none of my five books would have seen the light of day. I refer to 'lady luck' for as long as I can remember people have often grudgingly said 'You are a lucky so and so!' Here are just a few examples

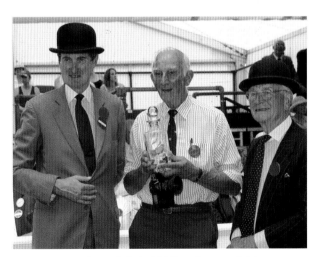

Peterboro' Foxhounds July 2006 and to mark his sixtieth year photographing the show Jim Meads was presented with an engraved decanter by Sir Philip Naylor-Leyland MFH and (right) Show President Roy Bird. (Courtesy Ginni Beard)

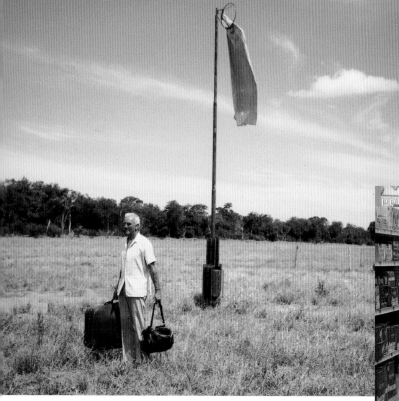

Two well known foxhunters as you've never seen them before! Mason Lampton MFH and photographer Jim Meads 'stocking up' in a 'Piggly Wiggly' supermarket in deepest Alabama. (Courtesy Dixon Stroud)

The wholesale hassle involved at airports nowadays is in marked contrast to this picture of the author waiting at Mana Pools Airport, in Zimbabwe. Before my plane could land, eight elephants had to be chased off the 'runway'!

On a visit to the Midland Foxhounds the author and Horse & Hound *Editor Michael Clayton, exit their own 'Air Force One' at Columbus, Georgia Airport.*

of what I mean. When I was nine years old and being a 'wild country boy' I excelled at climbing trees higher than anybody. Then, a branch broke and I plummeted thirty feet to the ground, suffering a broken neck and spending the first three weeks of World War II in hospital.

On 1 July 1944 a German Flying Bomb ('Doodle Bug') picked on our house with us in it. Luckily we were in bed asleep and only received cuts and bruises, digging ourselves out of the ruins and going to school. The next major piece of luck came my way on 13 September 1962, when I took my young sons Paul and Barry out to watch aeroplanes at the De Havilland Aircraft Company Airfield where I worked from 1946 to 1948. For some unexplainable reason, I took a camera with me, which I never do unless I am working. Suddenly a jet fighter coming in to land had a hydraulic malfunction and decided to crash less than one hundred yards from where we were standing. In an instant, I had the camera up to my eye and pressed the trigger as the pilot left his plane by ejector seat. Result – 'Picture of the Year' Worldwide for 1962. On 25 November 1978 I was out with Michael Clayton photographing the Tanatside Hunt; hounds had found and I was running across a big grass field, to keep in touch. Next thing I remember was waking up in Welshpool Hospital having been kicked in the face by a galloping horse. Being lucky I woke up!

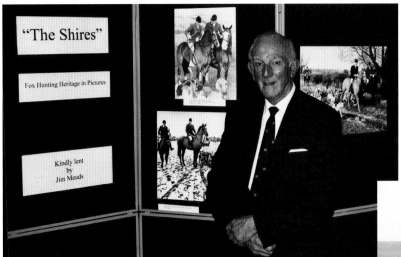

The author at a fund raising exhibition of his foxhunting photos which brought in £2,500 for the Museum of Hunting.

Then on 7 November 1996, I was flying to Kentucky with Arnold Garvey, the new editor of *Horse & Hound*, to photograph the Iroquois Hunt when our plane developed a major fault in its horizontal stabiliser and wouldn't fly below 280mph. After two hours, practising the 'crash position' and fully expecting to die the plane diverted to Wright Patterson Air Force Base at Dayton, Ohio, where they have a five mile long runway. With great skill, our pilots landed the plane at 300mph and managed to stop in four-and-a-half miles – hence 'Lucky Jim'!

With the MFHA of America celebrating its Centennial throughout 2007 I have included several pictures of the fantastic year long events which took place under the brilliant leadership of the MFHA President 2005–2008 Mason Lampton. My personal favourites were the Joint Meets; the astonishing Ball held in Cipriani's in New York City, organised by Suzy Reingold and enjoyed by eight hundred and fifty foxhunters and the spectacular closing ceremony held at Morven Park, Leesburg, Virginia.

To date (October 2007) I have been out with and photographed no fewer than 482 different packs of hounds and despite being seventy-seven years old, I have a burning ambition to reach the magic five hundred mark thus setting a world record, which will be very hard to beat.

I am greatly honoured to have Forwords written for this book by two great foxhunters, both of whom have, over the years, been of great assistance in furthering my career. HRH Prince Charles whom I first met and photographed on 19 February 1977 after which I was lucky enough to photograph him on numerous occasions out hunting, when he was always up at the sharp end, jumping the biggest fences, close behind the huntsman. Sadly, those splendid days have gone, since the 'ban of hunting with dogs' was introduced. Mason Lampton, President of the MFHA of America and son-in-law to Ben Hardaway MFH has been a true friend since we met on 25 January 1979 at George Sloan's wedding on a snowy day in Warwickshire. Sincere thanks to you both and Good Hunting.

The author signing copies of one of his books in the hunting field after a day with the Piedmont Hounds in Virginia. (left to right) Norman Fine, Editor of Covertside, *Jerry Miller MFH Iroquois Hunt, Randy Waterman MFH Piedmont Hunt and Ben Hardaway MFH Midland Hounds.*

Aiken Hounds, South Carolina, USA

The pack of crossbred hounds arriving at a meet where they were greeted by a member in a vehicle from an earlier age. Quite appropriate, as this pack was formed in 1914 when cars were few and far between.

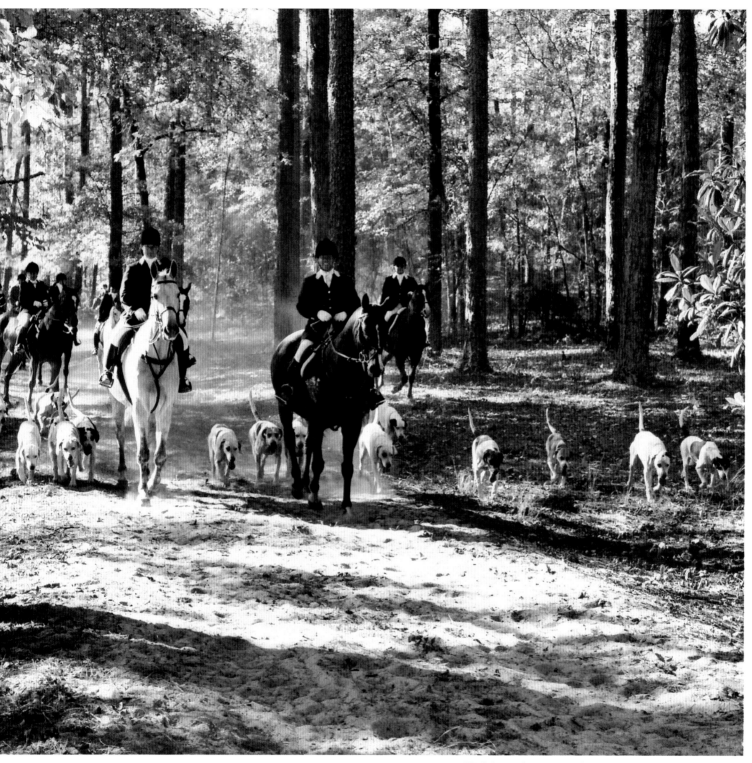

With hounds moving along a sandy trail through the famous and colourful Hitchcock Woods. At Aiken, are two of the Joint Masters: Linda Knox McLean, who hunts hounds, and on the grey, Eleanor Ward. Note the dust rising!

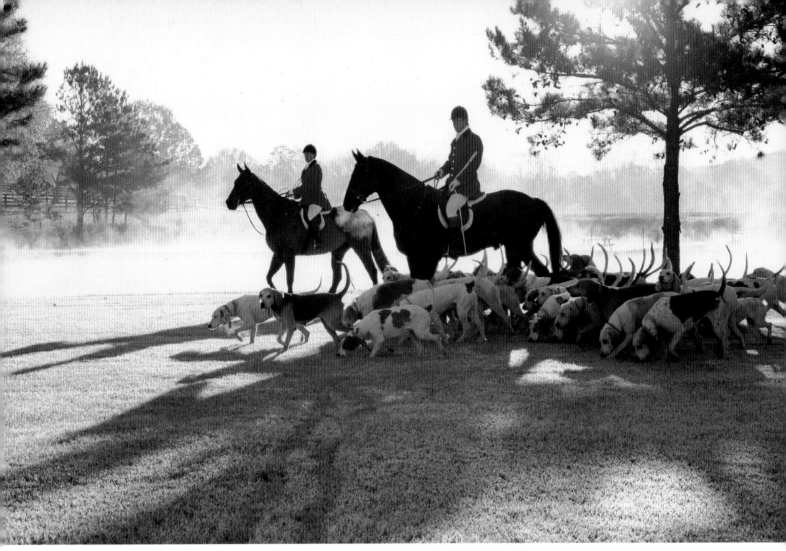

Bear Creek Hounds, Georgia, USA

With a white frost on the grass, and mist rising from a lake, Huntsman Guy Cooper and Whipper-In Kelly Barrett bringing hounds to the 8am opening meet at the Master's home. However bright sunshine soon raised the temperature to a more usual level!

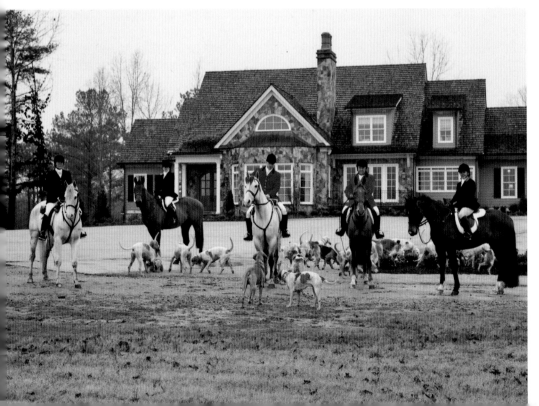

With hounds at the opening meet at the Master's home are (left to right) Heather Cooper, Hon. Sec; Kelly Barrett, Whipper-In; Guy Cooper, Huntsman; Hal Barry, Founder Master; Linda Barry, Master's wife. This hunt was established as recently as 2001.

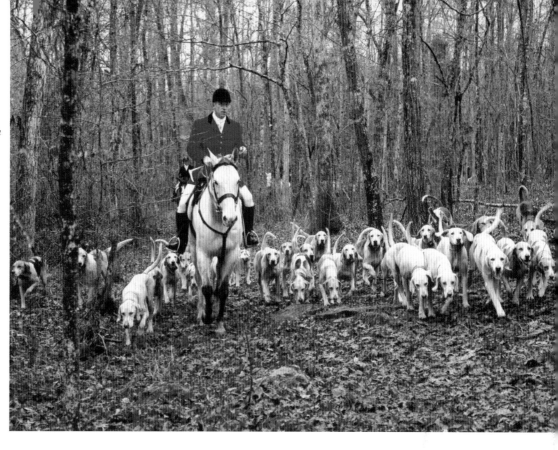

Huntsman Guy Cooper leading hounds through woodland, so typical of the countryside in many parts of Georgia, where the quarry can be coyote, red fox, grey fox or bobcat.

With steaming horses showing signs of a good hunt, Field Master Dr Warner Ray slows the pace while hounds are drawing through heavy undergrowth. Note the sandy soil, which never becomes too hard or too soft, for hunting, yet holds a scent.

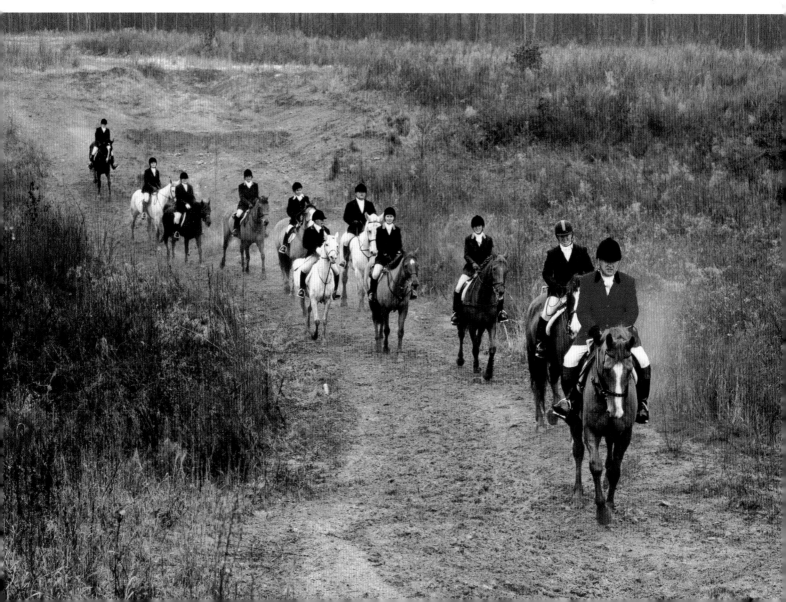

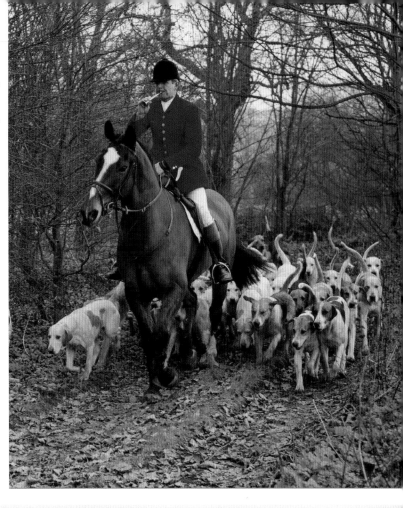

A noted exponent on the hunting horn, Huntsman since 1992 Patrick Martin famously blew his hunting horn from the stage in Hyde Park during the rally on 10 July 1997. Here he collects hounds at the end of a hunt.

Bicester with Whaddon Chase Hunt

Galloping his hounds to a 'Holloa' is Huntsman Patrick Martin after meeting at Thenford, home of the Heseltine family in the north of their country.

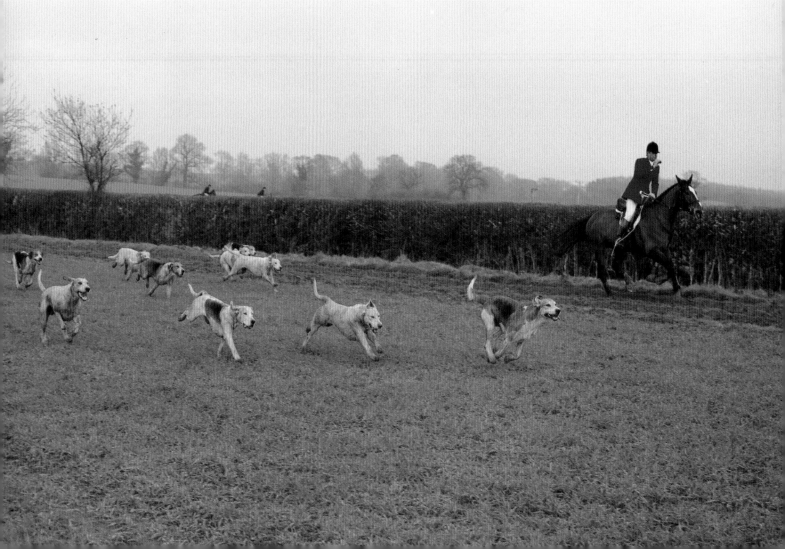

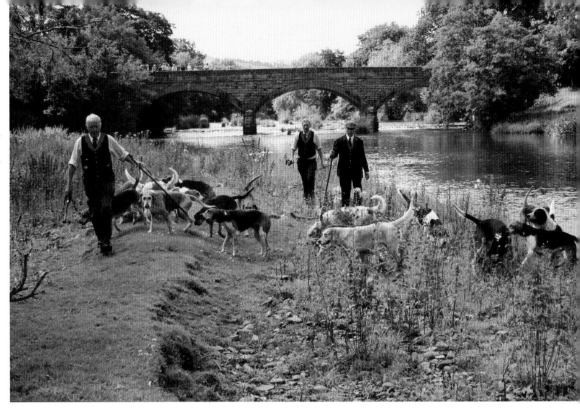

With followers watching from an old road bridge Master and Huntsman John Newton (right) with his pack of mostly draft foxhounds draws along the River Severn on a hot July day when getting wet was a pleasure!

Border Counties Mink Hounds

Master and Huntsman John Newton carefully leads hounds across the mighty River Severn to draw on the far bank with the temperature in the high 70s Fahrenheit. Can there be a more pleasant way to spend a day amidst wonderful scenery?

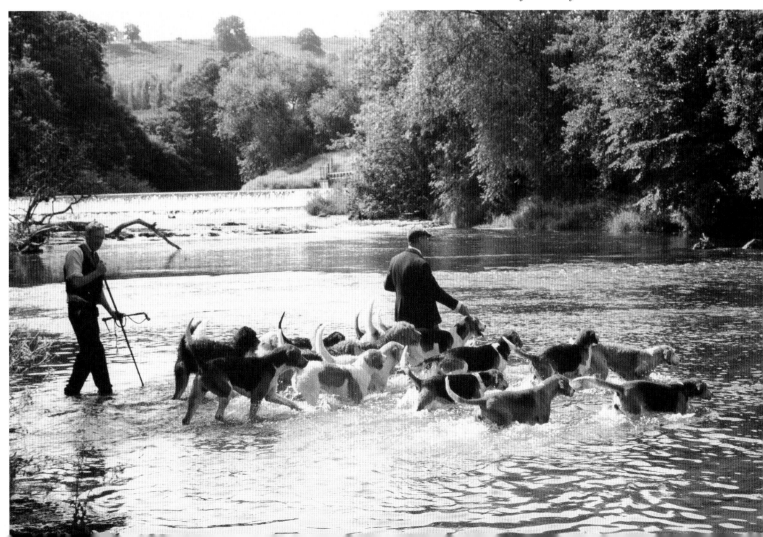

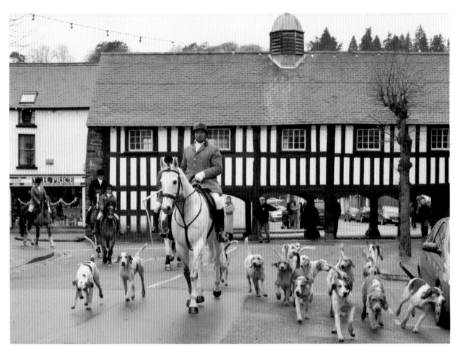

The David Davies Hounds, with Huntsman David Jones, passing the ancient black and white Market Hall in Llanidloes on their way to the meet at the Angel Hotel, where they were loudly cheered by a big crowd of people despite the cold.

Boxing Day

Huntsman David Jones giving his David Davies Hounds the signal to go at the Angel Hotel in Llanidloes, followed by Whipper-In Neville Owen. This was David's retirement year, having been with the pack since 1973.

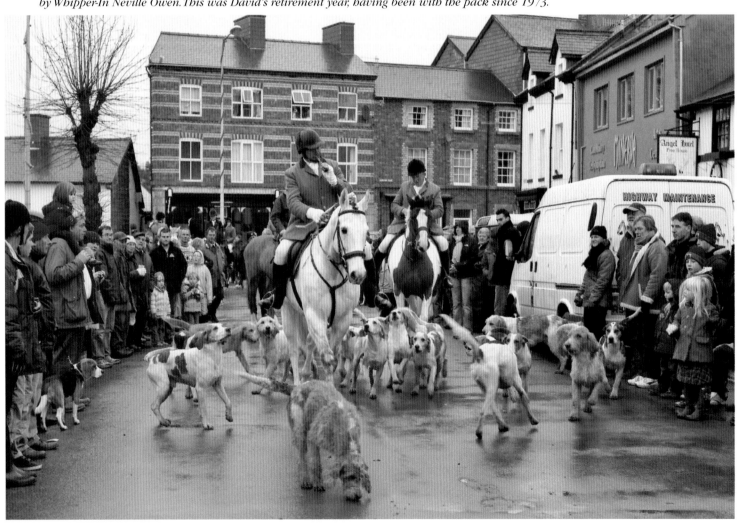

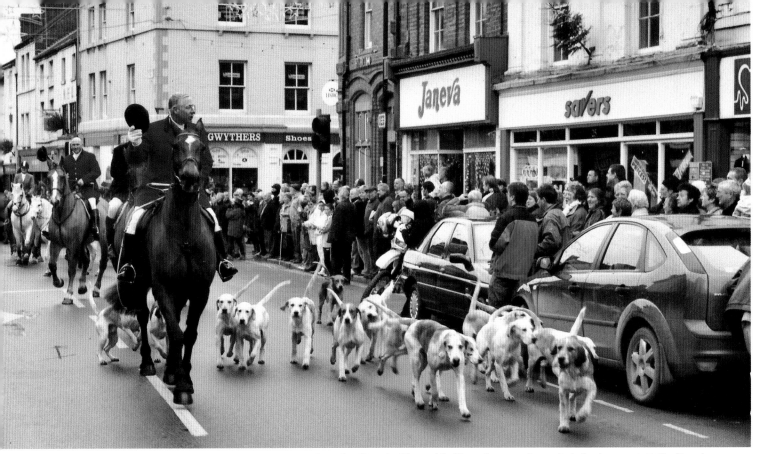

Joint Master and Huntsman Barry Fews leading the Tanatside Hounds away from their festive meet at the Royal Oak Hotel in Welshpool. Huge crowds lined the roadside, cheering the hounds and staff as they went to draw.

Acknowledging the cheers of the crowd as they parade through the main shopping street in Welshpool are Tanatside Joint Master Ian Coe and (right) Graham Jones leading the mounted field.

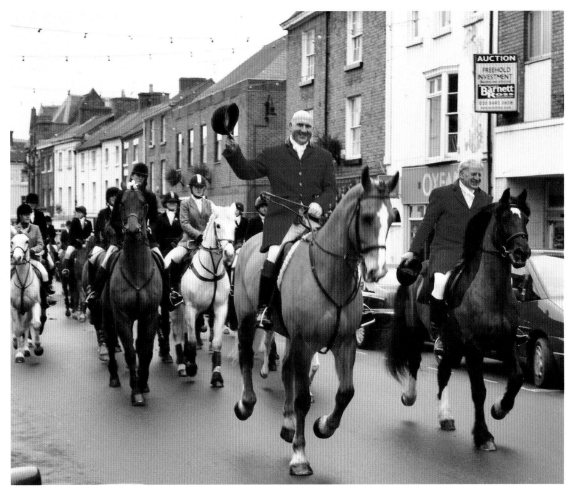

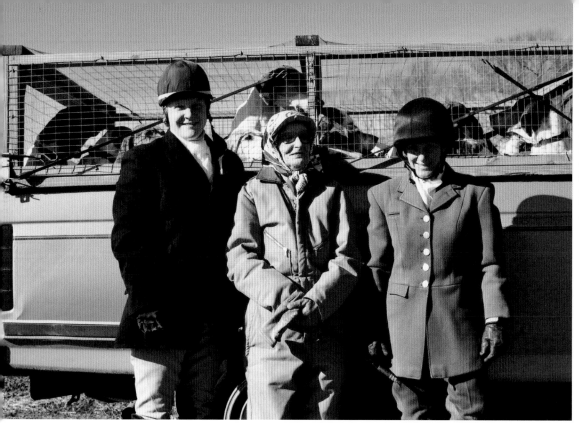

Pictured together during this hunt's last season 2003-2004 are three generations of the same family. Mrs Jane Sullivan MFH 1959-2004, her daughter Cindy Bedwell MFH 1987-2004 and left her granddaughter Nancy Bedwell who was next in line to have become a Master and Huntsman.

Brandywine Hounds, Pennsylvania, USA

Cindy Bedwell MFH and Huntsman wearing their distinctive brown uniform with hounds moving across corn stubble during their last season 2003-2004. On this bright winter's day, we enjoyed three good hunts on foxes.

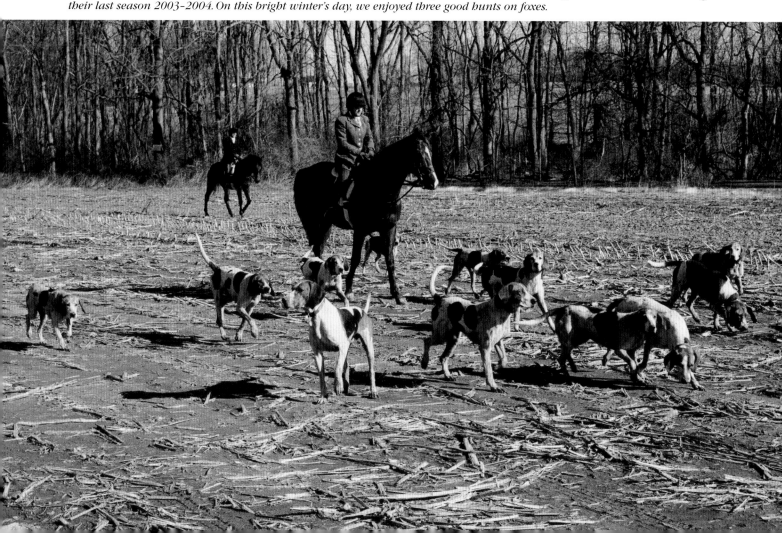

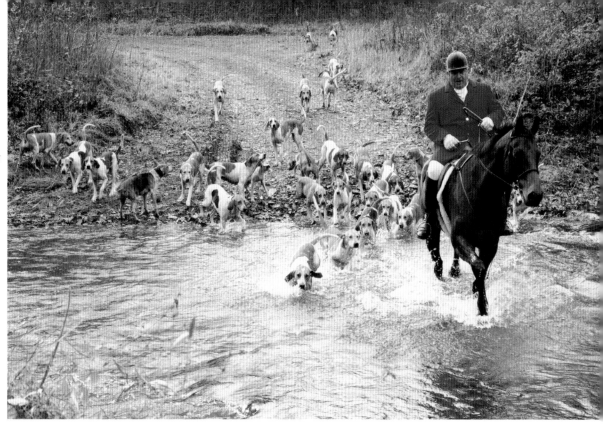

Long serving Huntsman Tommy Lee Jones who has carried the horn most successfully since 1970, crossing a creek with his pack of American and crossbred foxhounds at the beginning of a day's hunting.

Casanova Hunt, Virginia, USA

Huntsman Tommy Lee Jones blows 'Going Home' at the end of an excellent day's foxhunting, much enjoyed by a big field still emerging from an area of woodland over the hill.

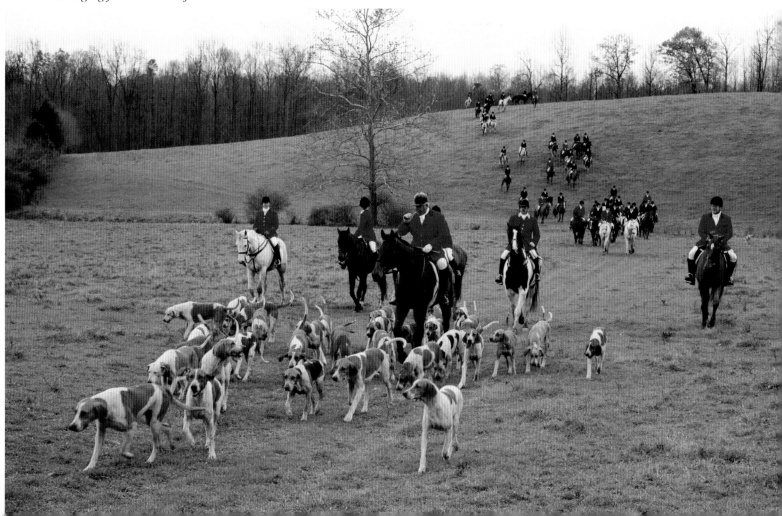

Characters of the Chase

Mrs Nancy Hannum MFH Mr
Stewart's Cheshire Hounds in
Pennsylvania 1945-2003 and
a great conservationist.

Lord Daresbury MFH Belvoir
Hunt 1934-1947 and the County
Limerick Hunt 1947-1977; loved
Old English Foxhounds.

Major Victor McCalmont MFH
Kilkenny 1949-1993 his
daughter Di Turner MFH
Heythrop 1977-1978 and
Quorn 1992-1995 and (right)
Rosemary Stobart MFH, Duke of
Buccleuch's 1979-1986,
Tynedale 1986-1998.

The Prince of Wales at the South of England Hound Show with Nicholas Soames MP and John Robson.

The Hon Urkie Newton, a great Meltonian and Lord King MFH Belvoir 1958-1972 and Chairman of British Airways.

Melvin Poe, one of America's best loved Huntsmen with his famous 'Fox Wine' during his years at the Orange County Hunt.

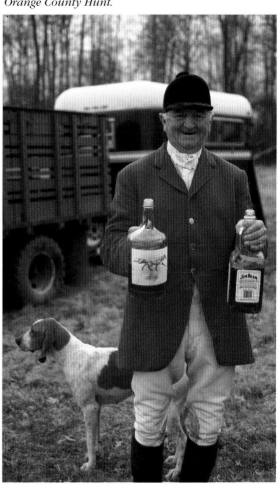

The Crown Equerry Lt Col Sir John Miller who helped introduce Prince Charles to foxhunting; with Cheshire Huntsman Johnny O'Shea 1966-1991.

Together at Lowther Michael Hedley MFH Border since 1973, Trevor Adams MFH Duke of Buccleuch's since 1989 and Walt Jeffrey MFH Jedforest 1983–2000.

Michael Clayton, Editor of Horse & Hound *and his 'Foxford' weekly column at the Myopia Kennels with Joint Master and Huntsman Russell Clark, on a snowy day in Massachusetts, USA in 1991.*

At Peterborough, Show Chairman Countess Fitzwilliam with Rosy Wallace, wife of Capt Ronnie Wallace MFH.

Judging a performance trial in Alabama are two well-built foxhunters, Willie Poole MFH Sinnington 1976–1982 with Ed Bacon, well-known American judge.

At a damp Rydal, Martin Letts MFH College Valley and North Northumberland since 1964, Ben Hardaway MFH Midland USA since 1950 and Bruce Logan MFH Coniston 1954-1978 and Show Chairman.

Andrew Barclay was a top class and highly popular huntsman of the Green Spring Valley Hounds in Maryland from 1980-2001 prior to which he was Whipper-In to 'Hall of Fame' huntsman Les Grimes.

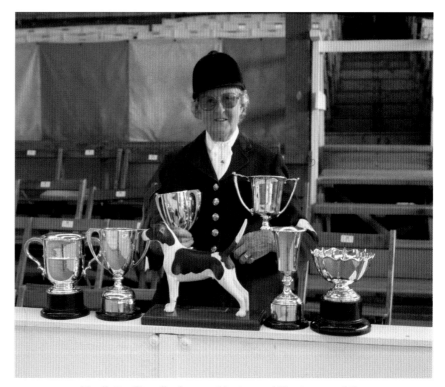

Mrs Betty Gingell who was Master and Huntsman of the Cambridgeshire Harriers from 1942-1995, during which time she bred a marvellous pack of stud book harriers, hence all these trophies at one Peterborough!

Two great horsemen who both served as Masters of the Tipperary Hunt in Ireland. Evan Williams who won the Grand National just before World War II, expertly hunted hounds from 1953-1971 and Timmy Hyde MFH 1991-2002.

Together at a very wet Virginia Hound Show where they were judging are Irmgard Hill MFH, Red Mountain Foxhounds in North Carolina since 1969 and Charmian Green MFH Warwickshire Hounds 1981-1989 and since 1990, previously MFH Fox River Valley Hunt in Illinois 1975-1981 and Exmoor 1989-1990.

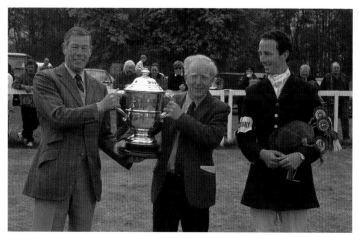

Presentation at the Irish Hound Show (left to right) Charles Barrelet MFH Co. Limerick 1993-1999; Michael Higgins MFH Tipperary 1973-1991 and Kilmoganny 1992-1999 with Kilmoganny Kennel-Huntsman Michael Kennedy.

Gloria Sellar was a Joint Master of the Frontenac Hunt in Canada with her husband Brig Gen Gordon Sellar from 1982-2005, right is Suzy Reingold, Master of her pack of Old English Foxhounds the Plum Run Hunt at Gettysburg from 1983-2003 when they disbanded.

Five Fell Huntsmen who walked and climbed thousands of miles during their careers. (Left to right) Stanley Mattinson (Blencathra) Pritch Bland (Melbreak) John Nicholson (Lunesdale) Dennis Barrow (Ullswater) and Barry Todhunter (Blencathra)

A trio of Quorn Joint Masters, Jim Bealby 1985-1991, Barry Hercock 1985-1991 and Joss Hanbury 1985-1991 and 1997 to the present day together at a puppy show at the Old Kennels.

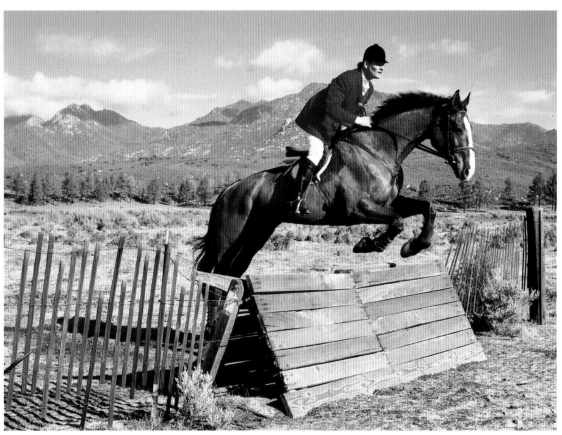

A big horse well over a big jump in California as Santa Fe Whipper-In Philip Chilson sets off at the start of a coyote hunt, amidst glorious mountain scenery.

Coops

Jumping a well built coop set into a new barbed wire fence is Evie Van Sant Mauldin MFH Mooreland Hunt in Alabama. Evie doubles up as Hunt Secretary, a busy lady!

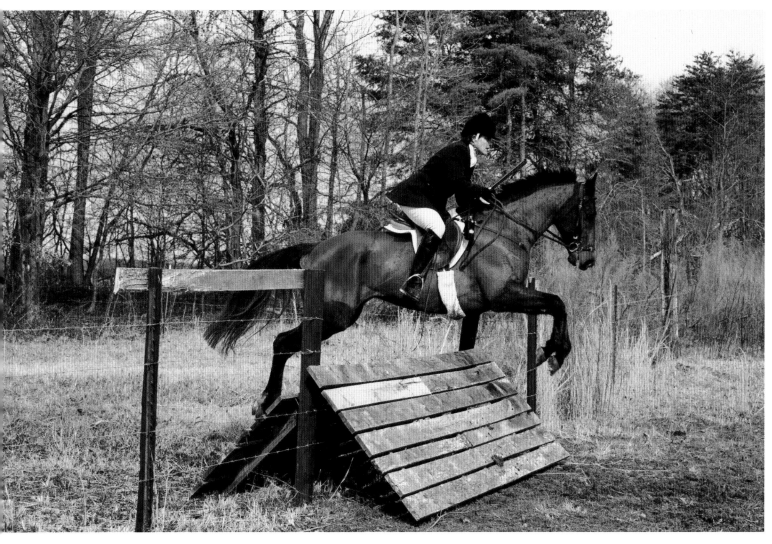

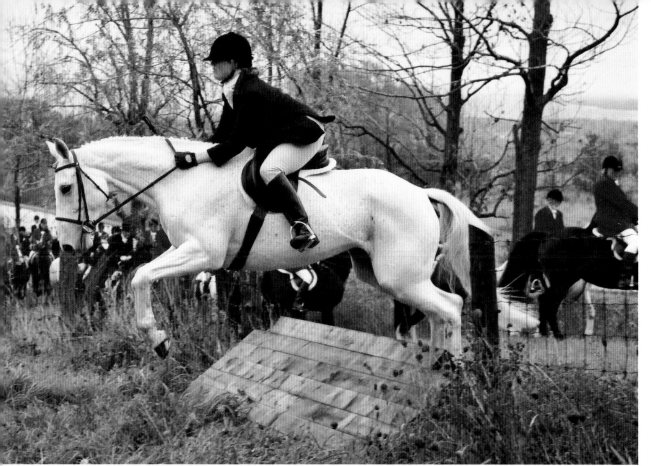

Professional Huntsman to the Beaver Meadow Foxhounds in Canada, Tarina McLennan during a Centennial Joint Meet in the Toronto and North York Country and with Georgian Bay just visible in the background.

Amateur Whipper-In to the Eglinton and Caledon Hunt in Canada Alastair Strachan MFH jumps out of a covert, with his radio in one hand, whip and reins in the other. This was during a coyote hunt in October.

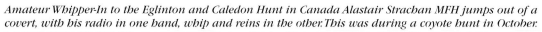

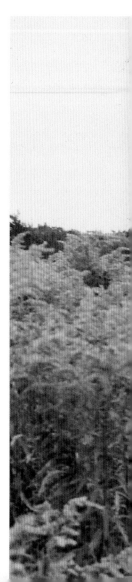

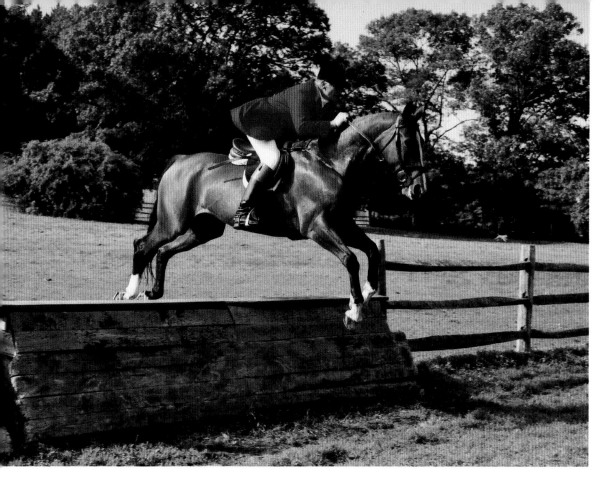

Donald Little who has been master of the Myopia Hunt in Massachusetts since 1989 leading the way after an early season meet and with much leaf still on the trees.

English Huntsman to the Montreal Hunt in Canada Antony Gaylard jumps into a colourful field of golden rod to keep with his pack of English foxhounds.

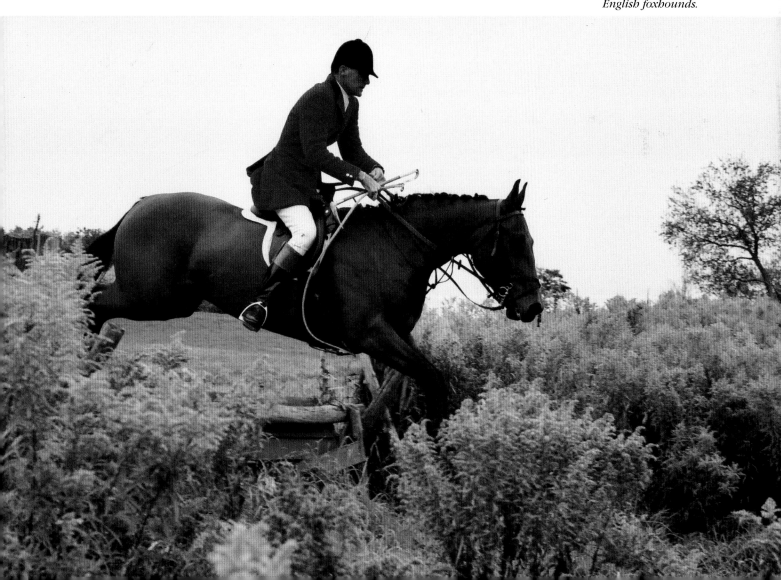

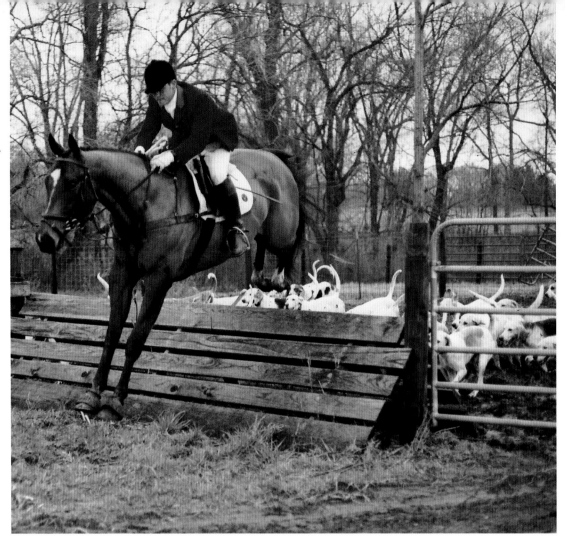

Giving his hounds a lead out of a covert is Mooreland Huntsman Rhodri Jones-Evans. At one stage of his career Rhodri was a Whipper-In to Sir Watkin Williams-Wynn's hounds in the UK.

Field Master to the Fox River Valley Hunt, Carla Whitebread setting the pace with a vista of open Illinois country in the background following their opening meet when the temperature reached 80° Fahrenheit!

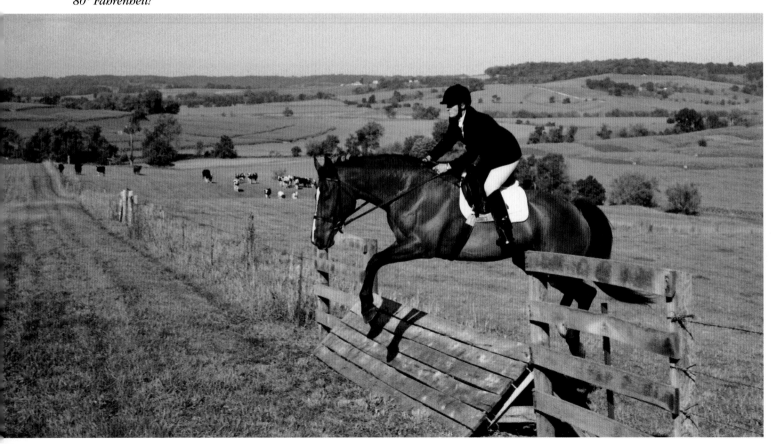

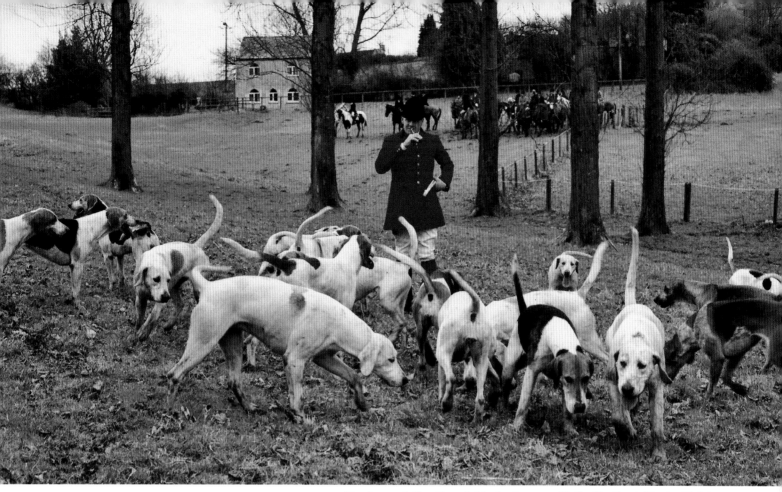

Cotswold Hunt

Huntsman Julian Barnfield who is now with the Heythrop Hunt with his hounds after they caught their fox, following a good, but twisty hunt on the Cotswold Hills. In the background is the mounted field just catching up.

Hounds and the few remaining followers climb out of a typical Cotswold valley as Huntsman Julian Barnfield blows 'Home' at the end of a day from Foxcote Manor.

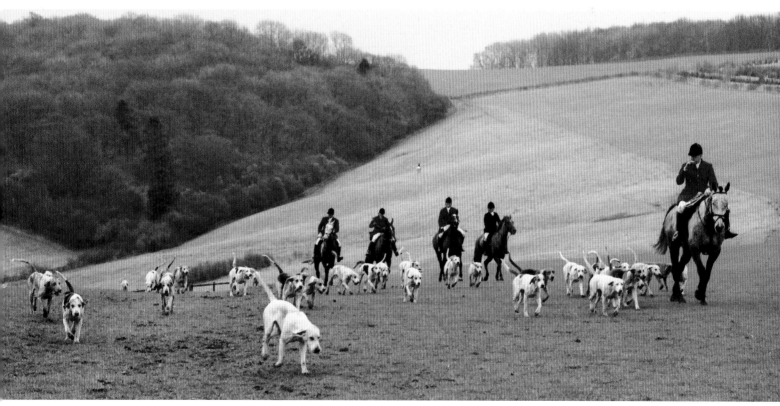

Cub-Hunting

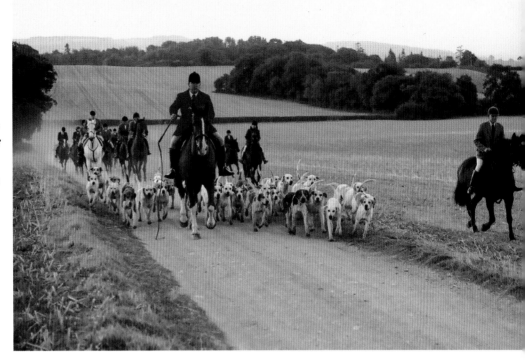

6.40am on 11 September 2007 and new Huntsman Richard Evans leads the Tanatside Hounds away from the kennels for his first morning cub-hunting in his new post. Note how the mounted field are kicking up the dust after a long dry spell. To the right is Joint Master Fred Hart who was Whipping-In.

New Tanatside Huntsman Richard Evans on his first morning with this pack has hounds on the move across a steeply sloping grassy hillside, with the ground like concrete! During the afternoon, a fresh outbreak of Foot and Mouth Disease was confirmed in Surrey with all hunting brought to a halt until further notice.

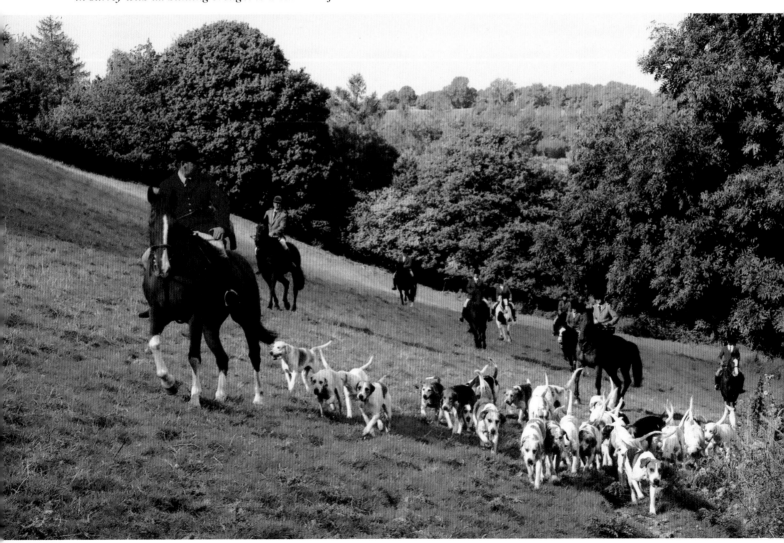

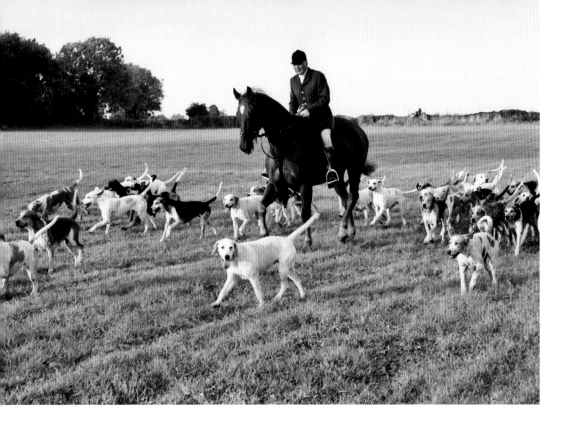

Joint Master and Huntsman Capt. Ian Farquhar bringing the famous Duke of Beaufort's hounds to an early morning meet at Sopworth as the autumn sun breaks through the clouds.

It isn't often that I see something new out hunting, but on Wednesday 15 October 2003, when I attended a meet of the Duke of Beaufort's hounds at Sopworth, I was astonished to find that the mounted field numbered 150!

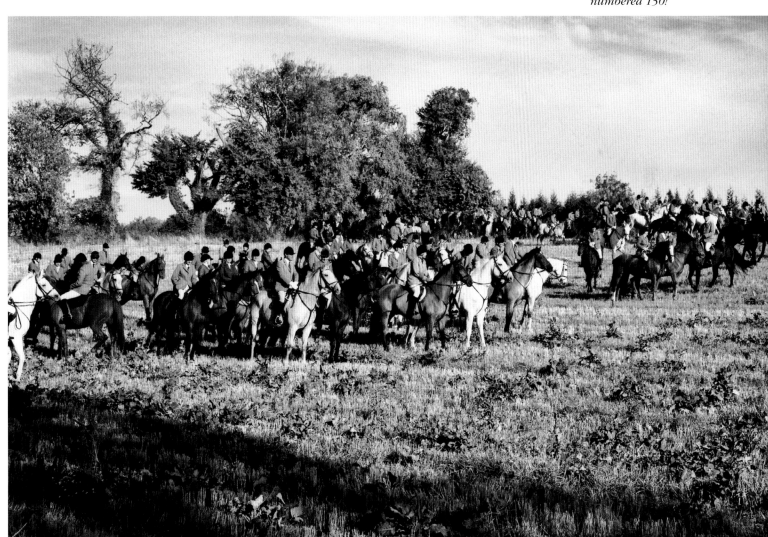

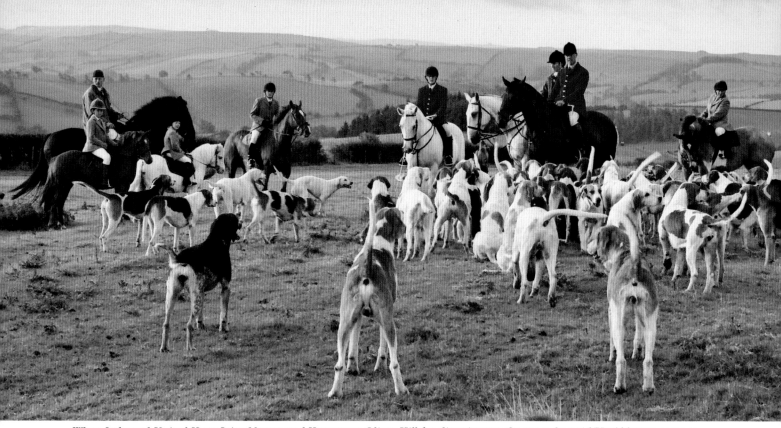

When I phoned United Hunt Joint Master and Huntsman Oliver Hill for directions to the meet, he said 'You'd better come to the kennels and follow the hound van or you'll get lost'! This picture shows Oliver surrounded by hounds and riders in the 'middle of nowhere', where the meet took place.

Oliver Hill, Joint Master and Huntsman of the United Pack bringing hounds out of a deep valley at the end of a four hour morning, which began at 7.30am. During this time we didn't even see or hear a road!

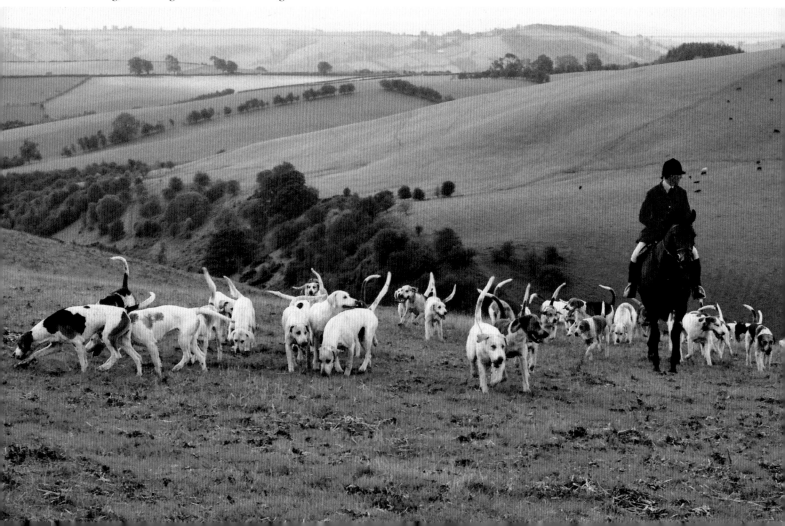

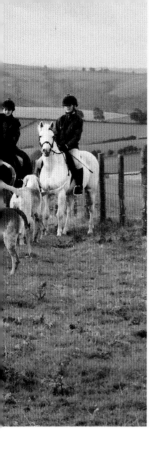

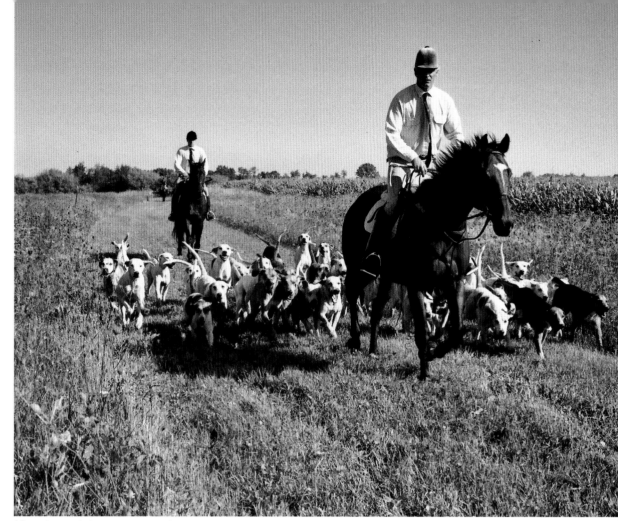

Their last cub-hunting meet of the season sees the Cornwall hounds with Tony Leahy MFH and Huntsman followed by Kennel-Huntsman Rob Warner moving through the corn belt in Illinois. The temperature had soon risen to the high 70s.

In lovely open country in Illinois, the Cornwall Hounds coming home after a warm morning's hunting, when a grey fox and coyotes were found and hunted.

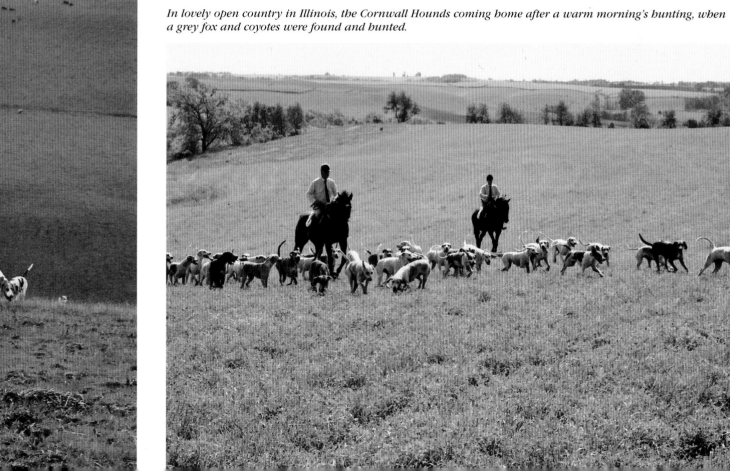

With an orderly pack of twenty-eight couple of English and Welsh cross foxhounds, Huntsman of the Golden Valley Will Pinkney leads the way from 7am meet at Lower Court, Clifford in Herefordshire.

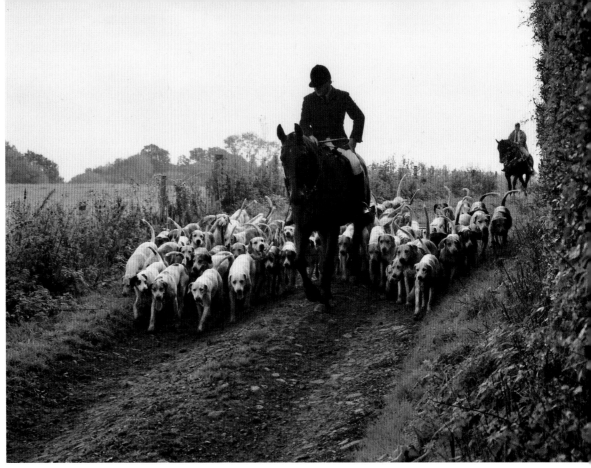

Golden Valley Huntsman since 2001 Will Pinkney with hounds and followers at the end of a good morning's hunting conveniently close to their kennels at Sheepcote, Clifford, Herefordshire.

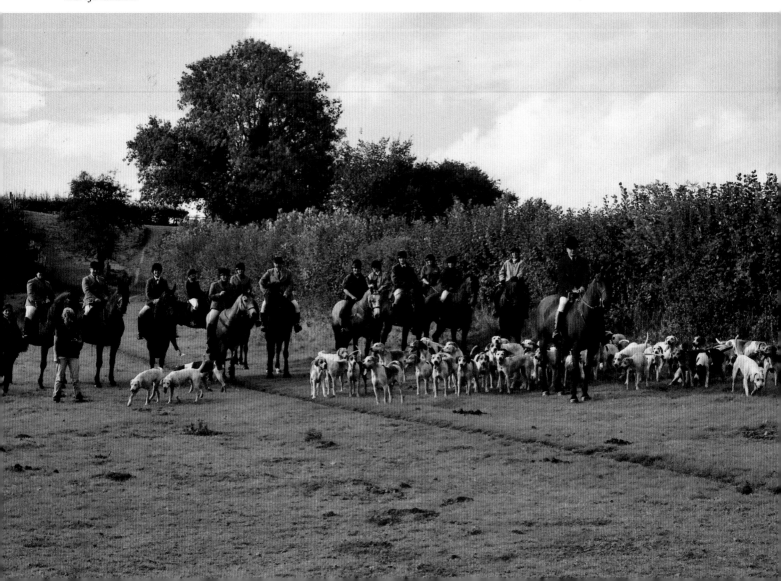

An early morning meet in the humid heat of Alabama as the Midland Foxhounds are loosed off to draw by Mason Lampton MFH and Huntsman. Note the sensible informal clothing and just how many white hounds are in the pack.

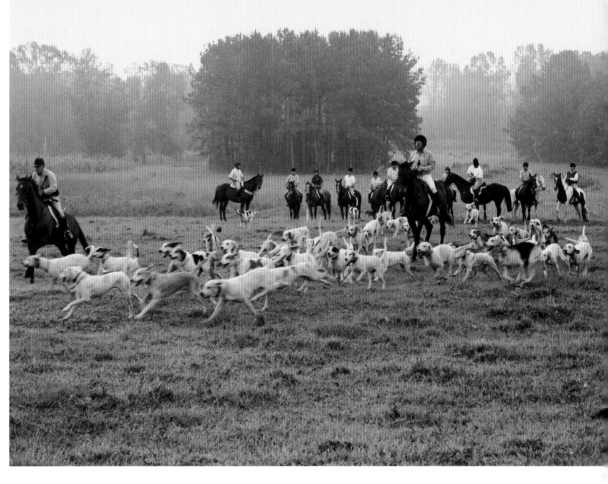

With his all bitch pack of light coloured hounds well grouped and staying close to a typical stone wall Nigel Peel, Joint Master and Huntsman of the North Cotswold Hounds moving across an area of arable during early morning cub-hunting.

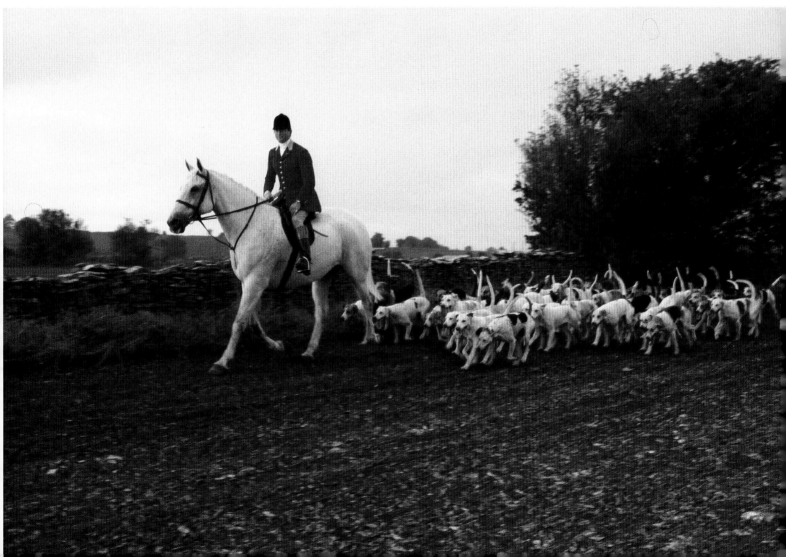

David Davies Hunt

The David Davies Hunt was founded in 1905 by the first Lord Davies with kennels at Llandinam in Montgomeryshire. Having now passed their centenary hounds are still kennelled at Llandinam and by tradition the opening meet is held at Plas Dinam, home of the present Lord Davies, who has been Master since 1963. This picture shows Lord Davies and his Huntsman David Jones with hounds on the lawn, in front of Plas Dinam on opening meet day.

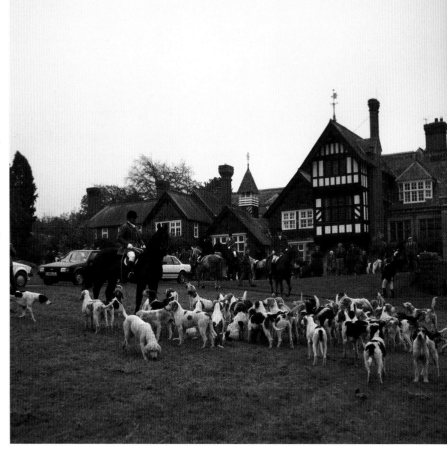

High on the Llandinam Hills after the opening meet Huntsman David Jones with hounds drawing one of several large bracken beds in which foxes have always lived.

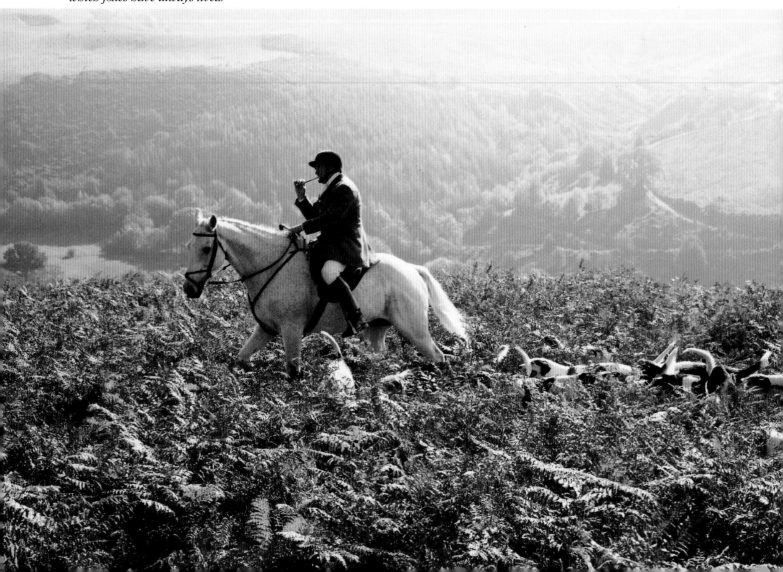

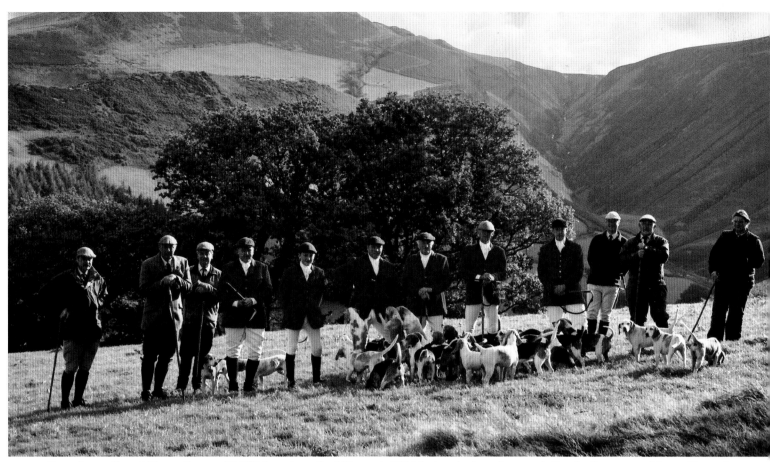

Hounds meeting at Rhos-y-Garreg, Mid-Wales, where the hills reach 1500 feet and where few people live. In the centre of the uniformed group is Huntsman Richard Mousley.

Derby, Notts and Staffs Beagles

Watching hounds at work in wonderful wild country of Mid-Wales are Gerald de Ville, Senior Joint Master, who owns the pack and left Joint Master, Tim Hurdley.

Taking a breather after a strenuous run are (left to right) Greg Mousley, – Joint Master and Huntsman, Dove Valley Minkhounds; Andy Hibbert, – Whipper-In, Dove Valley Minkhounds; Brian Pratt, – Whipper-In, Old Berkeley Beagles; Iain Storer, – Whipper-In, Glyn Celyn Beagles; Valerie Storer.

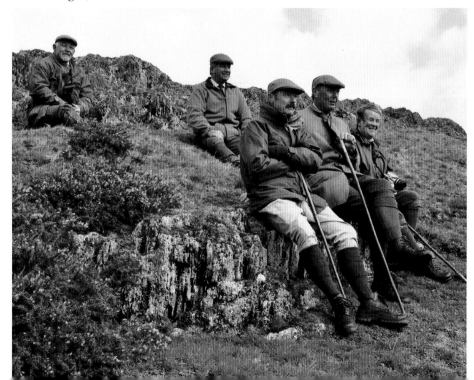

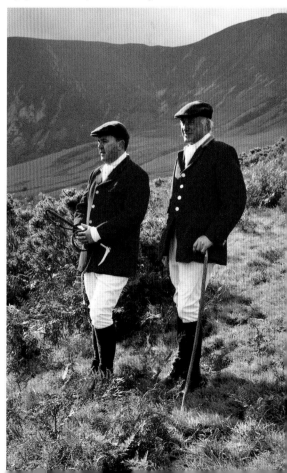

Directors of the American Masters of Foxhounds Association Meeting 2003

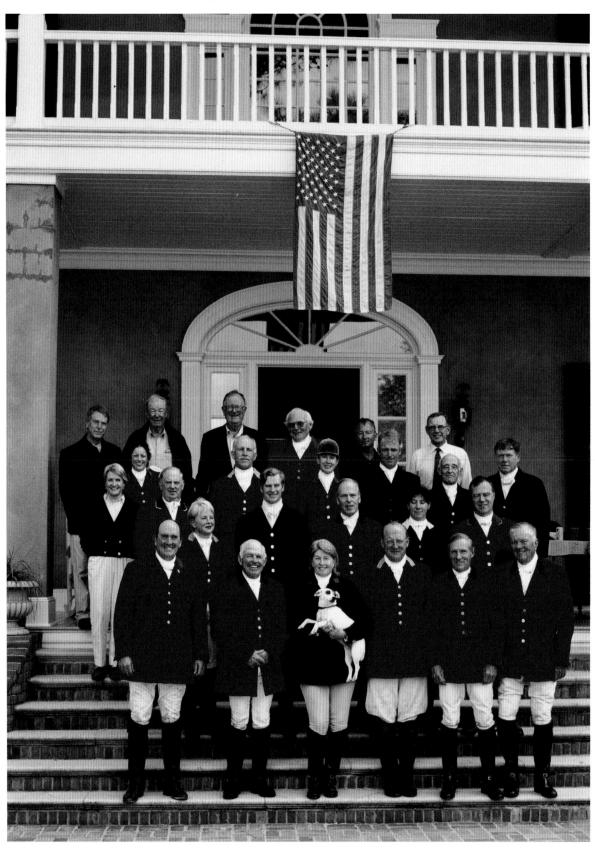

Here are the Directors grouped around Daphne Wood, President 2002–2005 on the steps of Live Oak House after an entertaining day's hunting with the Live Oak Hounds in Florida.

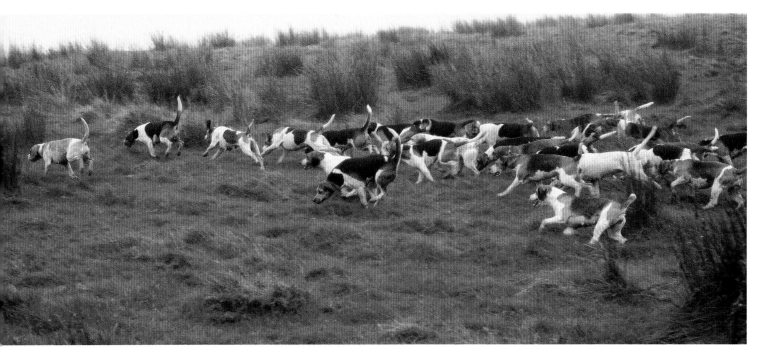

Dummer Beagles

This good looking all bitch pack in full cry across some open wild moorland high in the hills.

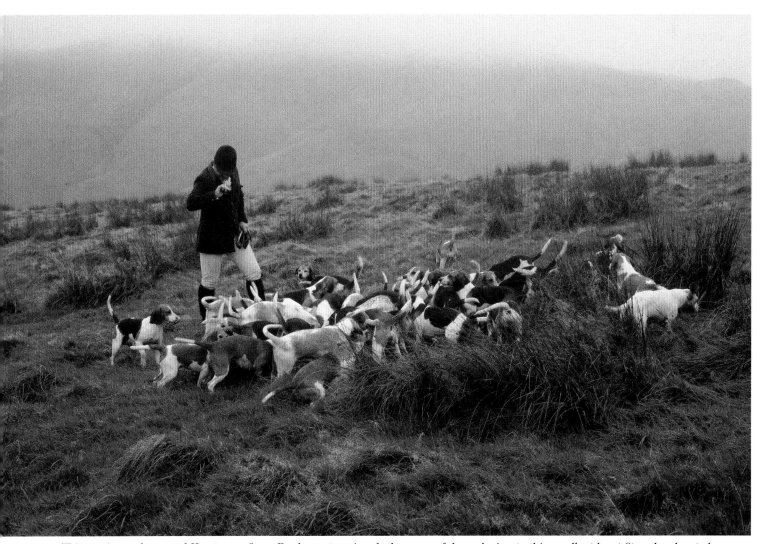

Thirty minutes later and Huntsman Steve Duckmanton signals the successful conclusion to this excellent hunt. Steve has hunted these show-winning hounds since 1985.

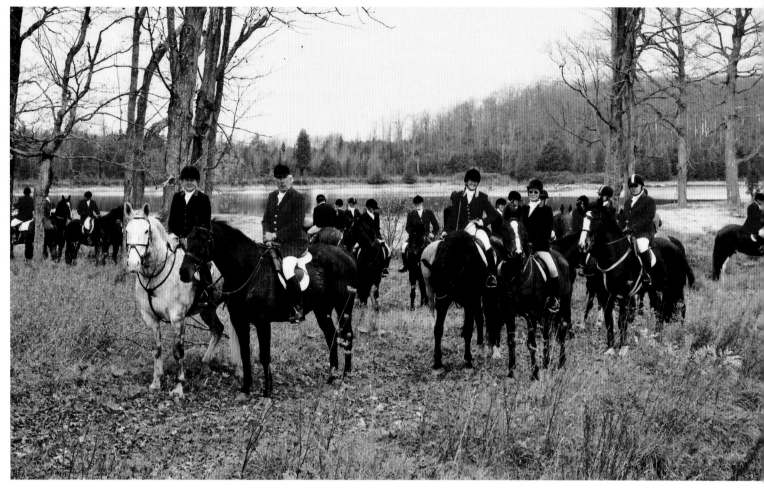

Eglinton and Caledon Hunt – Canada

In the front rank of the field as hounds draw a covert at Toad Hall are Michael and Laurel Byrne with Kris Hallman MFH and Huntsman of the Wellington Waterloo Hunt just behind. This was during the Bi-Annual Ontario Festival of Hunting in October 2006.

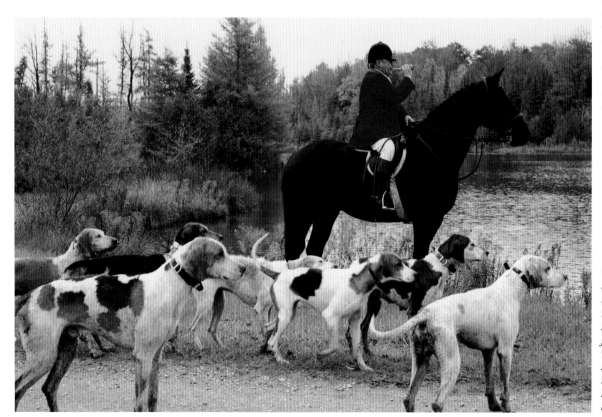

With the beautiful colours of the Fall beginning to tint the trees Huntsman Steve Clifton blows for hounds, which were on the other side of the lake. Note how intently the horse and hounds are watching.

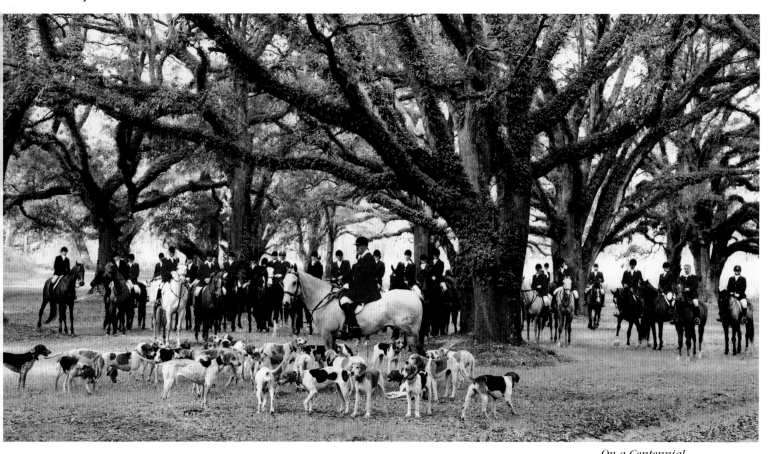

Elkridge-Harford Hunt – Maryland

On a Centennial joint meet visit to Florida, hounds with Huntsman Geoff Hyde pause under the spreading branches of a most impressive oak tree. The large mounted field enjoyed some tremendous runs in country very different to their own.

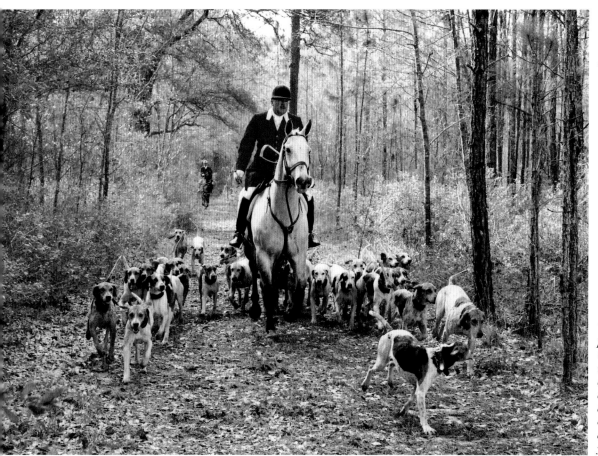

With his all bitch pack, Huntsman Geoff Hyde on the move through an area of woodland during an excellent day hunting fox and coyote in Florida during Centennial year.

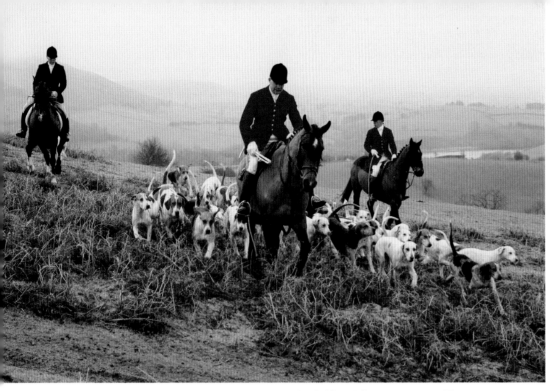

Bringing hounds to an invitation meet in the Golden Valley country are Huntsman Robert McCarthy, Whipper-In Robert Medcalf and Amateur Whipper-In Kate Brownlie. Robert McCarthy is now Huntsman to the Percy Hounds in Northumberland.

Essex and Suffolk Hunt

Four Joint Masters looking happy at the start of a day which ended in a snow storm! Liz Reid, Cheryl Grove; Mark Westwood and Gi D'Angibau.

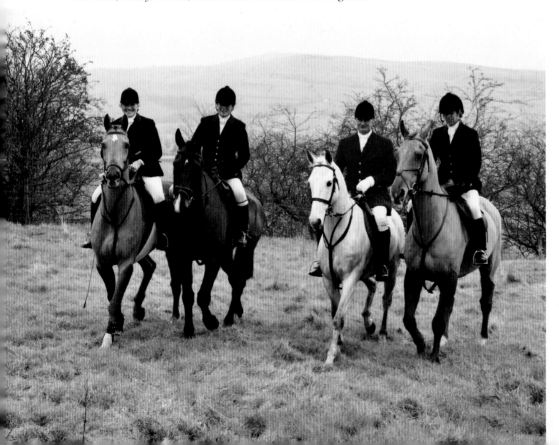

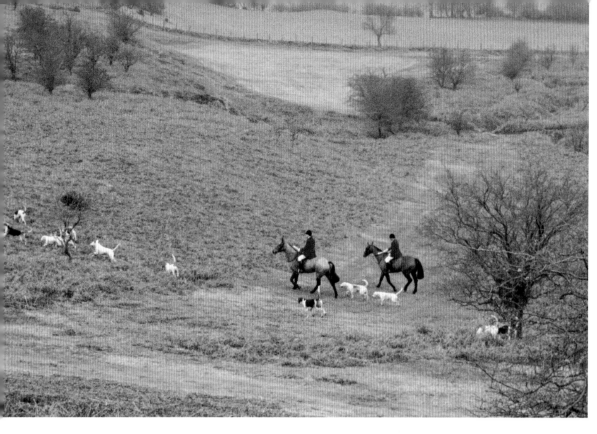

With hounds as they draw through a large bracken bed on a cold morning are Huntsman Robert McCarthy and Whipper-In Robert Medcalf.

Followers enjoying the ride, in country very different to where they normally hunt in the East of England and not a ploughed field in sight!

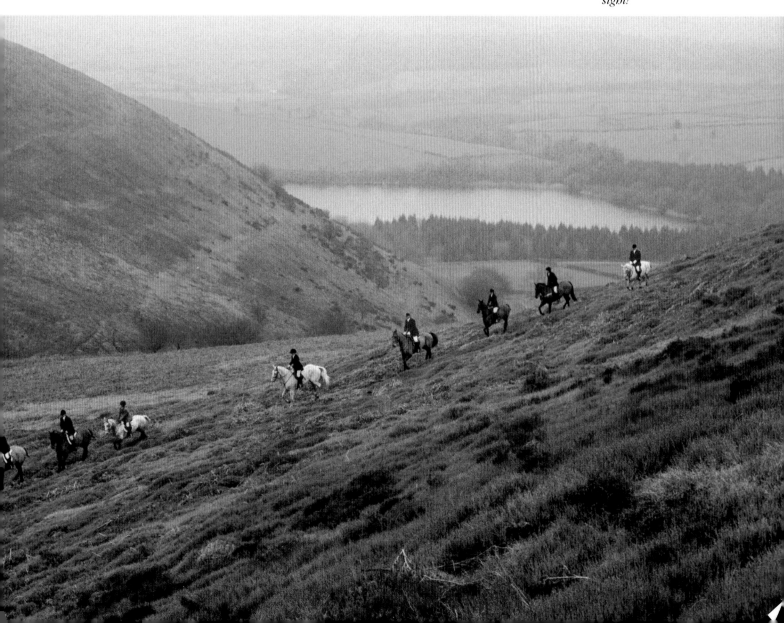

Falls

Tanya Nelson, Field Secretary of the Misty Morning Hunt showing conclusive evidence of a fall! But still smiling!

The frighteningly named 'Killer coop', in the Bear Creek Country, Georgia, USA, claims another victim!

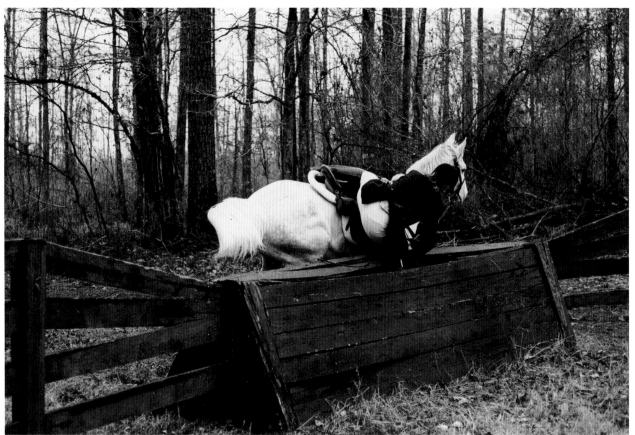

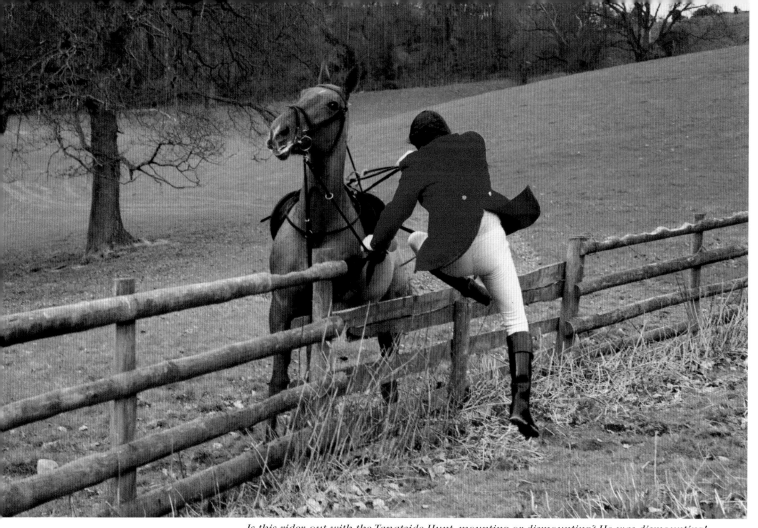

Is this rider, out with the Tanatside Hunt, mounting or dismounting? He was dismounting!

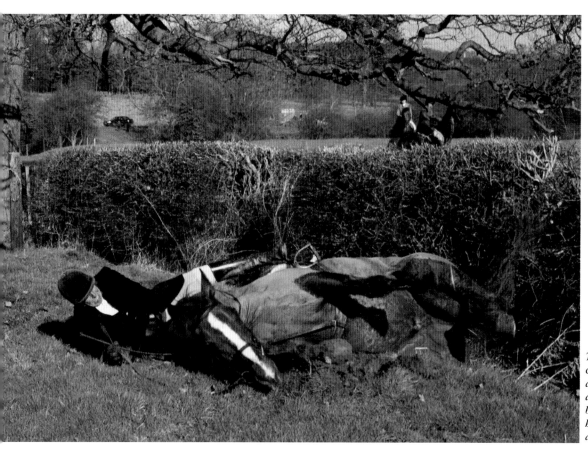

This real 'cruncher' was caused by landing short and catching the lip of a deep ditch probably by approaching the hedge too slowly. Horse and rider were unhurt.

A Pytchley follower is about to muddy his distinctive Padua red coat when his horse straddled a timber fence. Luckily the ground was soft.

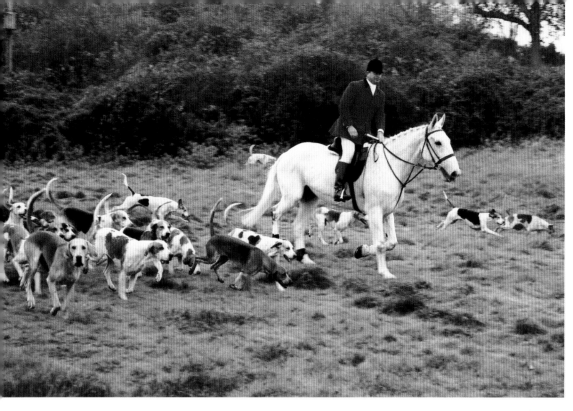

This hunt, whose country covers a huge area of Cornwall in the far south-west of England, was started in January 1780. Here Joint Master Paul Hancock, who has hunted these hounds since 1982 takes them to a fresh covert.

Four Burrow Hunt

On this day Joint Master Tony Blumenau was celebrating a major birthday and is pictured here surrounded by eight ladies, nicknamed 'Tony's Angels'!

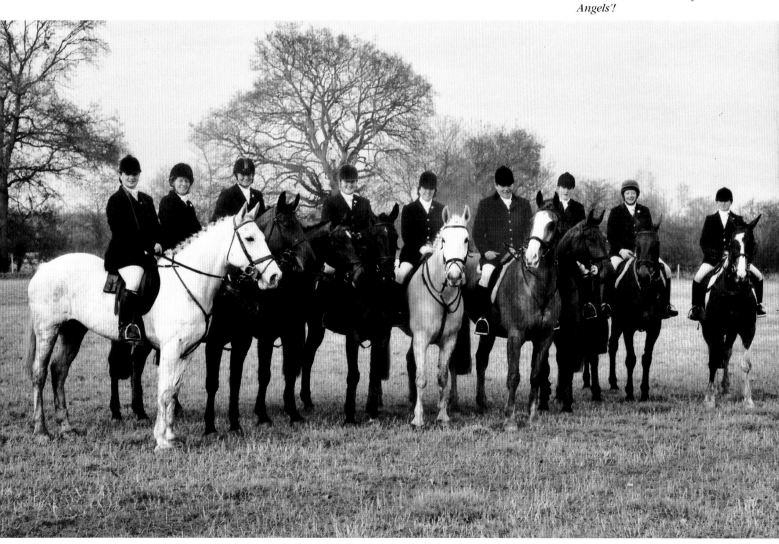

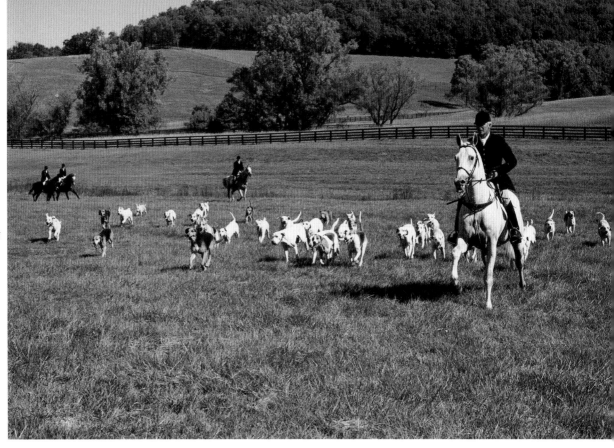

This good-looking pack of hounds with Joint Master and Huntsman Tony Leahy racing across a big grass meadow after a very warm opening meet held at St John's Lutheran Church of Massbach.

Fox River Valley Hunt – *Illinois, USA*

Nearing the end of a day's hunting when the temperature reached 80°Fahrenheit, hounds decided to stop for a swim in a nearby lake! Then they were soon back in full cry on another coyote, much refreshed!

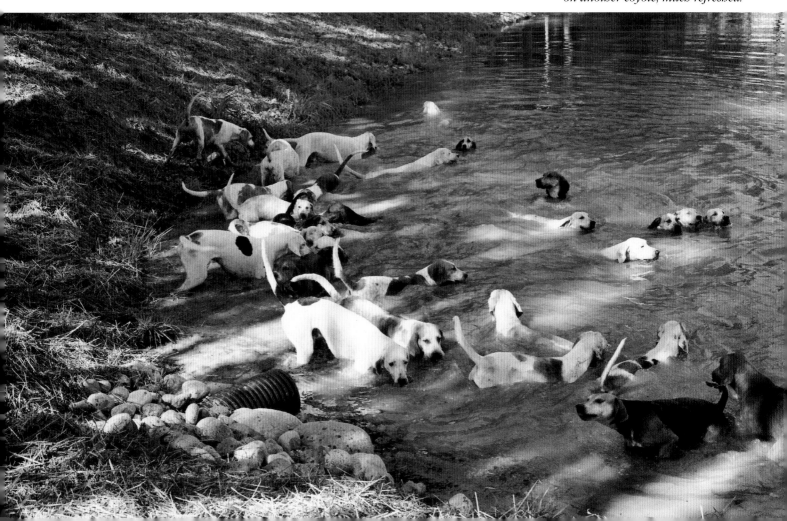

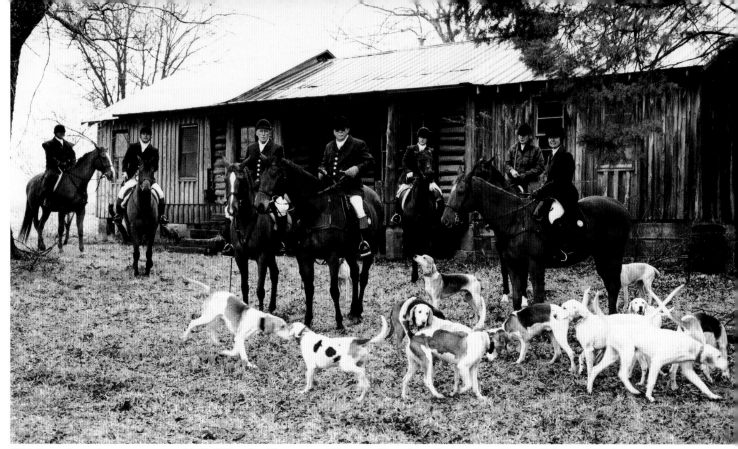

With hounds as they meet at an old Civil War dwelling named 'Roosters' Roost' are the two Joint Masters John and Barbara Lowery with Whipper-In Jack Goodman. Sadly this was one of the last times Barbara Lowery was able to wear her hunt uniform, as she died a short time later.

Full Cry Hounds – Alabama, USA

It was as cold and wet as it looks as hounds draw across one of many huge, flat cotton stubble fields with Joint Master and Huntsman John Lowery searching for a coyote, which they soon found and hunted.

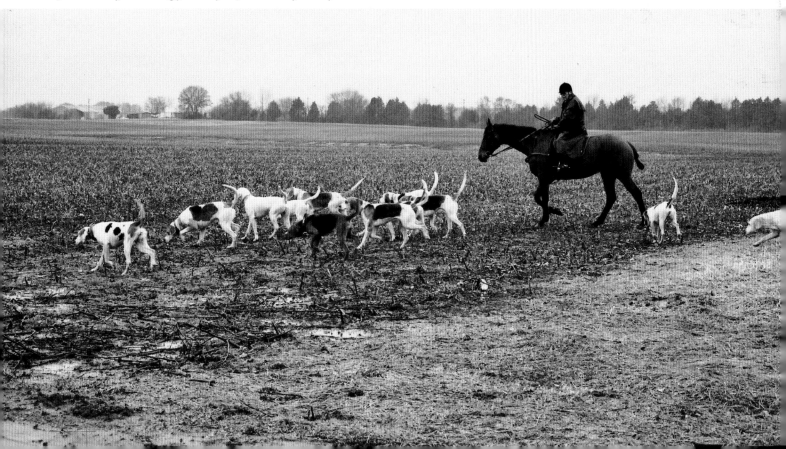

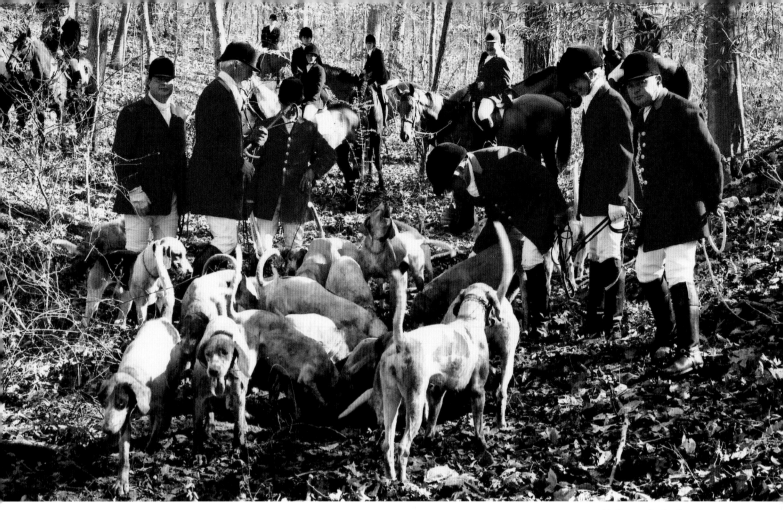

Gone to Ground

At the end of a hunt during a Centennial joint meet in the Mooreland Hunt country in Alabama. Mason Lampton MFH Midland Foxhounds, encourages his pack as they mark a coyote to ground in a covert with other Masters and staff in attendance.

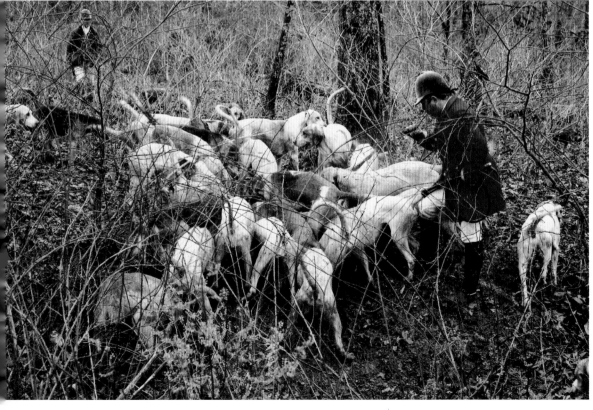

Toronto and North York Huntsman Mark Powell with his mainly modern English foxhounds marking a coyote to ground after a 'race' of eighty-five minutes, which left many horses 'blowing' hard.

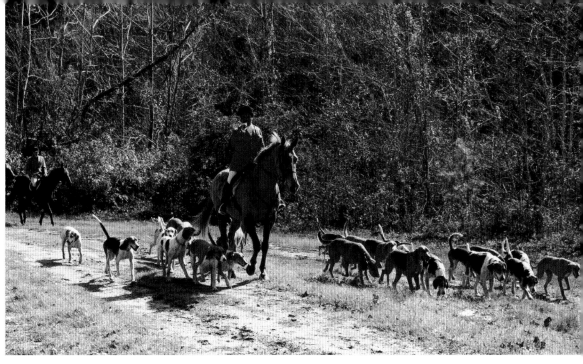

Joint Master and Huntsman of the Green Creek Hounds, Jefferson 'Tot' Goodwin collecting his pack at the end of a day's hunting in North Carolina, USA. Note some of his unique tan coloured hounds leading the way. These two packs have now amalgamated to form the Green Creek/Greenville County Hounds, North Carolina, USA.

Green Creek and Greenville County Hounds

Gerald Pack, who was Joint Master and Huntsman of the Greenville County Hounds from 1976-2006, putting hounds in to draw a large woodland covert on a warm sunny morning, just before the opening meet.

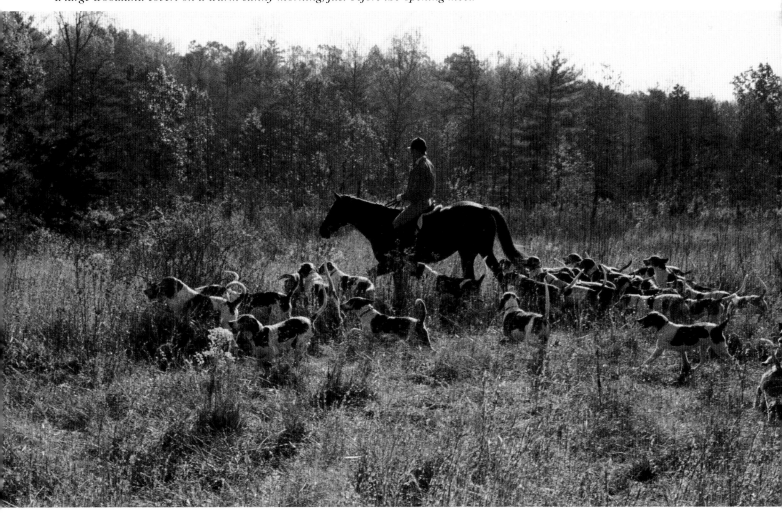

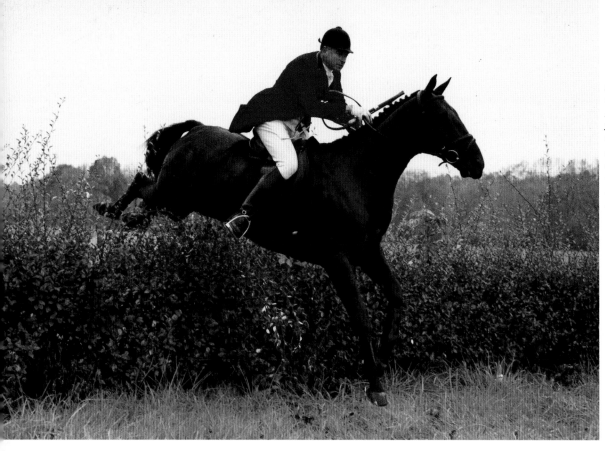

This is for me a unique picture, as it is the only living hedge that I've photographed being jumped in America. The rider is Carl Bouckaert, a Joint Master of the Shamrock Hounds in Georgia, he is also an International Three Day Event rider.

Hedges

Liz Tyrie has her horse jumping off its hocks as they negotiate a tall thorn hedge with the Staffordshire Moorland Hounds.

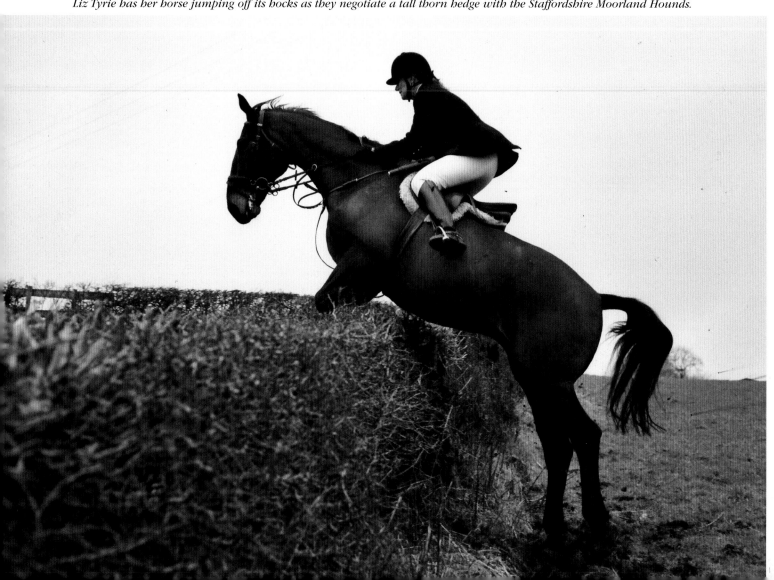

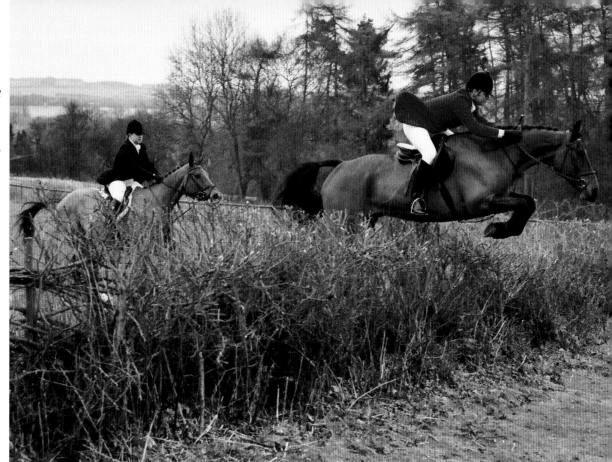

Cotswold Hunt Field Master Robert Brickell gives a good lead on a day when hedges, timber and stone walls were all jumped.

Giving a big Pytchley hedge plenty of height is Ann Jones, whose husband was a Joint Master 1984-1987.

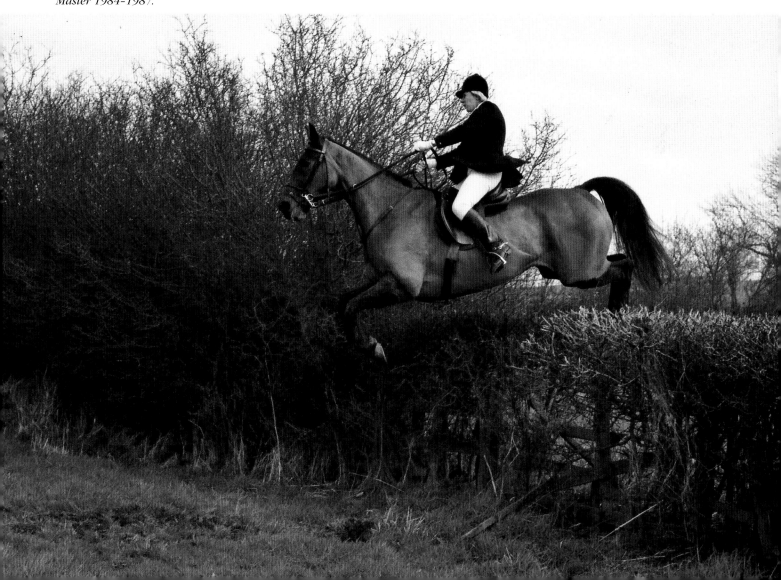

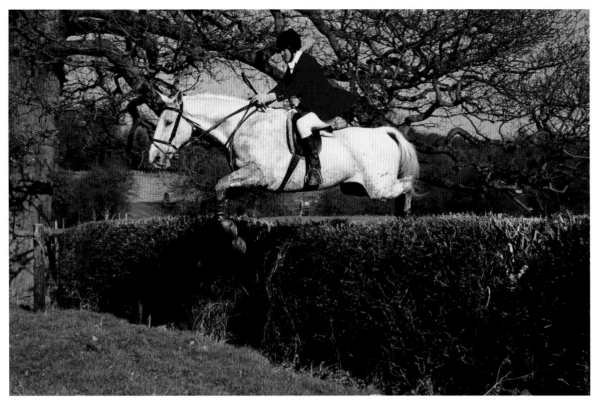

Proudly wearing the white collar of the Pytchley Hunt William Spencer sails over a recently trimmed thorn hedge. His father Richard has been a Joint Master since 1990.

Both Catherine Whittles and her bold chestnut hunter appear to be enjoying themselves during a hunt with the Staffordshire Moorland Hounds.

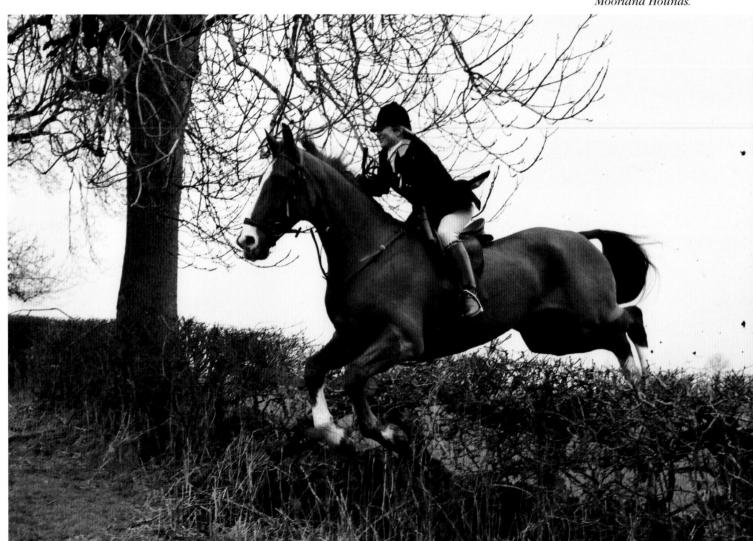

Heroes

Pictured here during a day's hunting on the Long Mynd is Otis Ferry, Joint Master and Huntsman of the South Shropshire Hounds. He was one of the brave young men who put their necks on the line in an effort to save hunting by cleverly making their way into the Debating Chamber of the House of Commons on 15 September 2004. By a strange coincidence, 15 September is 'Battle of Britain' Memorial Day, very appropriate don't you think?

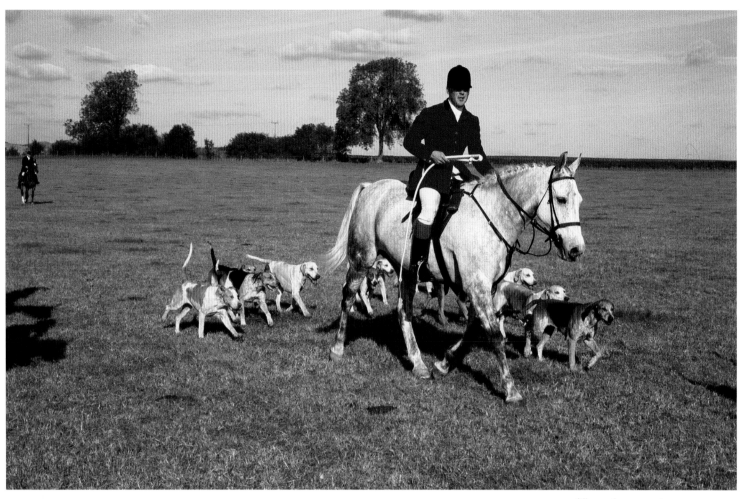

The only current
member of Hunt Staff
who made his way into
Parliament is Ledbury
Huntsman since 1995,
John Holliday, who had
previously been a
Whipper-In to the Quorn
and the Belvoir. Here
John is pictured with the
Ledbury Hounds on
opening meet day at
Corse Lawn.

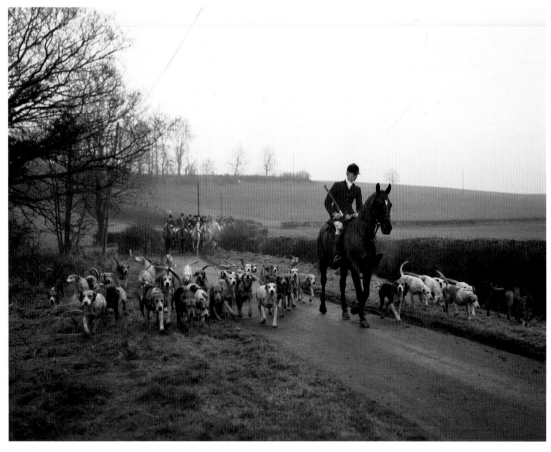

Another one of these heroes
is Andrew Elliot who
although no longer in hunt
service was First Whipper-In
to Huntsman Nimrod
Champion at the Ledbury
when I photographed him
leading hounds and a big
mounted field in 1981.

History was made twice at the Virginia Hound Show on Sunday 30 May 2004, when the result of the Grand Championship was announced. For the first time ever it was won by a Penn-Marydel Hound, while the handler was the youngest ever to win this honour. Here twelve year old Codie Hayes receives this splendid cup from Jimmy Young MFH and Jake Carle, President and First Vice-President of the Show Committee.

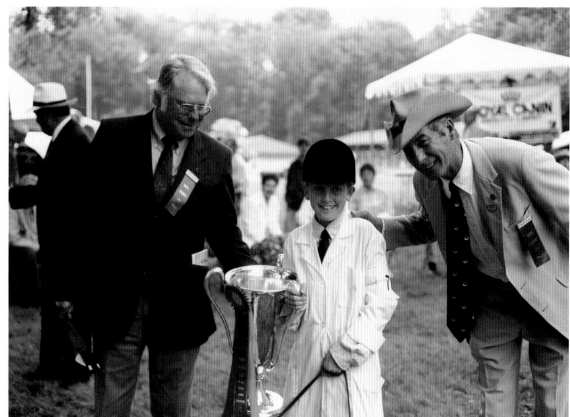

History

Here are the two history makers following the presentation! Holding the Grand Champion cup is the handler, twelve year old Codie Hayes, while her grandfather, Jody Murtagh MFH Rose Tree Hunt, holds the Grand Champion Hound Rose Tree 'Needy' which he bred and which Codie showed so expertly.

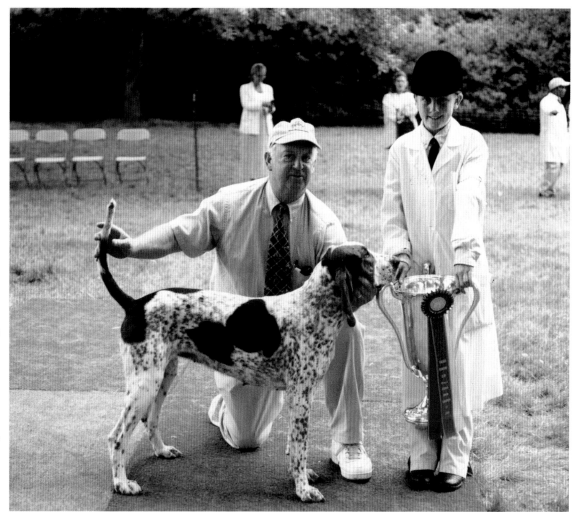

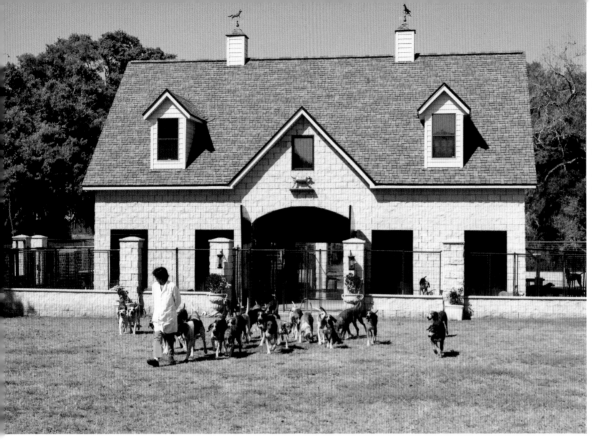

Just before their twelfth closing meet the Misty Morning Hunt opened fantastic new kennels, built on the Joint Master's property, Perry Plantation, Gainesville, Florida. Here Alexis Macaulay MFH and Huntsman takes her pack of mostly American hounds out on exercise.

Hound Exercise

Midland Hunt staff on mounted exercise watch as hounds enjoy a cooling dip in a lake on a hot September morning in Georgia close to the kennels.

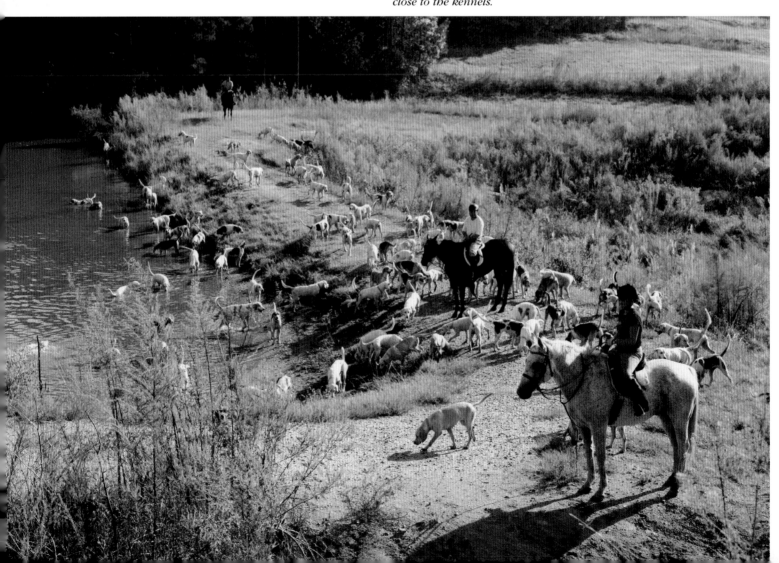

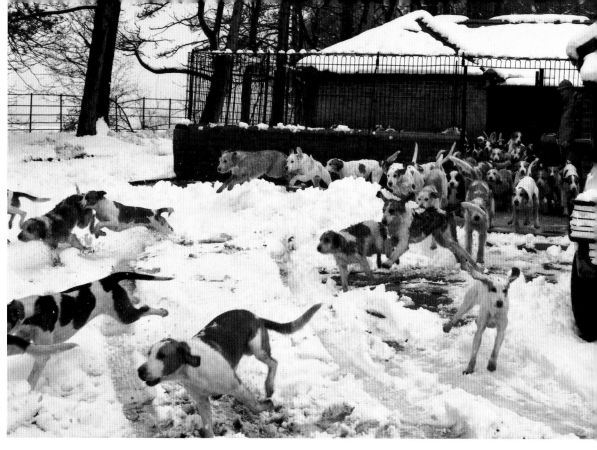

The David Davies pack of Welsh and Fell Foxhounds bursting out of the kennel gate in their excitement at the prospect of being walked out in the snow, as hunting had been cancelled.

At the end of David Jones' thirty-fourth and last season at the David Davies Hunt a heavy fall of snow made for some 'Winter Wonderland' pictures as he walked hounds out from the kennels in Mid-Wales in February 2007.

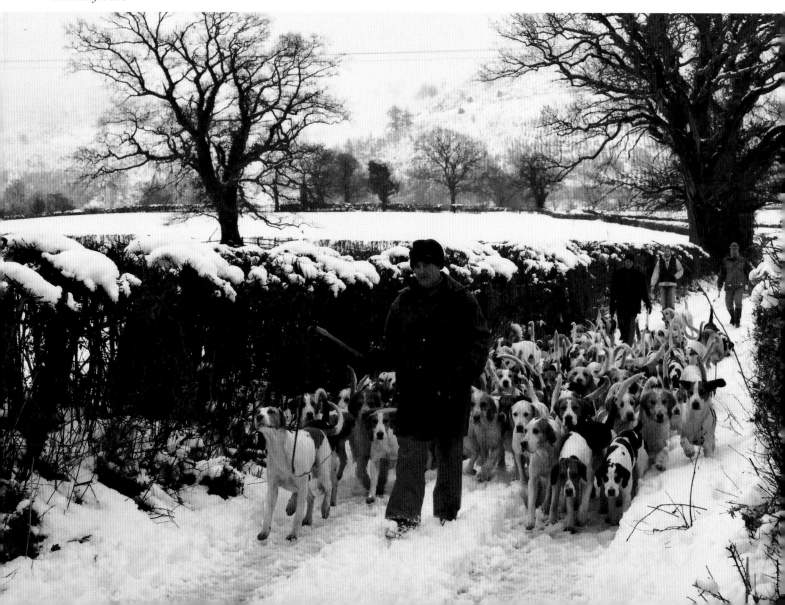

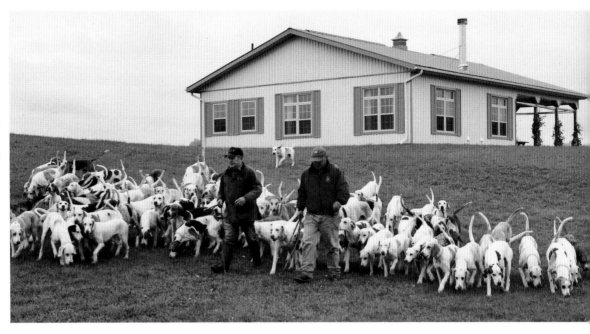

With their newly completed clubhouse in the background the Toronto and North York Hounds with Huntsman Mark Powell and visiting Huntsman Marc Dradge (Midland) walk the pack back to their kennels after morning exercise.

The Elkridge-Harford Hounds enjoying a walk with Huntsman Geoff Hyde during a Centennial joint meet visit to the Live Oak Hounds in Florida. Here they had a splendid hunt on a coyote, which are few and far between in their home country in Maryland.

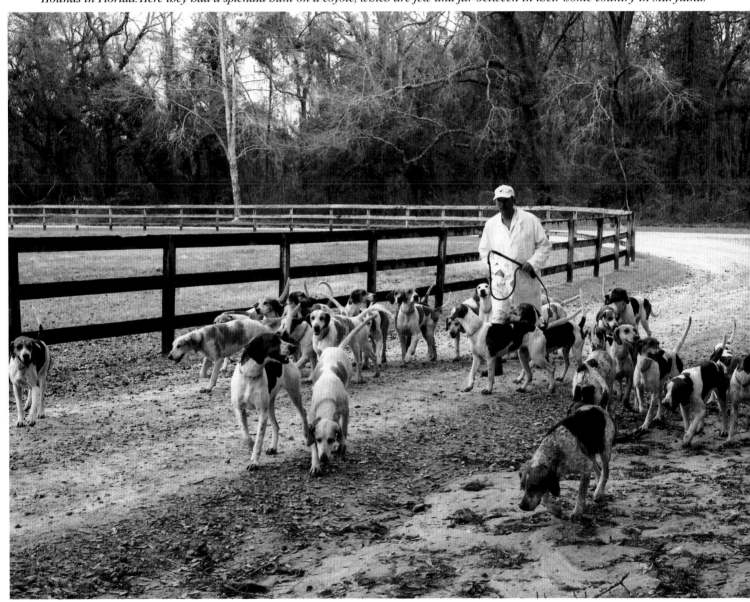

Surely this is the most picturesque setting for a major hound show held as it is in the Lake District of north-west England. The fell, or hill in the background shows why foxes are hunted on foot as the terrain is impossible for horses. With entered fell bitches being judged are Huntsmen of three of the best known fell packs. John Harrison, Ullswater, Barry Todhunter, Blencathra and Edmund Porter MFH Eskdale and Ennerdale.

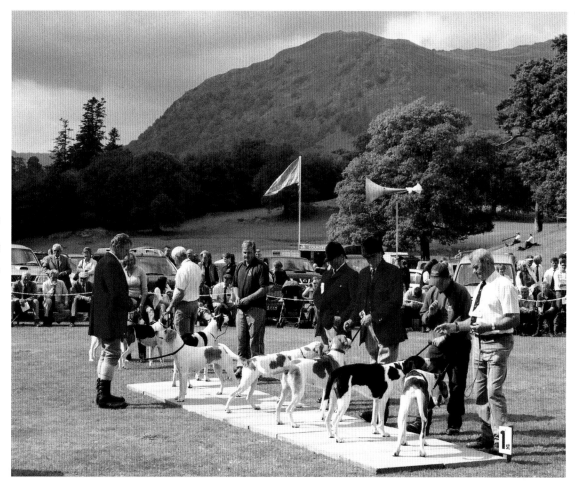

Hound Shows

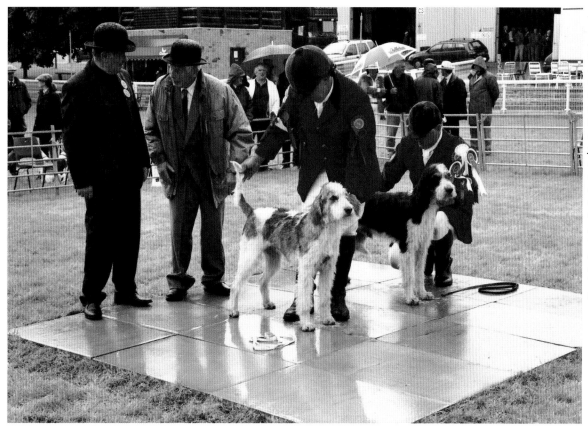

Held on the Royal Welsh Showground at Builth Wells this is the major show for Welsh Hounds and is enjoyed by big crowds of partisan supporters. However, it sometimes rains, as here in 2007, when judges Gareth Morgan and Dewi Price were soaked through when comparing two dual champions, Llanwnnen Farmers 'Brandy' with Ianto Evans MFH and Pembrokeshire 'Gerwyn' with Gary Barber, MFH.

How elegant Prince Charles looks in his Windsor livery hunting coat, with red collar and cuffs. He is pictured here in High Leicestershire during a day with the Quorn Hounds, hunted by Michael Farrin watching as they drew Parson's covert with a sea of grass behind.

HRH The Prince of Wales

Prince Charles hunted with numerous different packs in the U.K., but was most regular in High Leicestershire and with the Meynell. Riding up at the front the Prince and his chestnut hunter effortlessly clear a cut and laid hedge, with a binder, in the Quorn country.

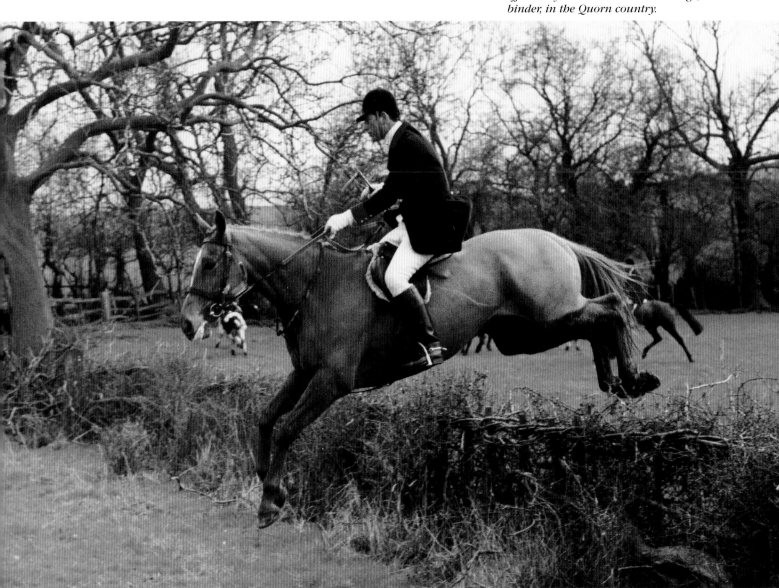

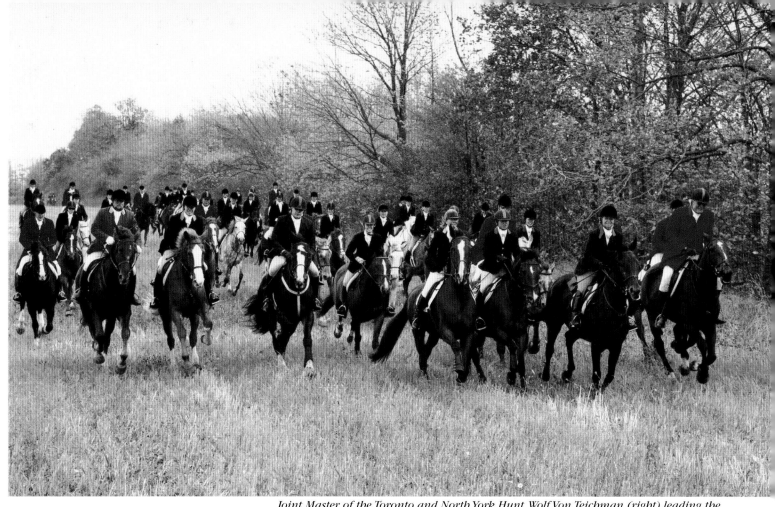

Hunt Fields

Joint Master of the Toronto and North York Hunt, Wolf Von Teichman (right) leading the way at the gallop, during a hunt in the Fall. These riders are from several different packs and were involved in the Ontario Festival of Hunting.

Riding together after a hunt, during a Centennial joint meet are (left to right) Rob Kinsley MFH, Elkridge-Harford; Daphne Wood MFH; Live Oak; Liz McKnight MFH, Elkridge-Harford; Dale Barnett, Whipper-In, Live Oak.

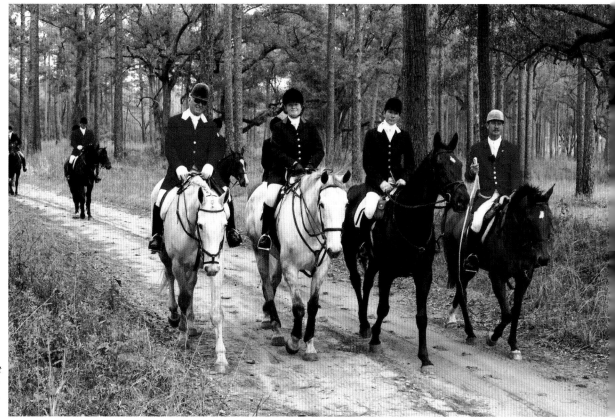

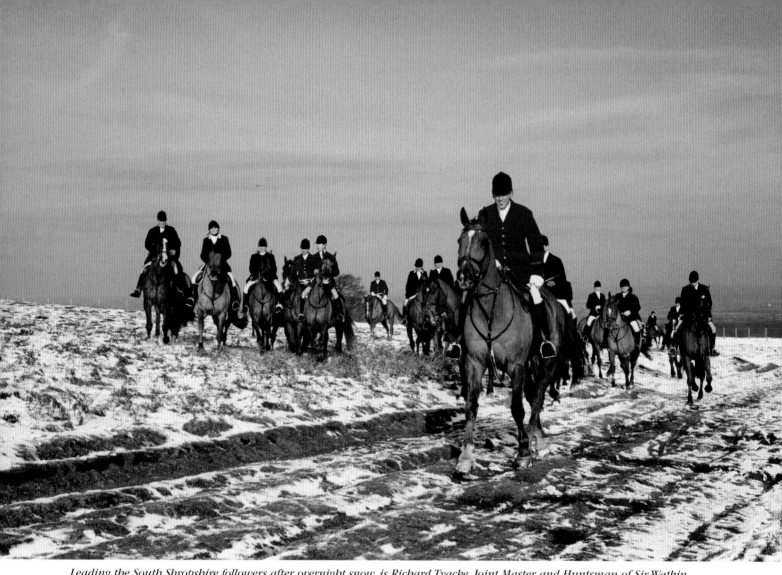

Leading the South Shropshire followers after overnight snow, is Richard Tyacke, Joint Master and Huntsman of Sir Watkin Williams-Wynn's hounds, who was visiting.

Seven American foxhunters out with the Duke of Beaufort's Hounds (left to right) Colin McNarr, Shellie Sommerson, Cameron Slade MFH, Moore County Hounds, North Carolina; Charles Siler, Maralyn Tremblay, Grace Bozick, Bruce Colley - son of Gene Colley MFH - Golden's Bridge Hounds New York.

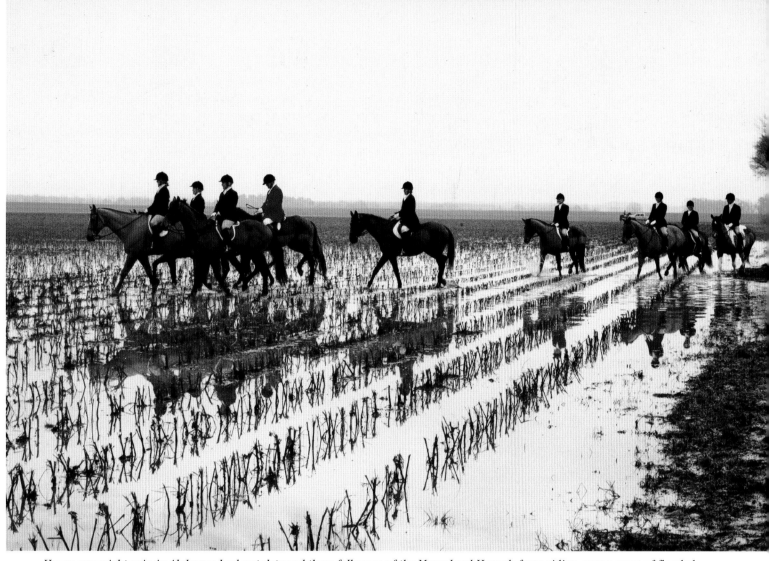

Heavy overnight rain in Alabama had not deterred these followers of the Mooreland Hounds from riding across acres of flooded cotton stubble fields when hounds were hunting a coyote.

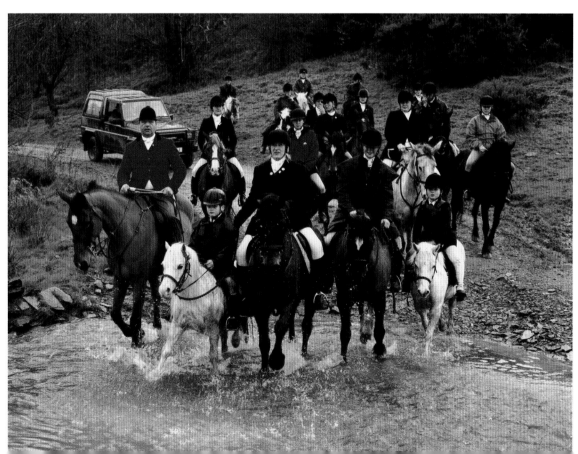

With young riders well to the fore, followers of the Llanwnnen Farmers Hunt cross a mountain stream on a day of heavy rain showers. To the front left is the Field Master Keith Ellaway.

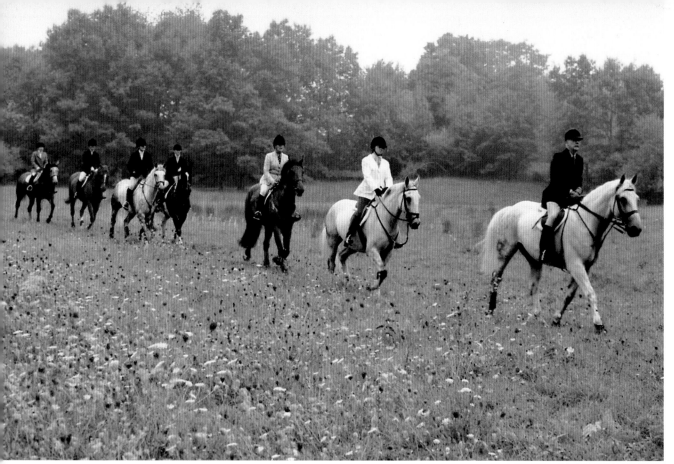

Farnham Collins, Joint Master of the Millbrook Hunt in New York State since 1978 heading a group of riders as they cross a meadow full of wild flowers, during cub-hunting in September.

These riders hunting with the Essex and Suffolk Hounds had listened to the weather forecast and were well dressed to deal with the rapidly approaching blizzard!

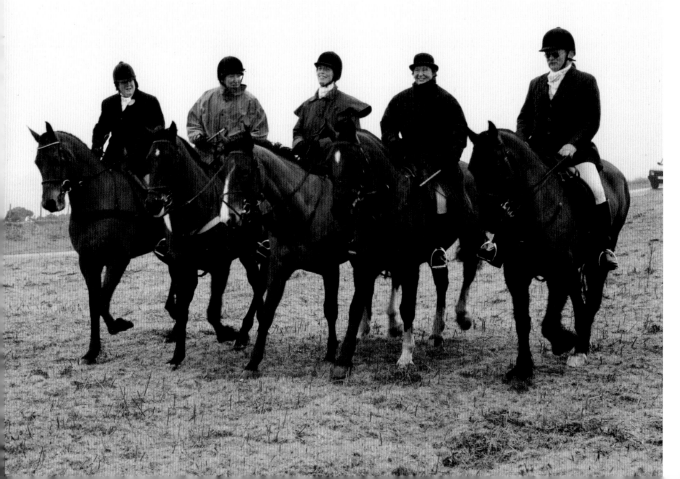

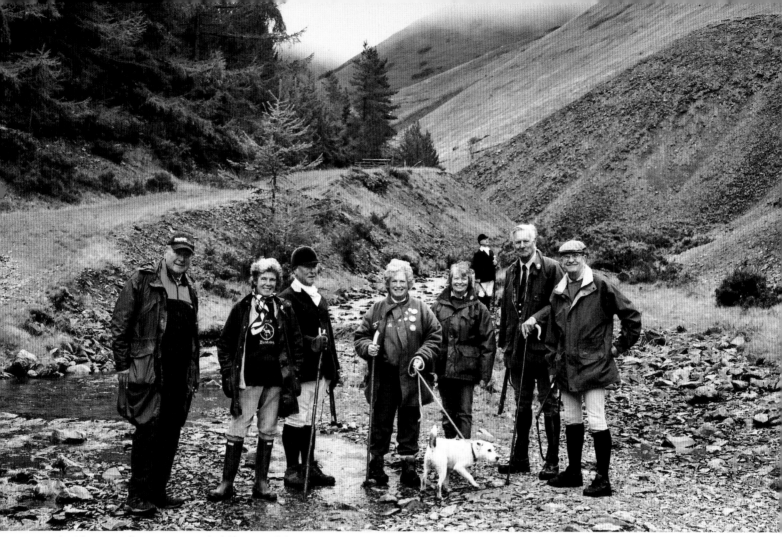

Amidst marvellous countryside followers of the Sandhurst and Aldershot Beagles cross a stream in the bottom of a steep valley, while low clouds envelope the hilltops. In uniform is Joint Master since 1997, Anthony Bowring.

An informally dressed group of supporters who hunted with the Border Counties Minkhounds, on a very hot day in June. Note the recently mowed hay awaiting the baler.

Hunting in Pink

Everybody who knows anything about Foxhunting, knows that it is incorrect to say that someone is 'Hunting in Pink'. This term is often used by anti-hunting newspapers and refers to the time when a Mr Pink tailored hunt coats in Piccadilly, London. However, with help from friends I have photographic evidence that one MFH has 'Hunted in Pink'! Joining me in this 'spoof' are Tony Leahy MFH and Huntsman Fox River Valley and Cornwall Hunts in Illinois and his lovely Whipper-In wife Heidi. Thanks also to the young lady who 'discovered' this shocking pink coat in her local Wal-Mart store!

Hunt Staff

Irish Hound Show in 1995.
Hunt staff grouped at the
end of the day complete
with rosettes.

South of England Hound
Show 1995, a multitude of
hunt staff who were showing
hounds gather for a 'team'
picture.

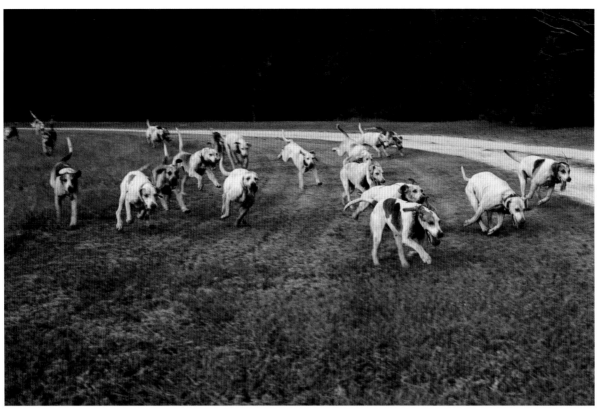

In Full Cry

The Live Oaks' splendid pack of English and crossbred foxhounds racing across a grass field only twenty seconds behind a grey fox. These include several show champions proving that they hunt as well as they look.

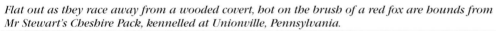

Flat out as they race away from a wooded covert, hot on the brush of a red fox are hounds from Mr Stewart's Cheshire Pack, kennelled at Unionville, Pennsylvania.

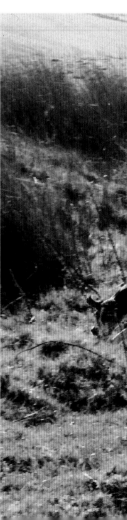

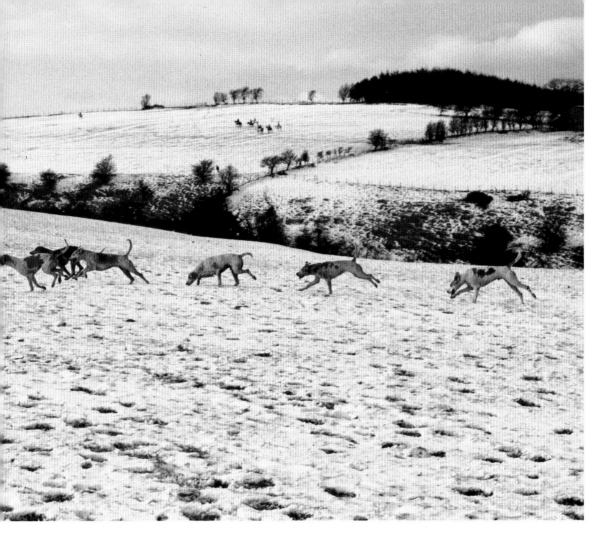

The leading four couple of Middleton Foxhounds hunting well in pursuit of a fox, which made for the snow-covered high ground. Notice some of the field on the far hillside keeping in touch with the hunt, yet not getting in the way.

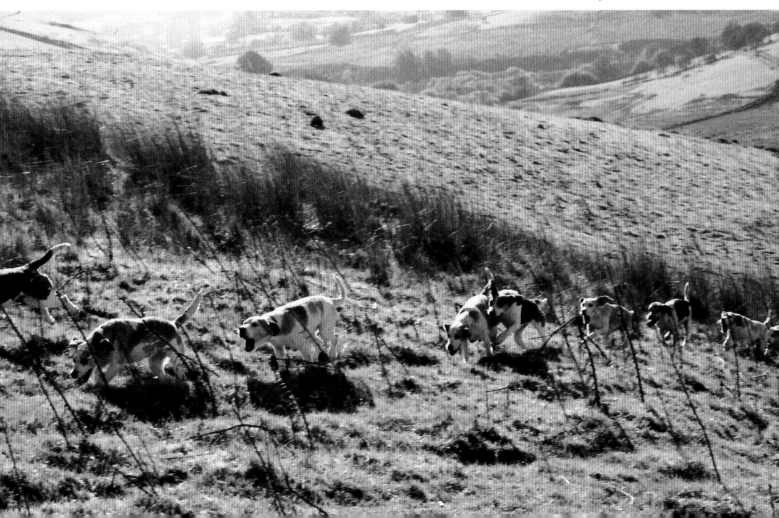

The Oakley Foot Beagles 'roaring' up a steep hill in wild and open hill country hot on the heels of a big hare, which gave us a run of several miles.

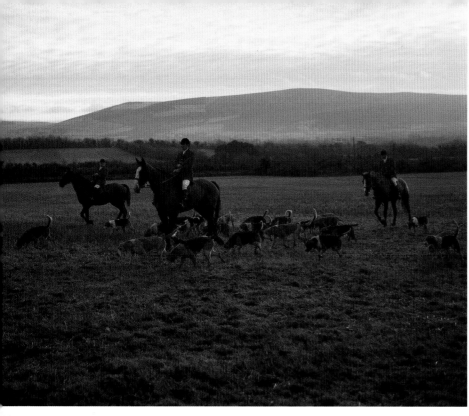

Duhallow Hunt: with mist beginning to appear along the hills in Co. Cork long serving Huntsman and Kennel-Huntsman Harry Clayton collects his pack of mostly Old English foxhounds at the end of a long day hunting, ready to hack home.

Ireland Recalled

Capt Brian Fanshawe who was Joint Master and Huntsman 1969–1972 of The Galway Blazers with hounds in Galway Bay after an exciting morning spent cub-hunting on Tawin Island.

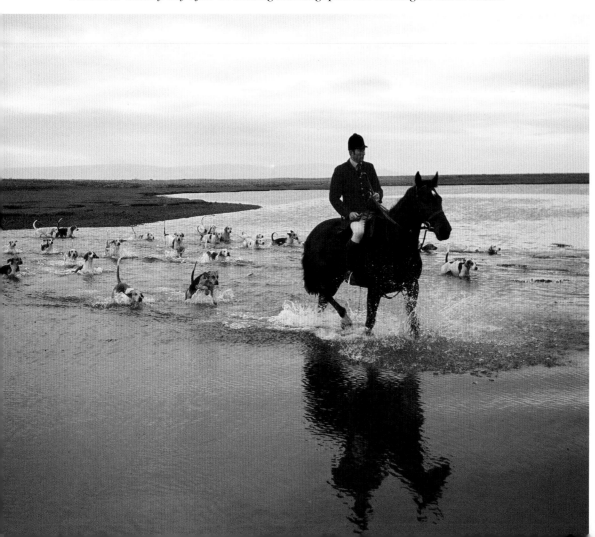

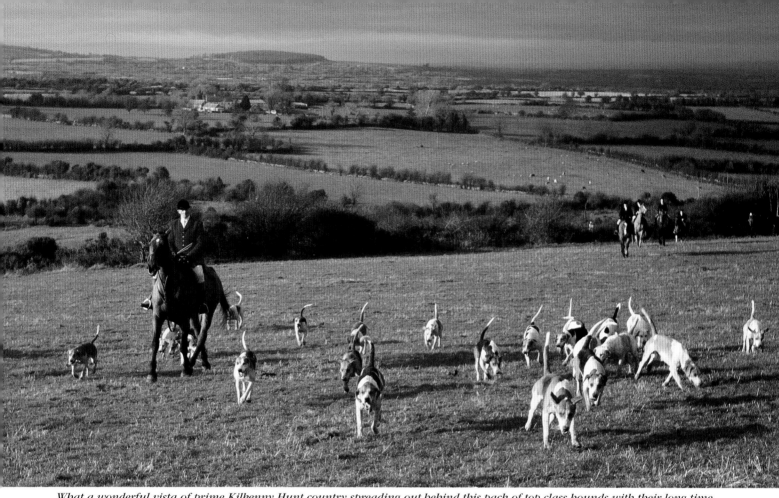

What a wonderful vista of prime Kilkenny Hunt country spreading out behind this pack of top class hounds with their long time Kennel-Huntsman Alf Wright during the Mastership of Major Victor McCalmont 1949–1993.

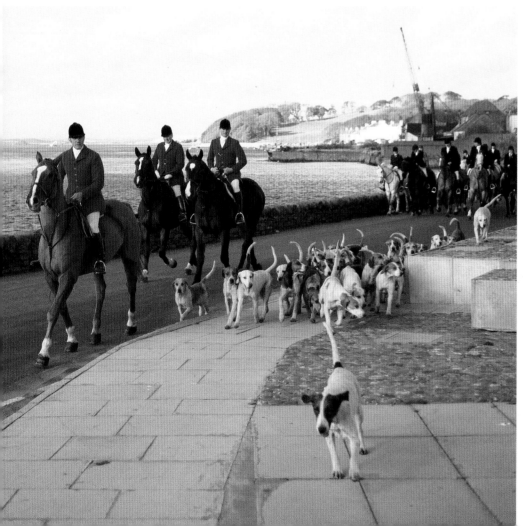

North Down Harriers: it is quite rare to see hounds on the promenade at the seaside, yet here they are, from a meet at Portaferry. In the lead is Kennel-Huntsman Paddy Hutchinson followed by the Joint Masters Bill Montgomery (Huntsman) and Ernest McMillen and a big field.

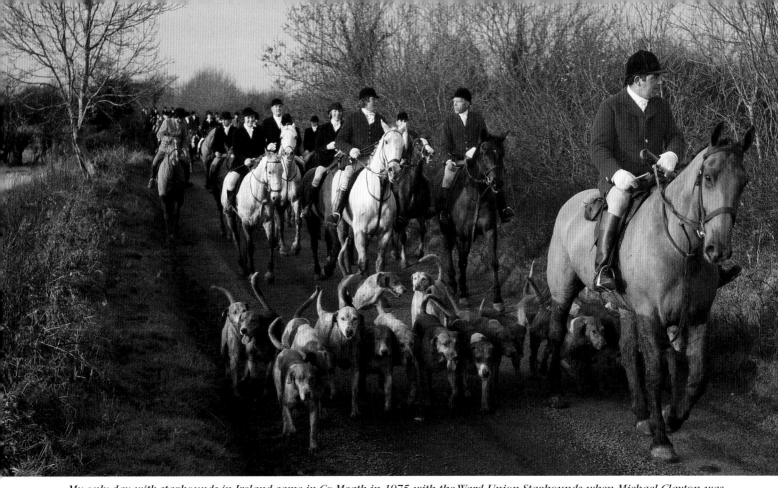

My only day with staghounds in Ireland came in Co.Meath in 1975 with the Ward Union Staghounds when Michael Clayton was featuring 'The Wards' in his 'Foxford's Diary' in Horse & Hound. Here Huntsman Eamonn Dunphy leads his mud-spattered pack home in late afternoon sunshine.

Irish Foxhunting has thrown up many great characters over the years including Elsie Morgan who was Joint Master and Huntsman from 1953–1984 of West Waterford Hunt with her husband Tom yet they came to the Emerald Isle from Wales! Her pack of mostly white hounds were bred with much assistance from Ikey Bell the innovative hound breeder, who was born in America.

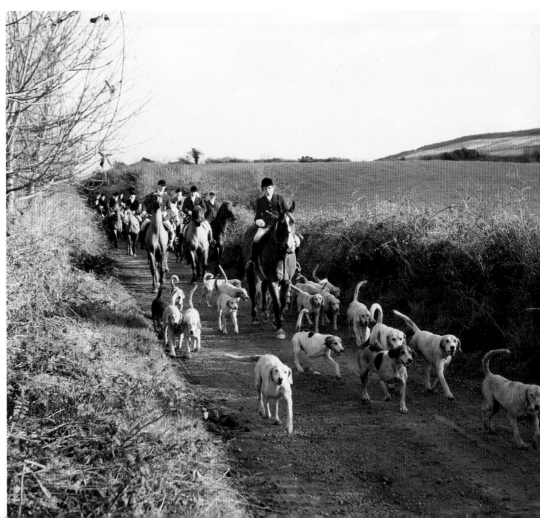

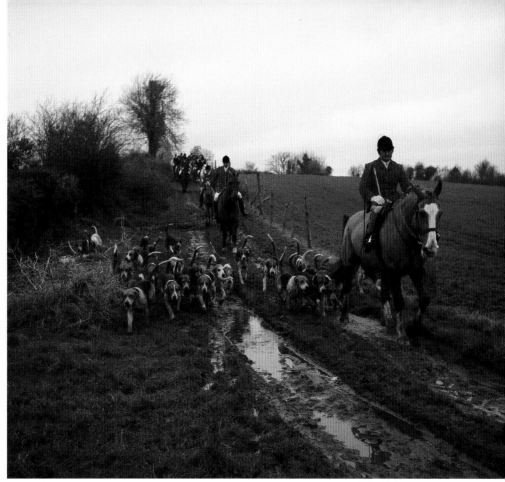

Kildare Hunt: on a good white faced chestnut hunter Kennel-Huntsman Joe Lenehan leads hounds along a very muddy farm track. Behind the Old English looking pack is Joint Master and Huntsman Thomas Long 1967-1976.

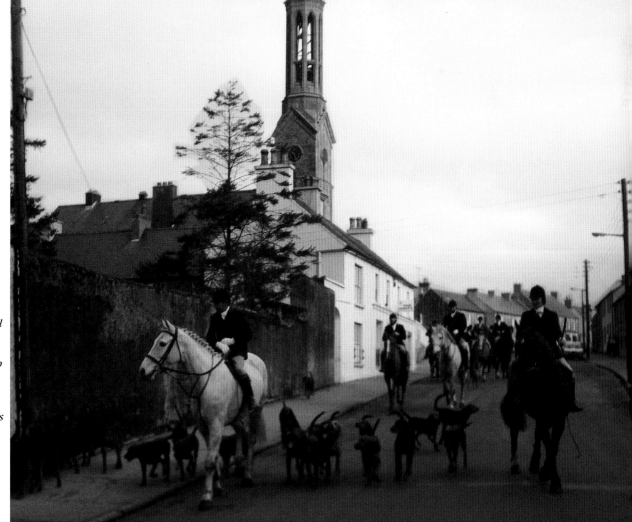

NAAS Harriers: a typical Sunday afternoon in Co. Kildare in 1975 with this pack of all black and tan hounds moving along a village high street on their way to draw. With them is Paddy Powell who hunted hounds from 1961 until they were disbanded in 1982.

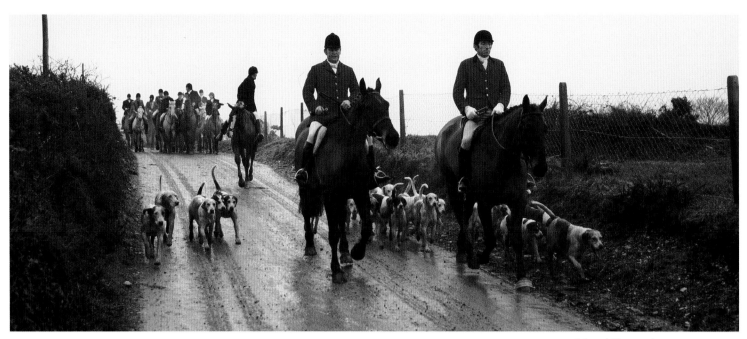

Island Hunt: what an amazing partnership these two great foxhunters and show hunter riders have forged since 1973. In that year, George Chapman was appointed as Master and Huntsman with Billy O'Connor as Kennel-Huntsman and Whipper-In. In 2007, they are still in office, although Billy now hunts the hounds and this picture taken on a 'soft day' at the Harrow shows the indomitable pair, hacking hounds home.

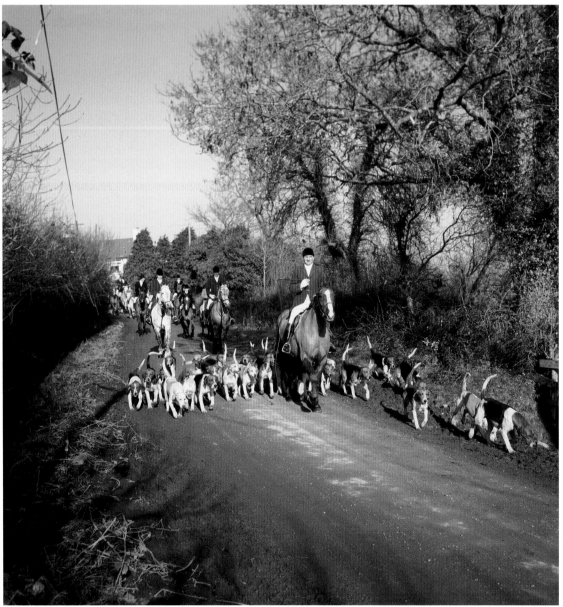

Louth: leading hounds to draw is Michael McKeever who was Kennel-Huntsman 1958–1972, Huntsman 1972–2002 and then Kennel-Huntsman to his son Noel from 2002 to 2005. Heading the field on the dapple-grey is Billy McKeever, a Joint Master from 1973 to 1998.

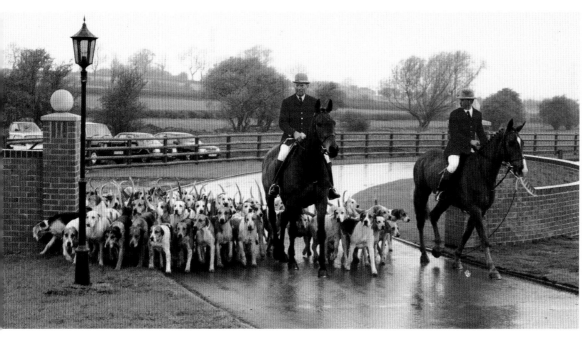

These two previously unpublished photos were taken on 29 April 1991 at the new Quorn Hunt kennels at Kirby Bellars. In this one, with the rain pouring down, Huntsman from 1968 to 1998, Michael Farrin and Whipper-In Jimmy Boyle bring hounds to the new kennels for the very first time ready to move in.

Kennel Opening

In this second picture, Huntsman Michael Farrin has brought hounds to the kennel gate, which is being ceremonially opened by HRH Prince Charles. Prior to the ban on hunting with dogs Prince Charles regularly hunted with the Quorn.

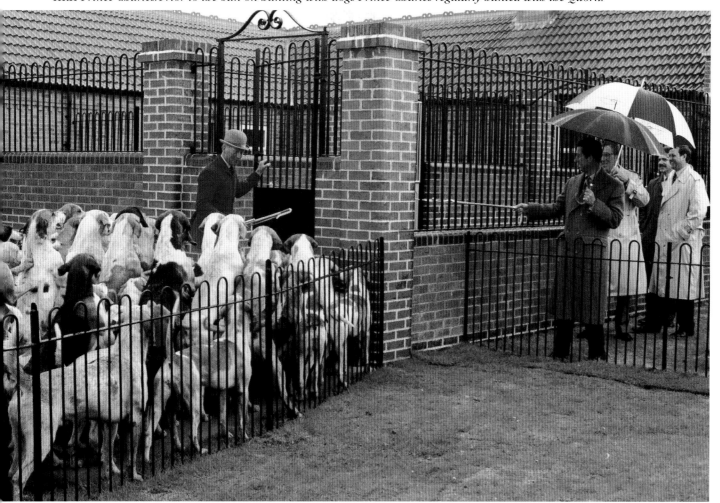

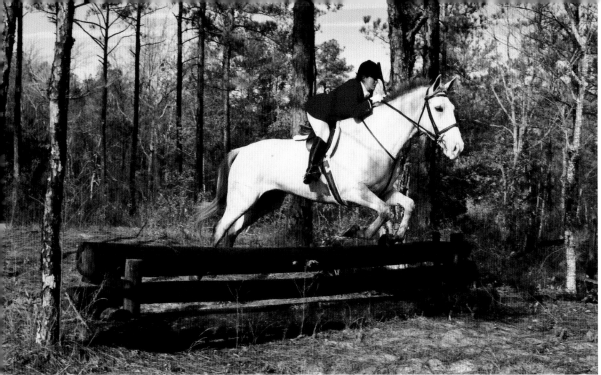

With her grey hunter giving this very solid jump plenty of room, Joint Master of the Moore County Hounds, Cameron Slade, is obviously enjoying this hunt in the Walthour Moss Foundation property at Southern Pines, North Carolina.

Ladies in Scarlet

Matching hunt uniform coats and matching grey hunters for two of the Honorary Whippers-In to the Metamora Hunt in Michigan as Gail Plunkett and Lisa Kingsley set off on point duty.

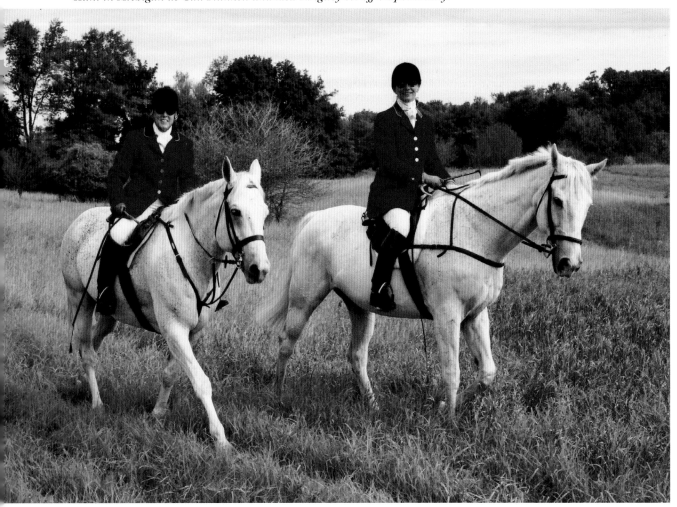

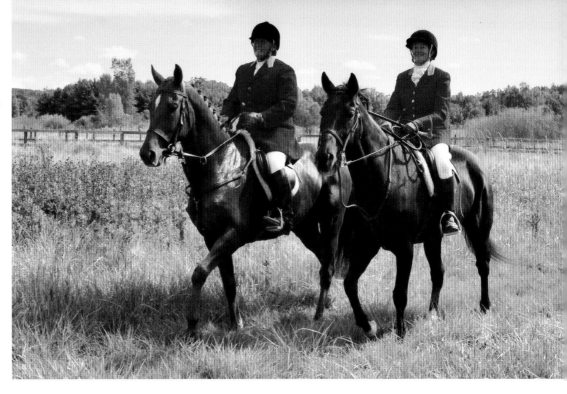

Coming in at the end of a day's hunting in Michigan are two of the Joint Masters of the Waterloo Hunt, Dr Sally Taylor Stommen and Arlene Taylor.

Leslie Rhett Crosby whose father formed the Mooreland Hunt in Alabama in 1961 has been a Joint Master since 1993 and regularly acts as Field Master. Note how she is looking to see where hounds have run, as she jumps this coop.

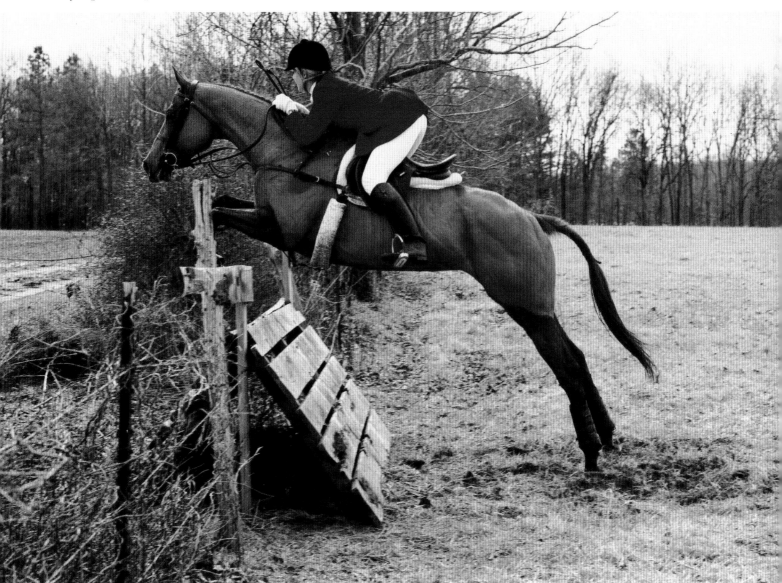

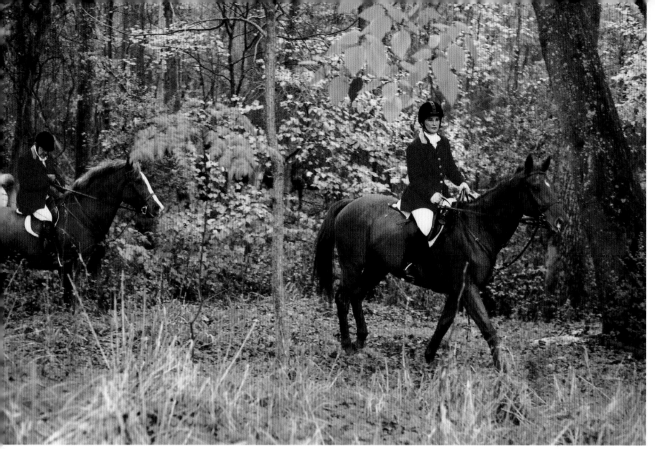

Leading the way through a typical wood in Georgia, is Sally Rasmussen MFH Shakerag Hounds. On this day she was also performing the role of Field Master.

First Whipper-In to the Misty Morning Hounds, Patti Rozensky in action on a warm day in Florida. She also helps to walk hounds out on exercise several days a week.

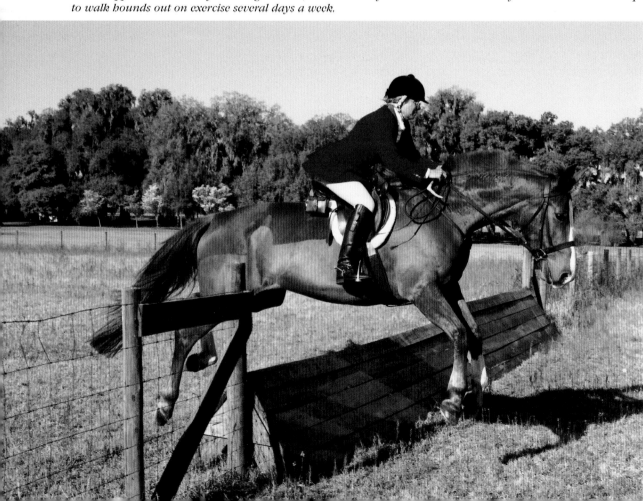

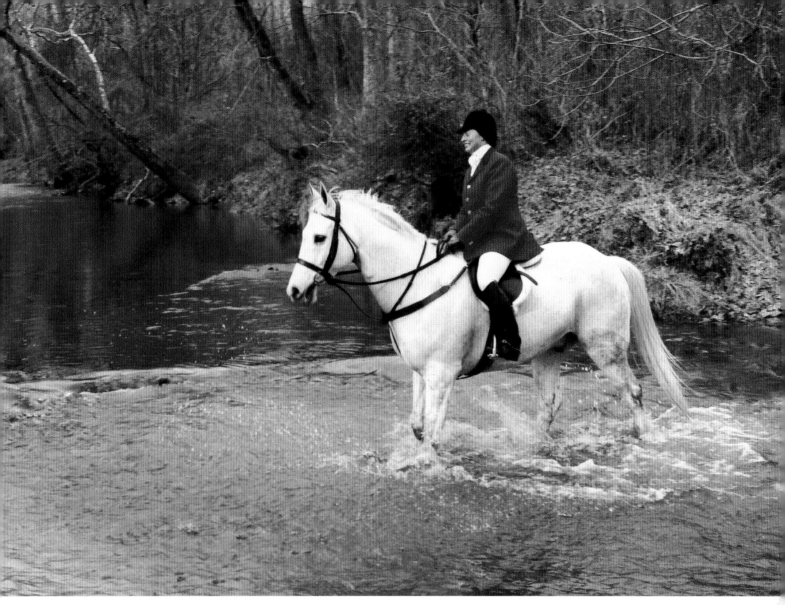

In 2006 Jeanne Clark joined her parents Bill and Joyce Fendley in the Mastership of the Casanova Hunt in Virginia. Here she is fording a creek during her other role as Whipper-In.

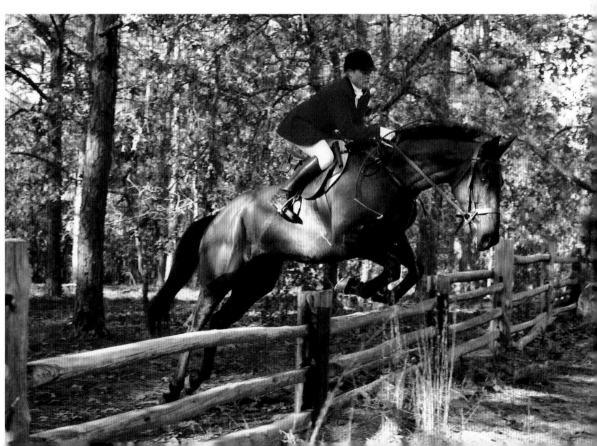

Following in her father's footsteps as a Huntsman of Penn-Marydel Hounds, Missie Murtagh carries the horn with the Tennessee Valley Hunt. Her father Jody hunted the Rose Tree Hounds in Pennsylvania for many years and now hunts the Moore County Hounds in North Carolina.

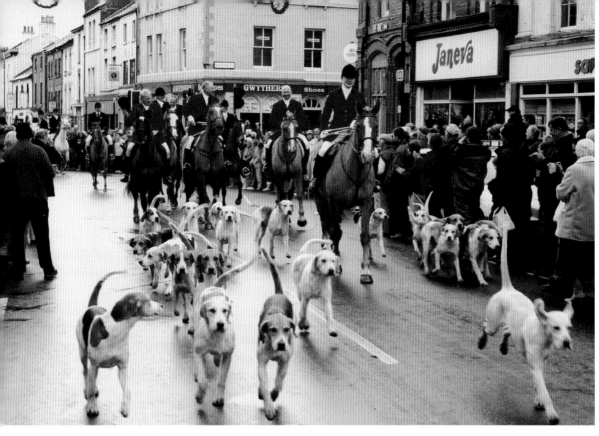

It is a rarity in England and Wales to find a lady in scarlet hunting a pack of foxhounds. However, Jenny Stafford did this at the Tanatside 2004–2005 and is pictured here on Boxing Day parading hounds along streets packed with well-wishers.

Jumping timber on the delightful Walthour Moss Foundation property is Moore County Whipper-In Cindy Pagnotta.

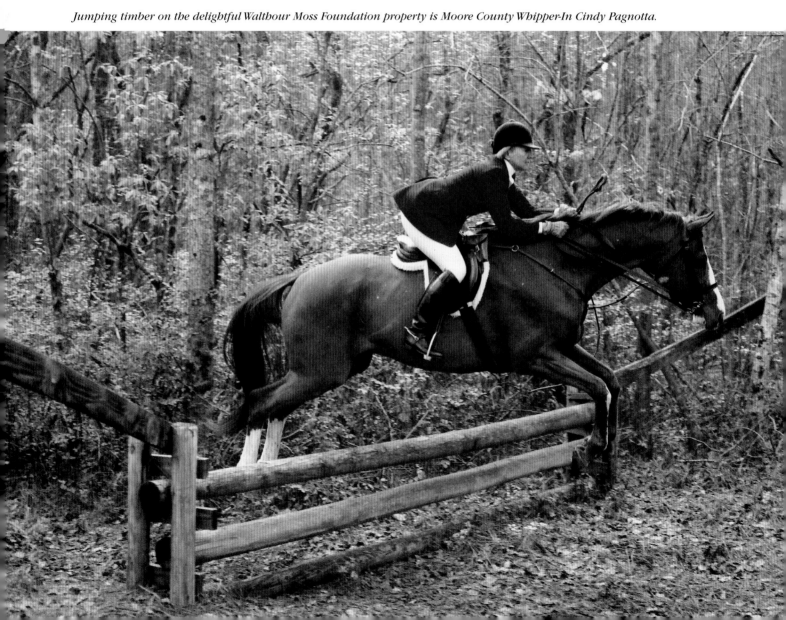

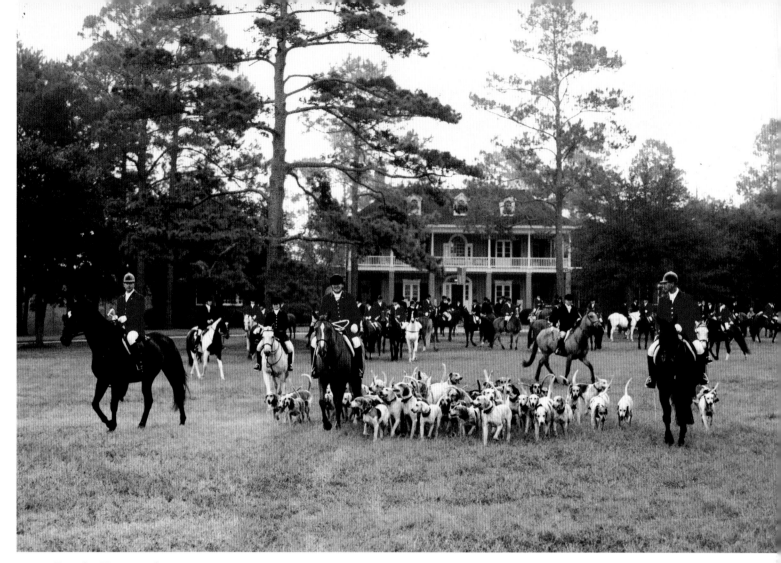

Founder Master and Huntsman Marty Wood leading hounds from the Hunts' thirtieth opening meet at Live Oak House. Flanking the pack are professional Huntsman Charles Montgomery and Whipper-In Dale Barnett, with the time just 8am and the sun beginning to rise behind the house.

Live Oak Hounds, *Florida, USA*

Blowing 'Gone to Ground' is Founder Master and Huntsman Marty Wood at the end of a very fast run after a grey fox from the Hunt's thirtieth opening meet. This good fox was left, to run another day.

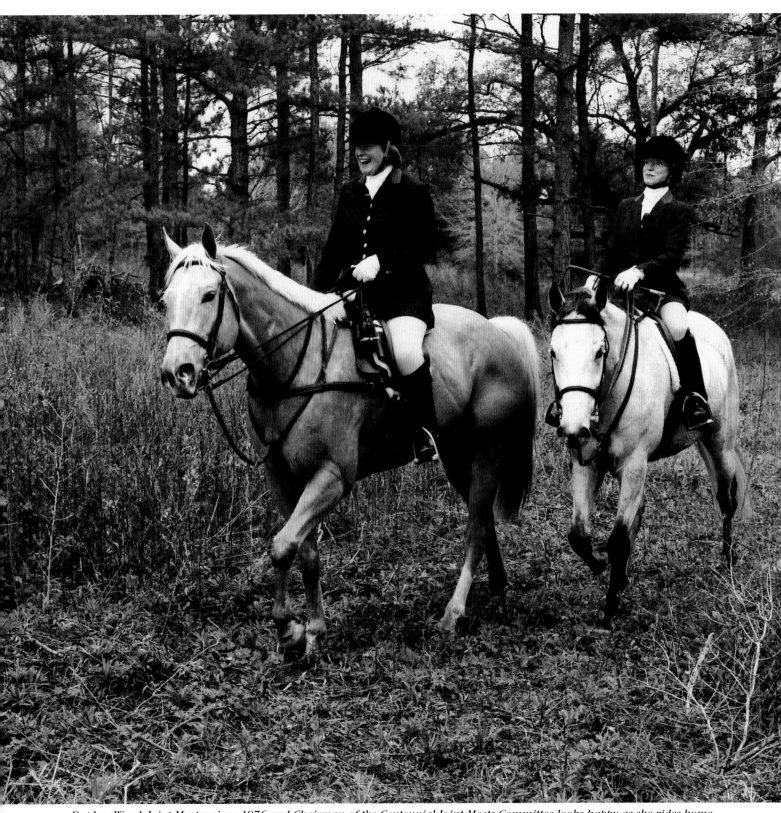

Daphne Wood, Joint Master since 1976 and Chairman of the Centennial Joint Meets Committee looks happy as she rides home with Gage Ogden, after a spectacular 'coyote race'!

Llanbrynmair Hounds

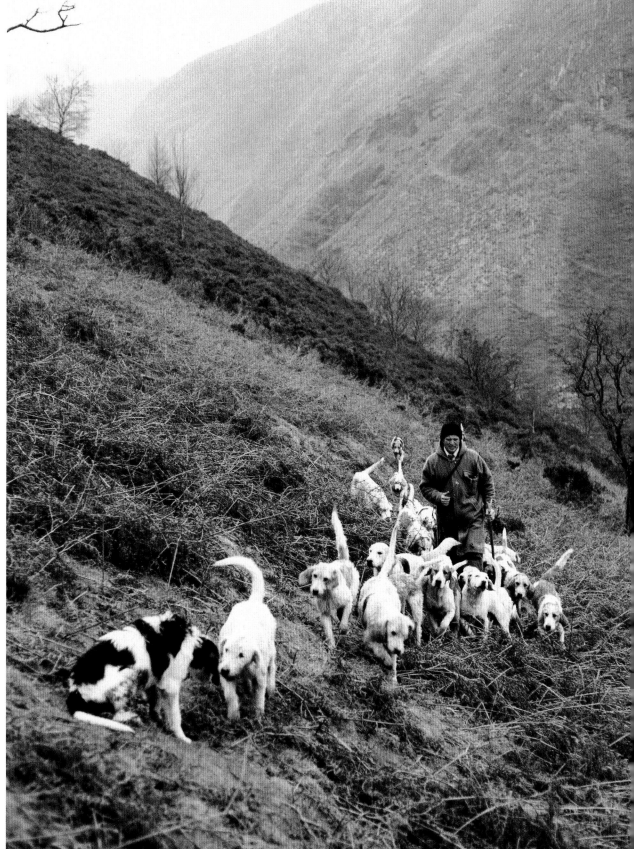

With a bitterly cold snow squall moving down this steep rocky valley, Huntsman John Corfield, well wrapped up to keep out the wet, brings his pack out of a big gorse covert to draw another similar one further along the slopes.

As this is a 'gun pack' I felt it appropriate to show the 'field' and here are six of them! John Cleaton, John Vaughan, Iolo Owen (Hunt Secretary), Hywel Pugh, John Lewis and Tom Breese.

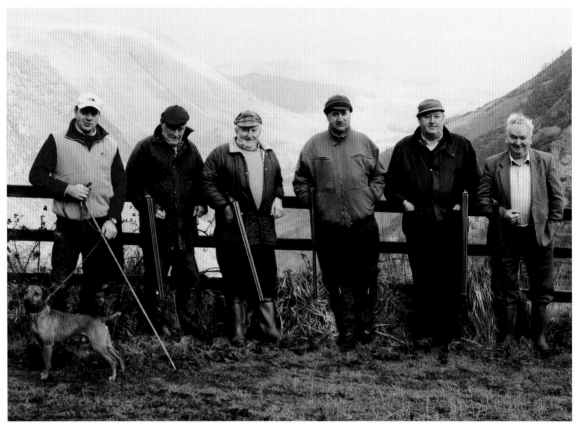

With a desolate and foreboding valley far below Huntsman John Corfield leads hounds home after an exciting six mile hunt in rugged terrain. I was delighted that none of the field were close enough to the fox to shoot him! Note the hill-top trees, bending in the bitterly cold wind.

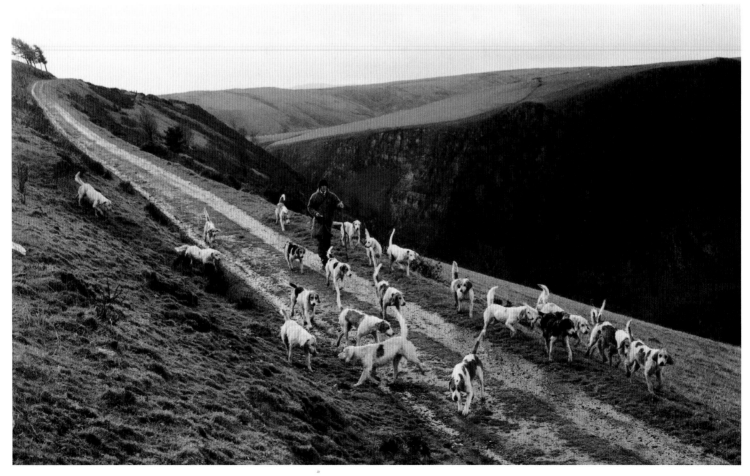

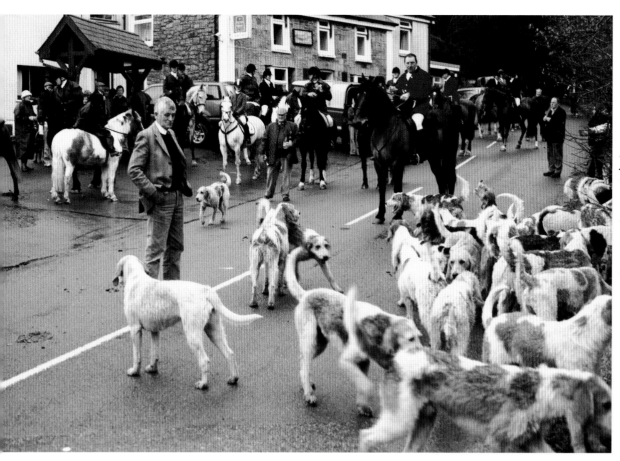

I find this picture so full of the atmosphere of a Welsh fox hunt! With hounds meeting in the road outside a pub are the two Joint Masters, Ianto Evans, who hunts the hounds and on foot, Dic Evans. In the background are mounted followers of all ages, many sampling a warming drink!

Llanwnnen Farmers Hunt

With his pack of good-looking Welsh foxhounds showing signs of the wet and muddy conditions, Joint Master and Huntsman Ianto Evans takes them to a fresh draw. This hunt was established in 1953 by five local farmers and all hounds are pure Welsh, winning many prizes at top summer shows.

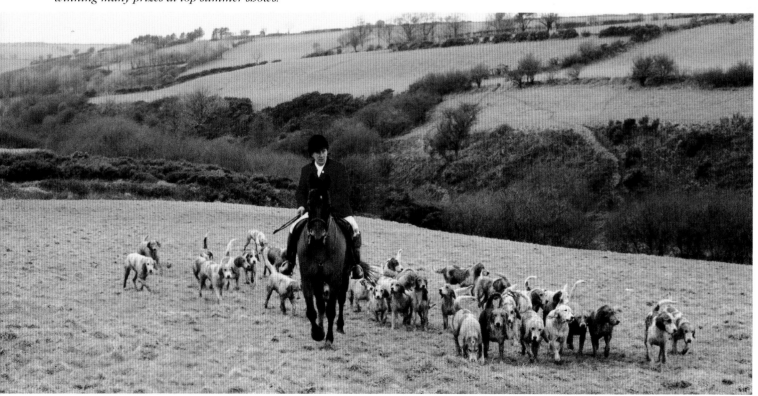

The lead hounds hunting up a steep muddy hillside with an excellent cry, which is a great asset in the large gorse coverts which abound in the area as well as in woodland.

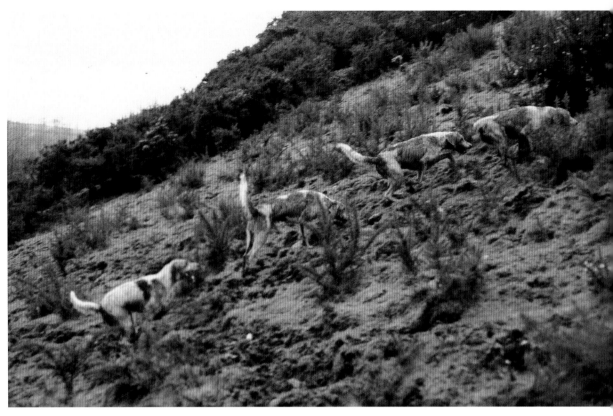

Leading hounds and the few surviving followers home at the end of a very wet day are Ianto Evans MFH and Huntsman and Whipper-In Roy Thomas.

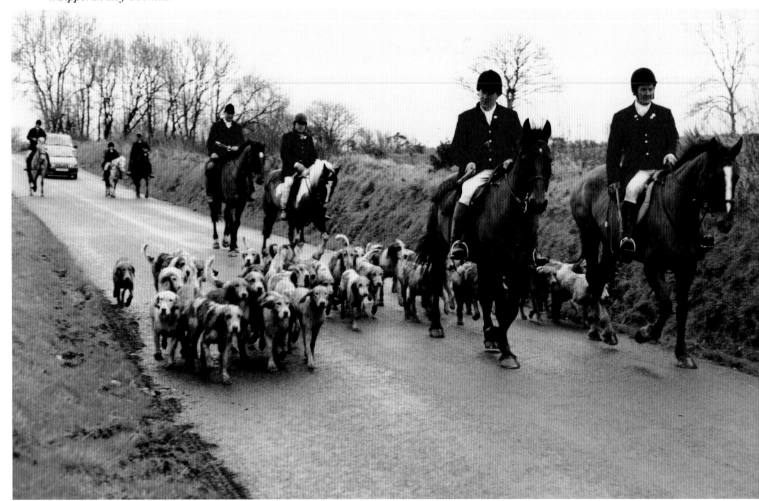

Long Serving

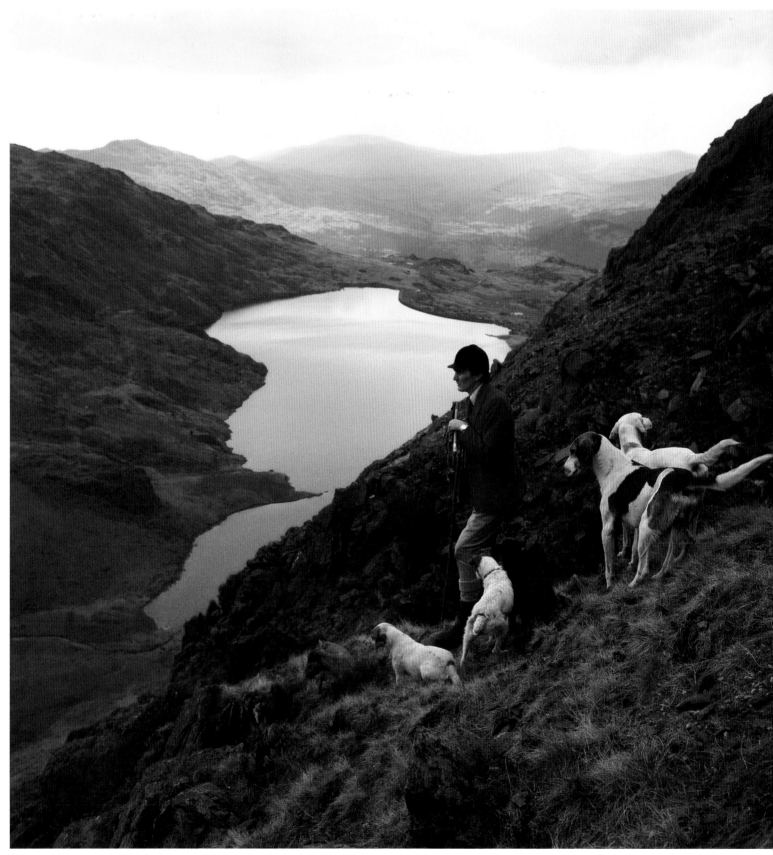

Edmund Porter is the longest serving professional Huntsman in the UK, having carried the horn with the Eskdale and Ennerdale in their mountainous Lake District country since 1963 which is admirably shown in this picture. He has also been Master since 1979 as was his father John from 1953-1991 and his grandfather William from 1910-1952.

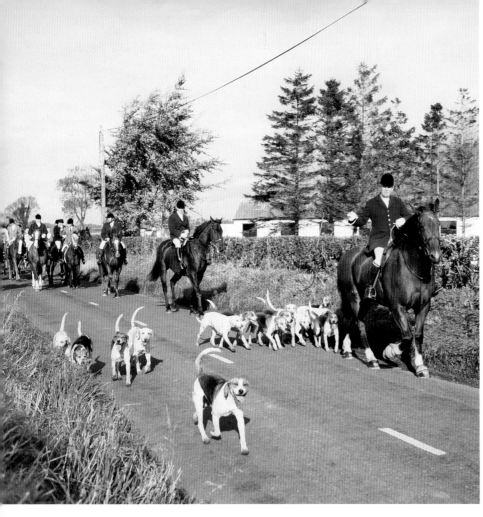

I find it quite amazing that George Briscoe who was appointed Joint Master and Huntsman of the Tara Harriers in Ireland's County Meath as long ago as 1942 is still in office in 2008! He hunted hounds with great skill for fifty seasons and still follows the hunt by car. What a record!

In 1967 Jim Lang was promoted from First Whipper-In to Huntsman at the Burton Hunt whose country is in North Lincolnshire by Arthur Lockwood, who had been Master since 1959. Forty-one seasons later Jim is to retire as the longest serving professional Huntsman to a mounted pack of foxhounds in the UK and now the senior Joint Master is John Lockwood, son of Arthur!

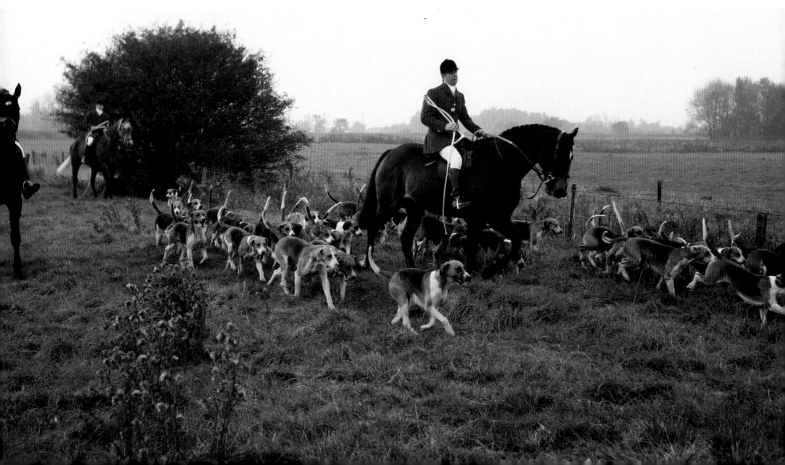

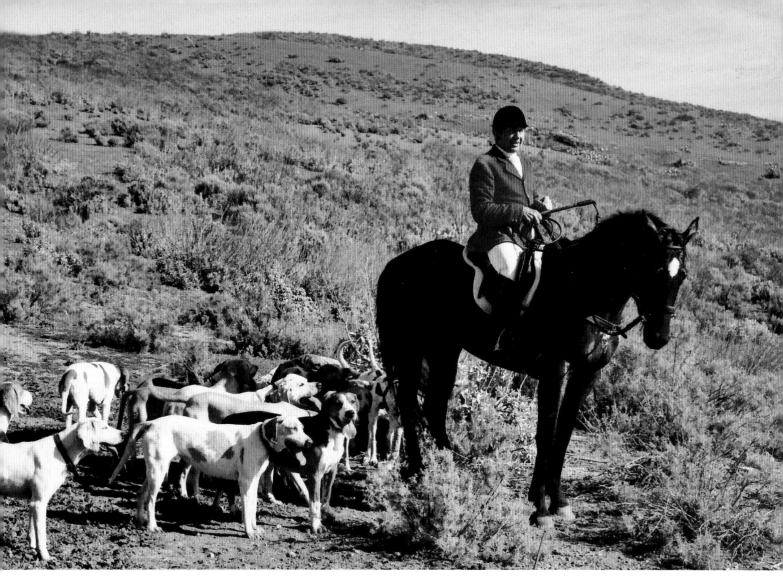

When David Wendler retires at the
end of 2007-2008 season he will
have hunted the West Hill Hounds
in California for fifty-four years!
He was originally appointed by
the Hollywood song and dance
film star Dan Dailey, who was
Master throughout the 1950s. For
many years David was also
a top class steeplechase rider.

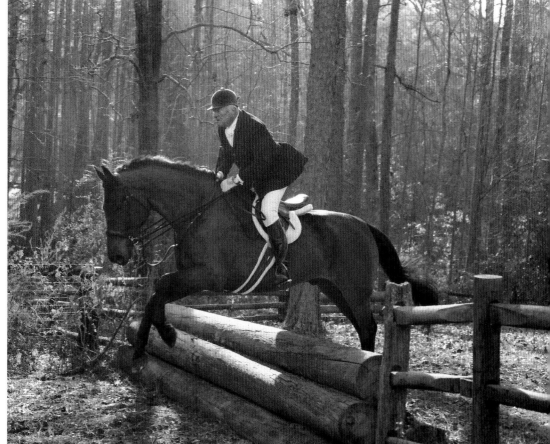

The third longest serving Master in
America Dick Webb has been in
office with the Moore County
Hounds in North Carolina since
1961. Amazingly he still Field
Masters, despite having celebrated
his eightieth birthday
a while ago!

Masters gathering in the bar before sitting down for dinner in the Grand Hyatt Hotel, where the MFHA from the UK made a presentation to Ben Hardaway MFH Midland GA in honour of his hound breeding success over the years.

MFHA of America,
Centennial Masters Dinner in New York City in January 2007

Some of the 850 people who gathered in Cipriani's for the ball so brilliantly organised by Suzy Reingold while drinks were courtesy of Ben Hardaway MFH for the entire night!

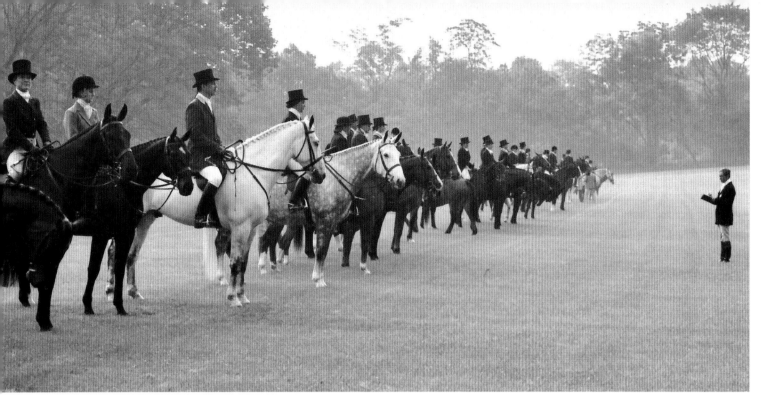

Field Hunter Championship Final at Morven Park, Leesburg, Virginia. The sixty finalists taking part in the section to find the best turned out horse and rider at 7am, in conditions reminiscent of a morning's cub-hunting! Horses had travelled from all over America and Canada to compete, having qualified during the year. The overall winner 'Sputnik' is third from left.

Field Hunter Championship Final at Morven Park, Leesburg, Virginia. The Grand Champion Centennial Field Hunter 'Sputnik' ridden by Stuart Sanders about to receive the fabulous Champions 'Cooler' from Horse Country's Marion Maggiolo. Watching are Penny Denegre MFH, Mason Lampton MFHA President and with a presentation saddle, Ann-Mary Bennenson.

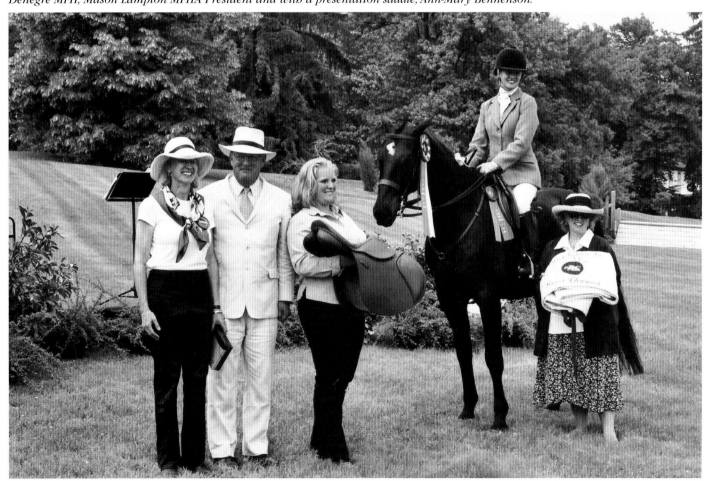

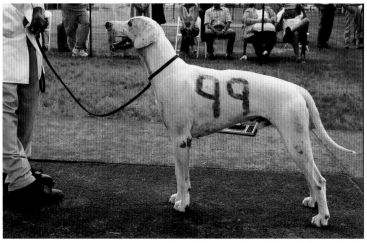

Performance Trial Conformation Grand Champion, pictured at Morven Park on the closing day was Hillsboro 'Goblin' from Tennessee. This is one time when the number ninety-nine was the lucky one!

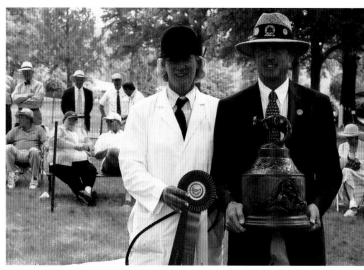

Chairman of the Centennial Performance Trial Series, EPP Wilson MFH, presents the Grand Champion Trophy to Hillsborough Hunt Whipper-In Karen Gray, whose husband Johnny hunts the hounds in their country, near Nashville, Tennessee.

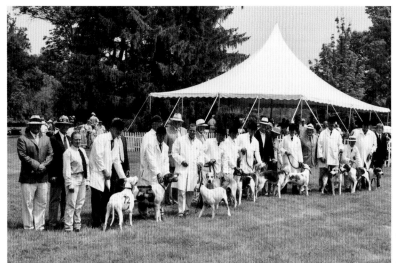

MFHA of America Centennial 2007

A line-up of the Centennial Champion Hounds during the closing ceremony at Morven Park, Leesburg, Virginia over Memorial weekend.

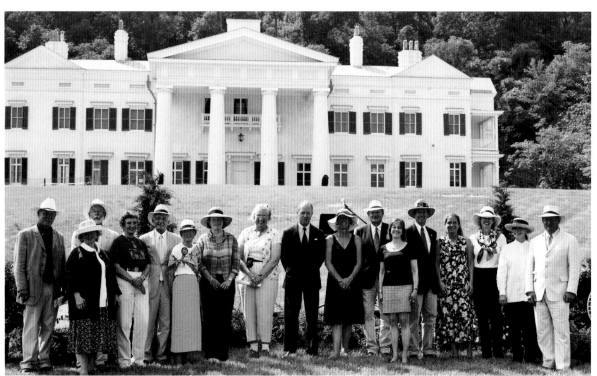

The Centennial Committee gather on the lawn in front of Morven Park Mansion (left to right) Lt. Col. Dennis Foster, Marion Maggiolo, John Anderson, Lynn Dillard, Norman Fine, Viviane Warren, Daphne Wood, Cindy Piper, Turner Reuter, Liz McKnight, René Latiolais (Chairman), Suzy Reingold, EPP Wilson, Gretchen Behan, Penny Denegre, Joyce Fendley and Mason Lampton.

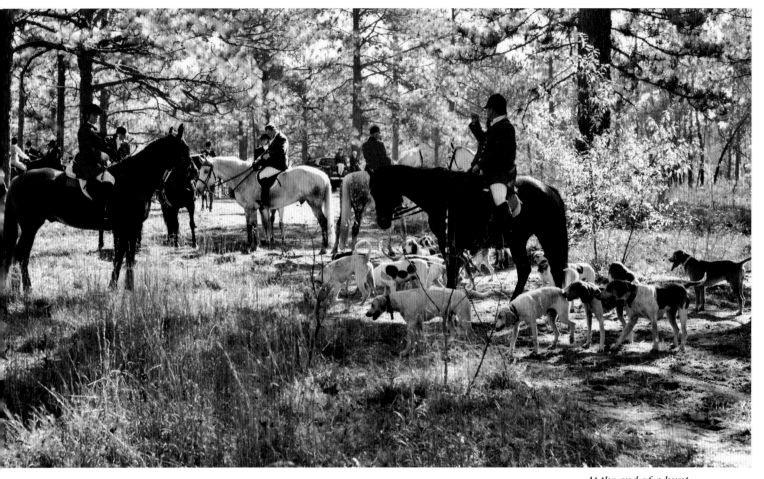

Mecklenburg Hounds, North Carolina

At the end of a hunt during Centennial year, Huntsman Doug Russell collects his hounds before hacking home for a well-earned hunt breakfast.

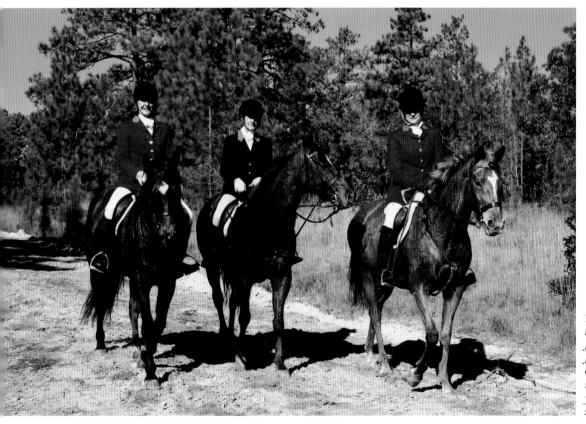

Together on a dirt track through a pine wood are Jeanine de Vaney MFH, Janet Johnson and Sherry Cantrell Whipper-In. This was during a Centennial year hunt, under a blue sky.

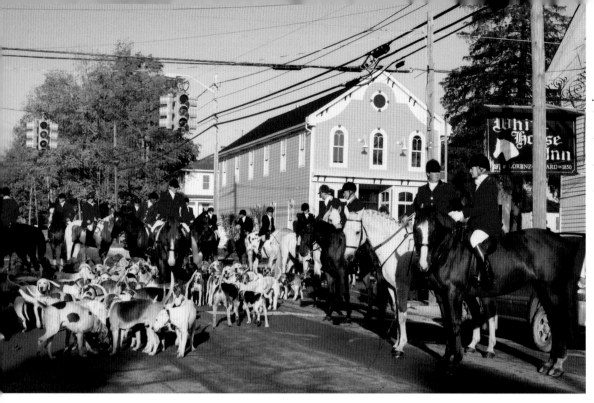

One of the Centennial Joint Meets, hosted by the Metamora Hunt. This one at the White Horse Inn in Metamora, Michigan. By the pub sign are Joint Master Joe Kent and his Whipper-In wife Gay.

Meets

This is the best attended meet that I've been to and was one of a series held throughout the UK to show the strength of public feeling against the ban on hunting with dogs. Held on the Royal Welsh Showground at Builth Wells no fewer than 750 riders followed the David Davies Hounds for a days' hunting with more than 1000 supporters on foot.

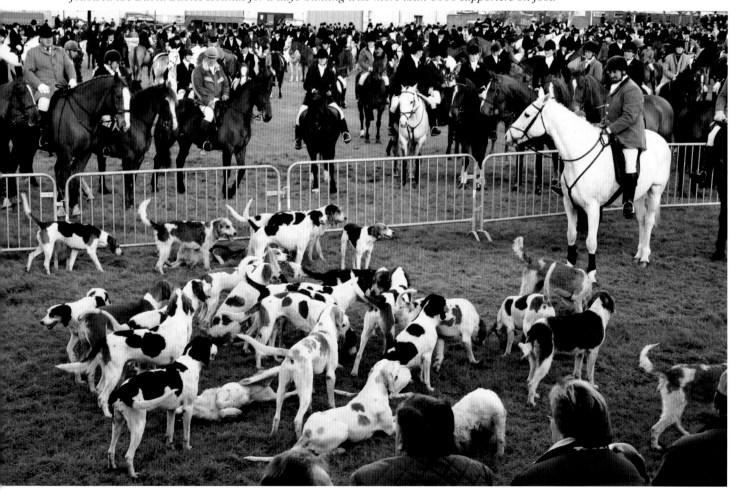

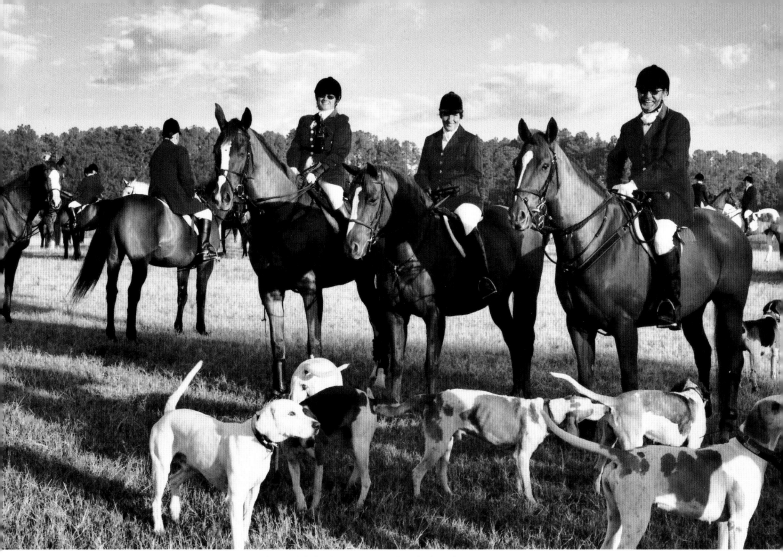

Although the Why Worry Hounds were only established in 1990 in South Carolina and recognised in 2003, already they have won prizes at summer shows and in performance trials. Pictured here are the three Joint Masters, Jeanie Thomas with large radio pack, Lynn Dillard and George Thomas, Huntsman.

A typical early morning cub-hunting meet in a farm yard for the Golden Valley Hunt. Despite it only being 7.30am drinks and sausage rolls were brought round for everyone. Here Joint Master Chris Davies is thanking the hosts 'Chuff' and Candia Compton watched by Joint Hon.Sec. Beryl Gough. Huntsman Will Pinkney is with hounds while injured Joint Master Liz Thorneycroft, is on foot.

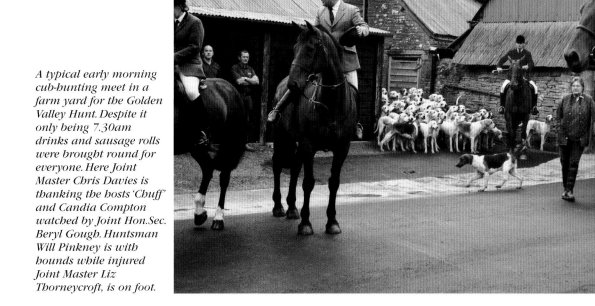

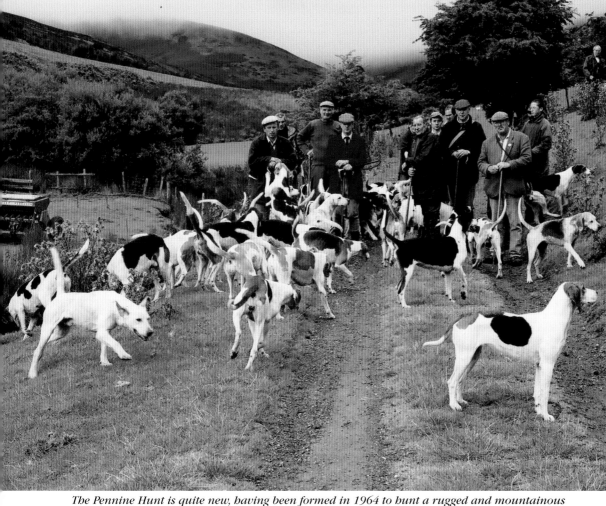

The Pennine Hunt is quite new, having been formed in 1964 to hunt a rugged and mountainous country along the spine of Northern England. Here, the pack of fell hounds are waiting impatiently for Huntsman, since 2001, John Weller, to give them the word 'go' as clouds descend onto the high ground.

The Border Counties Mink Hounds and followers gather around Master and Huntsman John Newton to hunt the River Severn on a hot July day. Note that there are several Old English type foxhounds in the pack, mostly from Sir Watkin Williams-Wynn's kennels.

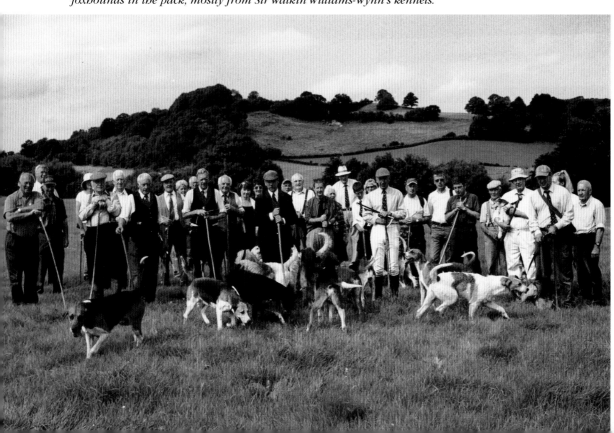

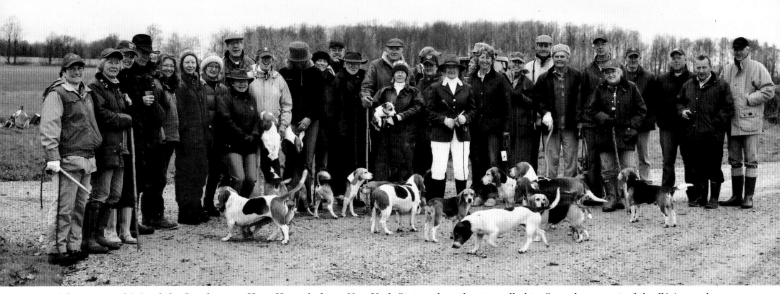

A large crowd joined the Sandanona Hare Hounds from New York State, when they travelled to Canada as part of the Bi-Annual Festival of Hunting. In the centre is Joint Master and Huntsman since 1977, Betsy Park. This amazing lady was also professional Huntsman to the Millbrook Foxhounds NY, from 1978–2004! Among the field are Masters and staff from the Tintern Bassets and Pond Hill Beagles, both based in Canada, as well as many foxhunters.

With hounds on a bleak and steeply sloping hillside enjoying a joint meet are Jimmy Mallett, Huntsman of the North Lonsdale Hounds and Tom Davies, Huntsman of the Dysynni Valley Pack. A splendid day's sport followed in wild country and many hills were climbed!

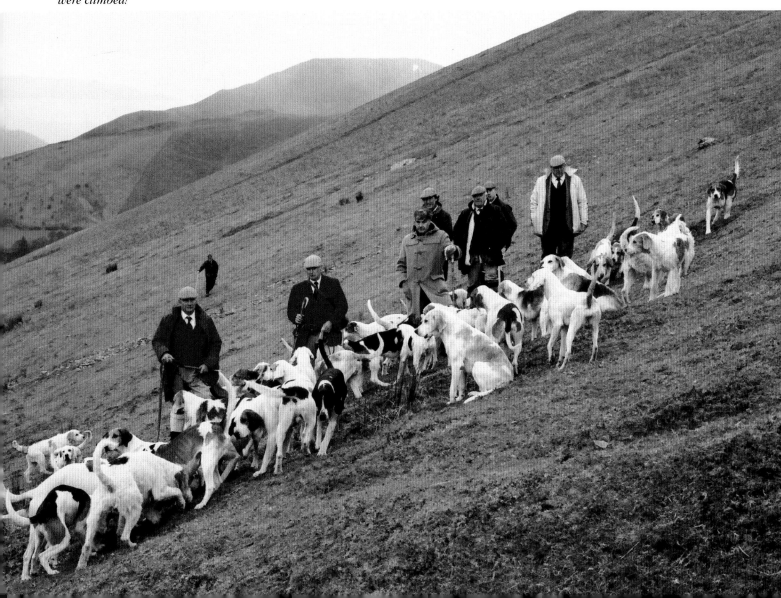

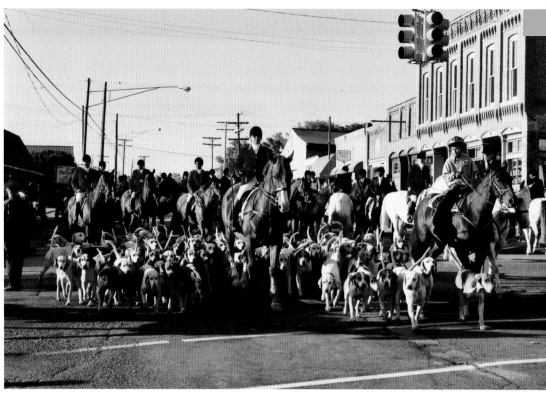

Dedicated Huntsman Patricia Pearce, aided by a keen young rider, leading hounds through the centre of Metamora, during a Centennial Joint Meet. Amazingly, there were 53½ couple of hounds out on this day, with three Huntsmen, Pat Pearce, 'Tot' Goodwin MFH (Green Creek) and Danny Kerr (Camargo)

Metamora Hunt, **Michigan, USA**

With hounds moving along a dirt road on the way to a fresh draw is Huntsman Patricia Pearce, while members of the field emerge from a covert, where the previous hunt finished. As can be seen, the ground was 'as dry as a bone'!

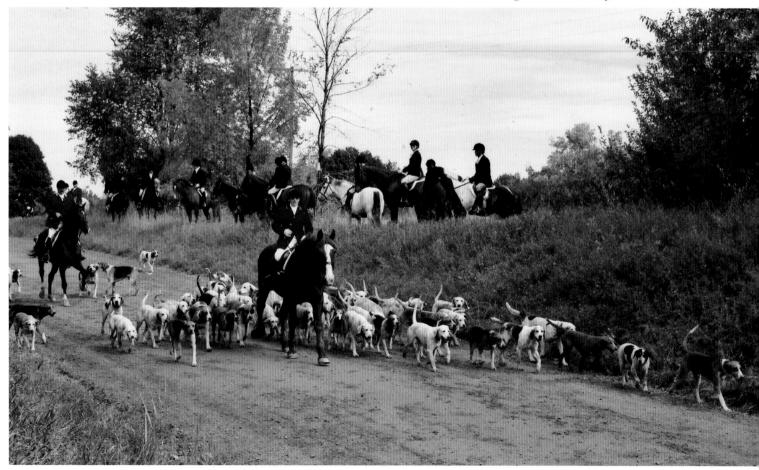

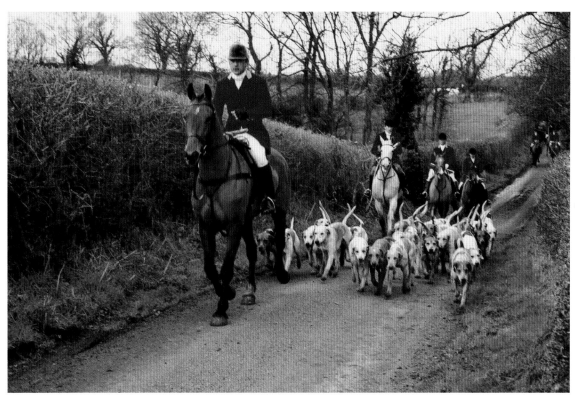

Joint Master and Huntsman Charlie Gundry taking hounds to draw along a country lane. He is bred to be a Huntsman as his father Robin hunted Sir Watkin Williams-Wynn's hounds, while his grandfather Major Gerald Gundry was a Joint Master and Huntsman of the Duke of Beaufort's 1951–85.

Followers enjoying a gallop on lovely old turf, but with snow on the high ground. Later in the day, hounds ran onto the snowy hills, where they caught a well hunted fox.

Middleton Hunt

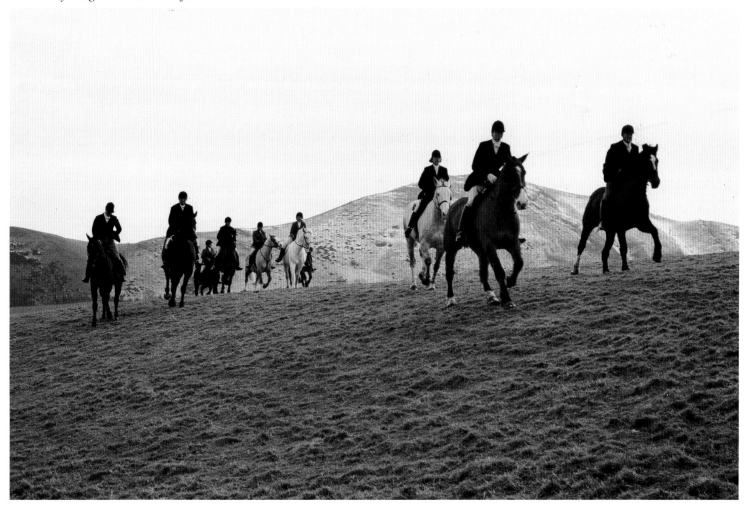

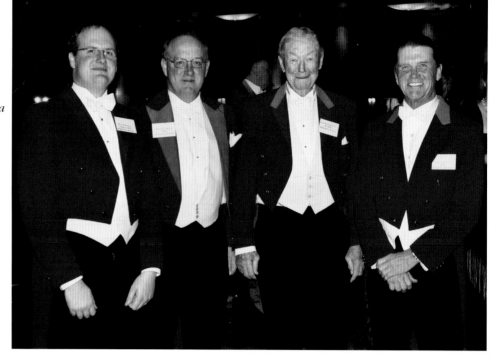

Pictured together at the MFHA of America Centennial Dinner in New York City are four of the Joint Masters. Mason Hardaway Lampton MFH, Mason Lampton, MFHA President 2005-08, Ben Hardaway MFH since 1950 and John Flournoy MFH. The Dinner was held in the Grand Hyatt Hotel on 42nd Street.

Midland Foxhounds, Georgia, USA

Joint Master and Huntsman Mason Lampton with hounds after accounting for a bobcat in the fascinating 'Dead Tree Swamp'. In Alabama these tall, white trees must make it a ghostly place at dusk or dawn.

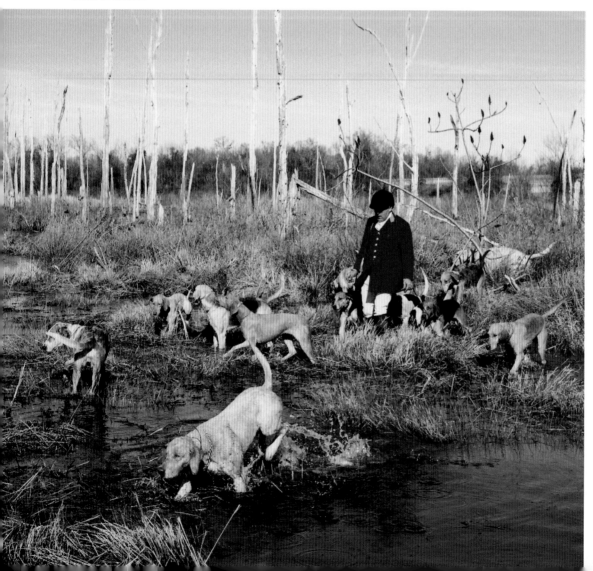

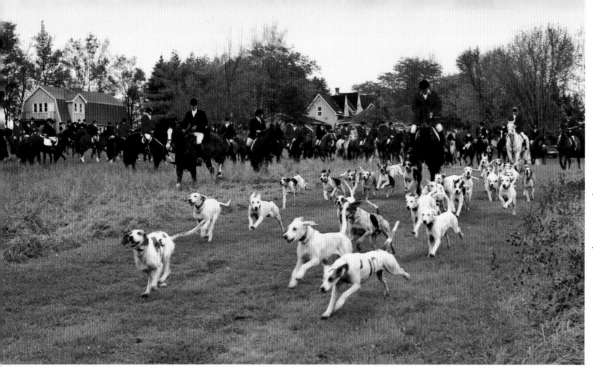

Having driven 1100 miles to Canada for some Centennial Joint Meets Mason Lampton MFH and Huntsman was determined to show great sport! Here, his happy hounds joyously leave a meet at the home of Derek French MFH Eglinton and Caledon Hunt, followed by an excited mounted field numbering 120!

The same hounds some four hours later! Having had a couple of short runs, they found a big coyote which they 'raced' for ten miles in sixty minutes. By then Mason Lampton MFH and Huntsman and Toronto and North York Huntsman Mark Powell were the only two still with hounds. It was decided to stop them as the big field had fallen by the wayside! Here Mason and Mark have been joined by Huntsmen Steve Clifton and Marc Dradge to walk hounds back to a road.

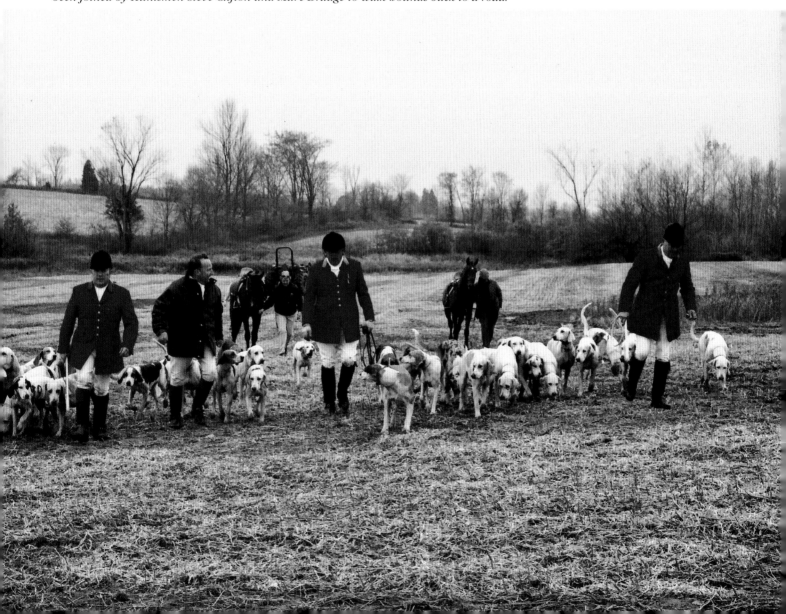

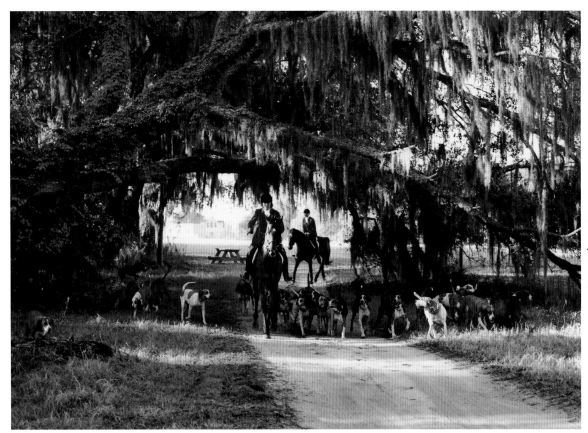

7.30am and an early morning sun lights up the Spanish Moss hanging from an ancient live oak tree as Alexis Macaulay MFH and Huntsman leads hounds away from the kennels on Perry Plantation, home of the Joint Masters.

Misty Morning hounds, Florida, USA

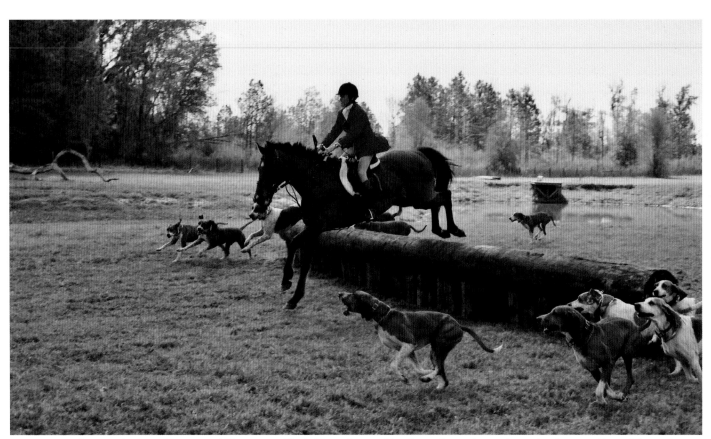

Lots of action for Joint Master and Huntsman Alexis Macaulay and her hounds, as they enjoy a fast hunt on Perry Plantation where the new kennels have been built.

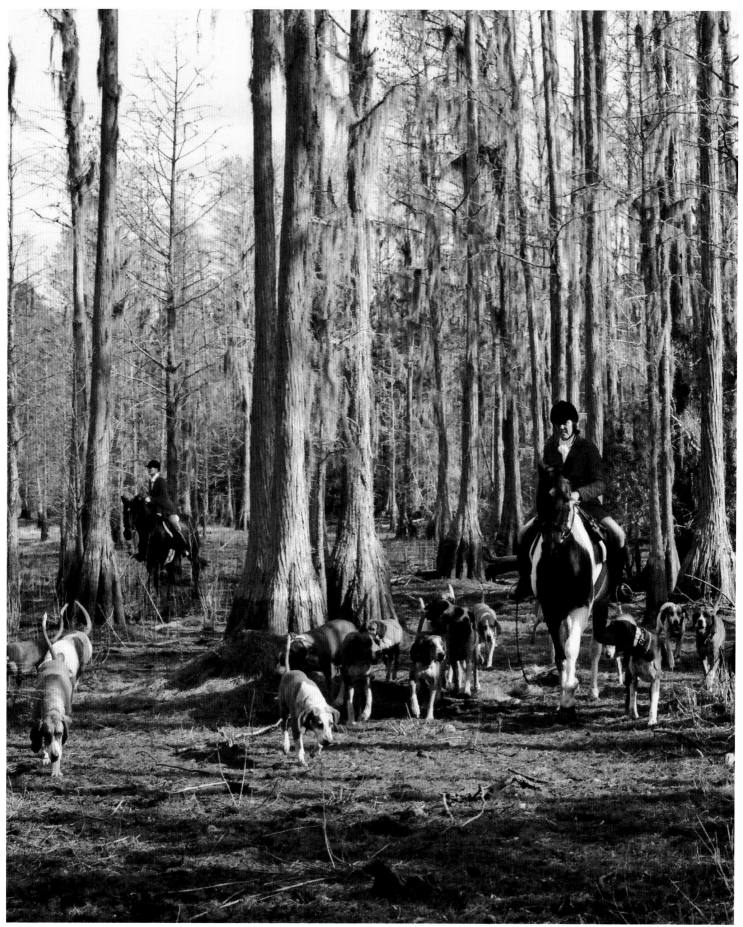

'Going home'! With hounds as they back back to the trailers is Joint Master and Huntsman Alexis Macaulay passing through an impressive group of cypress trees, in a drying out swamp, the result of a drought.

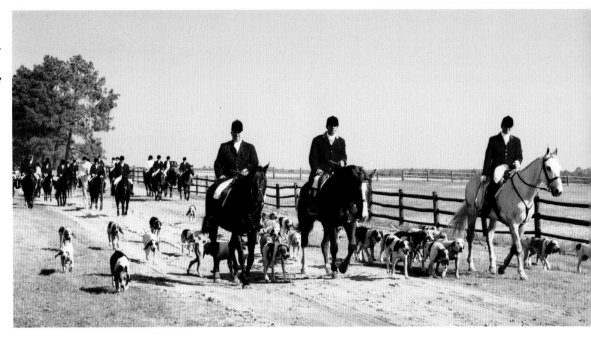

Coming in at the end of a Centennial Joint Meet are the Huntsmen of the three participating packs, Jody Murtagh, Moore County; Fred Berry MFH, Sedgefield; and David Raley, Red Mountain. Following is the mounted field, which numbered 90 horses with the temperature up to 80° Fahrenheit.

Moore County hounds, *North Carolina, USA*

Professional Kennel-Huntsman Kerrie Hayes brings hounds back to the Mile-Away Farm Kennels after a busy but warm day's hunting around Southern Pines when a grey fox and a coyote were hunted.

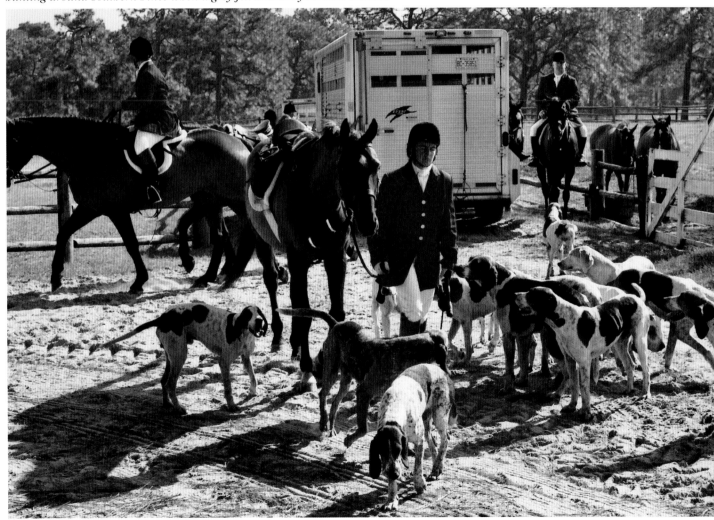

Hounds and Huntsman Jody Murtagh moving through a creek during a grey fox hunt in the Walthour Moss Foundation Forestry at Southern Pines.

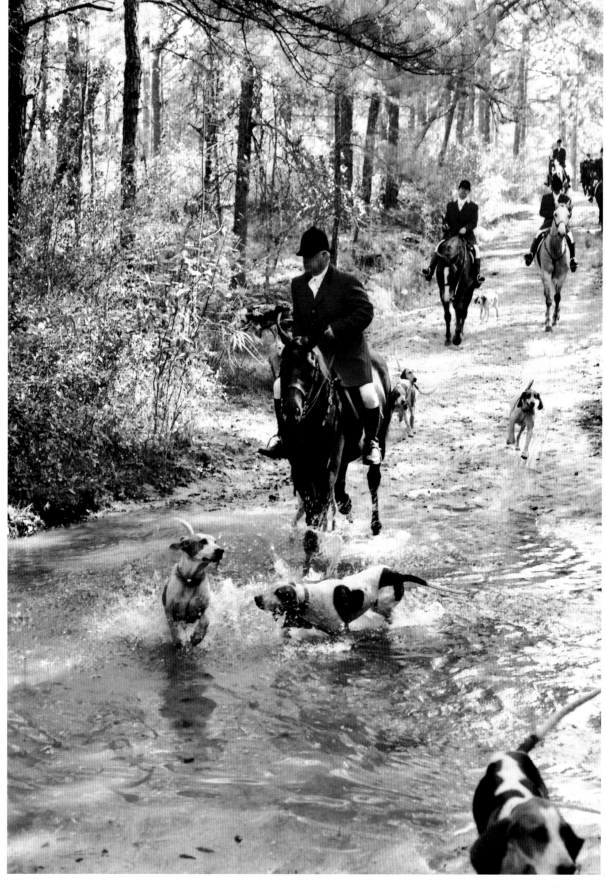

Mooreland Hunt, Alabama, USA

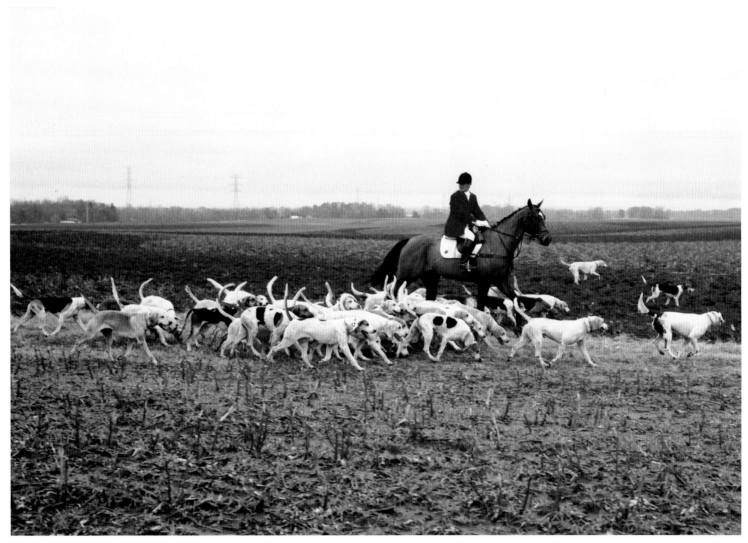

With bounds as they move across country, typical
of this cotton growing region, is professional
Huntsman Rhodri Jones-Evans. It is often possible
to watch a coyote being hunted because the fields
are so big and there are no hedges to block the
view!

The four Joint Masters in New York City for the MFHA
of America Centennial Ball. In Cipriani's, Dr Jon
Moody MFH, Evie Van Sant Mauldin MFH, Leslie Rhett
Crosby MFH, Dr Jack Sewell MFH, here 850
foxbunters danced the night away.

Mr Stewart's Cheshire Foxhounds, *Pennsylvania, USA*

Dressed in the Hunt's informal uniform Huntsman Ivan Dowling taking hounds to a fresh draw with a sea of grass behind. Along the side of this field is a wooden fence, so typical of their hunt country and which people love to jump.

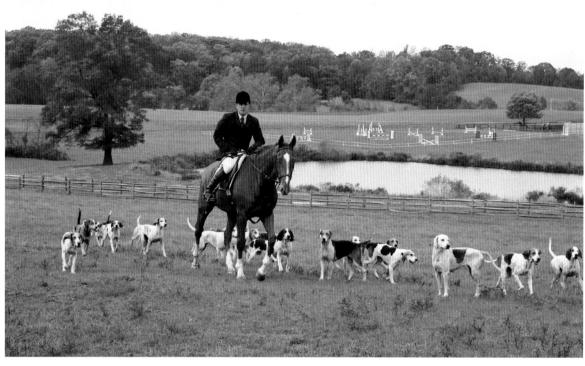

An impressive front rank to the field during a Director's Hunt from the Unionville Kennels. (left to right) Lt. Col. Dennis Foster, MFHA, Executive Director; Terry Paine MFH, Santa Fe Hunt California; Laura Sloan, Bruce Miller MFH and Field Master and Marvin Beeman MFH, Arapahoe Hunt, Colorado.

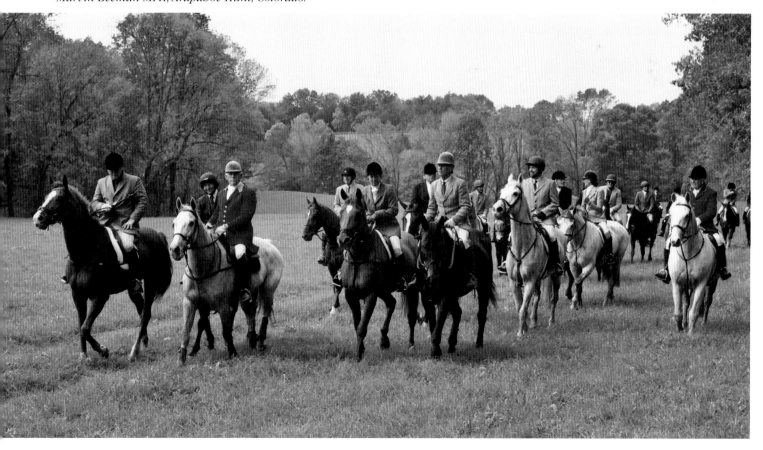

Myopia Hunt, *Massachusetts, USA*

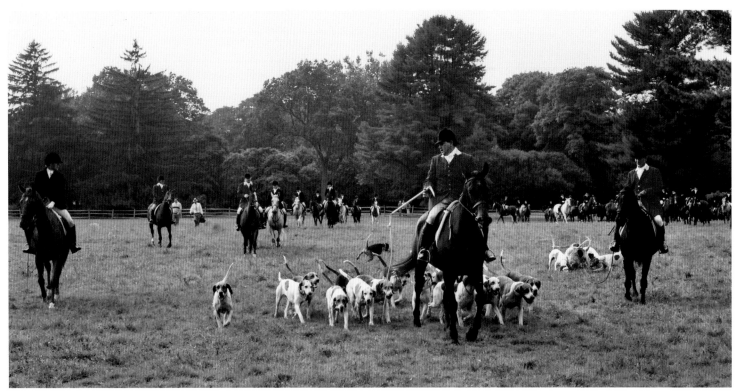

With a large opening meet field beginning to move in the background Huntsman Eugene McKay leads his hounds away to the first draw. During this day, a large variety of different obstacles were jumped as followers tried to keep in touch with hounds and their enthusiastic Welsh Huntsman.

With a late afternoon sun shining on them, happy smiling followers return to their trailers at the end of an exciting day's hunting after their opening meet with Master since 1989, Donald Little, Field Mastering.

Nostalgia

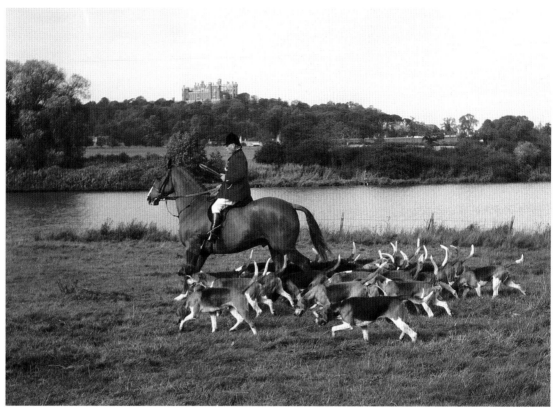

Belvoir Hunt (The Duke of Rutland's): Jim Webster who hunted these Old English Hounds with tremendous élan from 1956 to 1983 seen here on the move across country with Belvoir Castle, home of the Duke of Rutland, prominent on the hill behind.

Cottesmore Hunt: a really snowy day in High Leicestershire with Huntsman Peter Wright and Whipper-In John Seaton leading hounds and a barely visible field in search of somewhere safer to hunt but to no avail! This was in 1977 from Somerby.

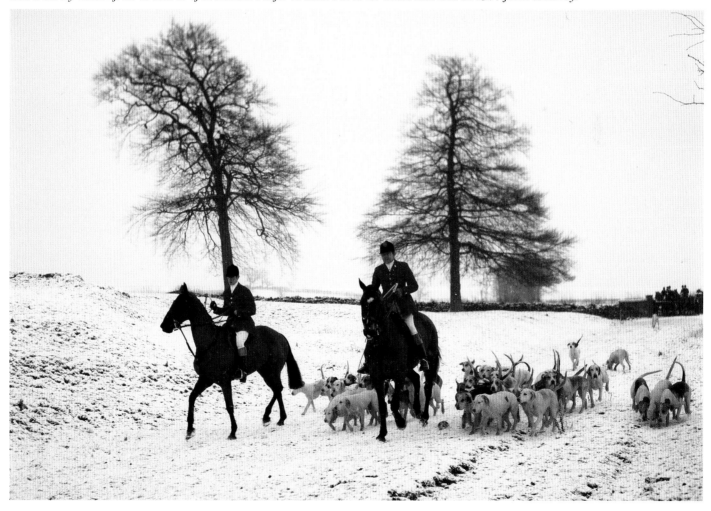

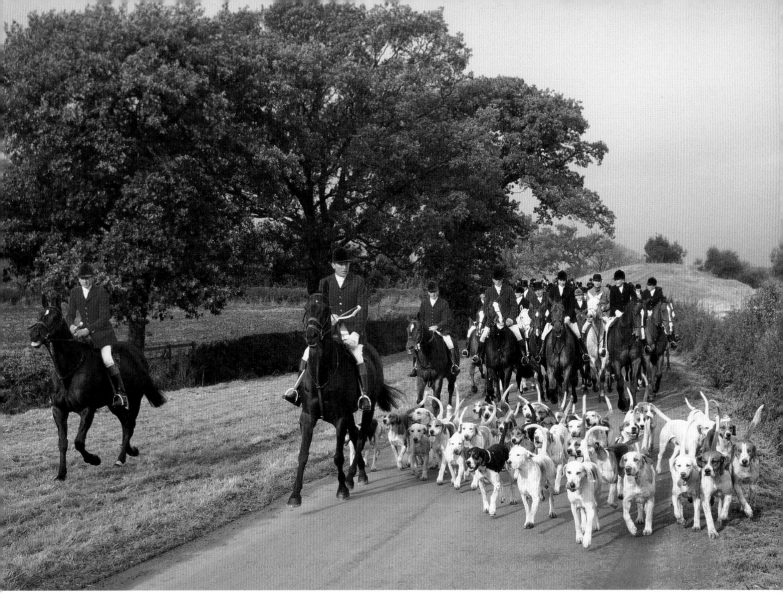

Quorn Hunt: tradition dictates that the opening meet is held at Kirby Gate, which means hacking some miles to the first covert, Gartree Hill, where the sport begins. Michael Farrin, Huntsman 1968-1998 and Whipper-In Tony Wright are pictured with hounds and followed by a huge, excited field, en route to Gartree Hill in 1980.

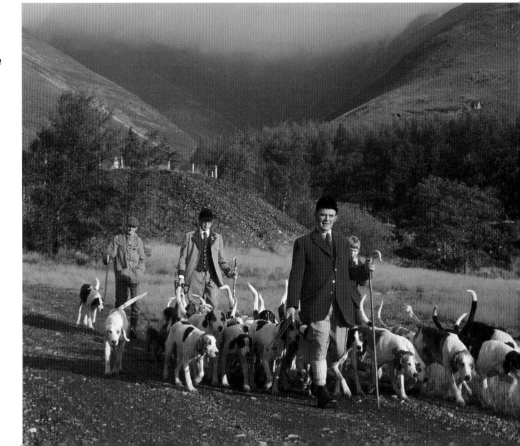

Blencathra Hunt (John Peel's): with hounds as they walk down from the kennels at Gate Ghyll, Threlkeld are Johnny Richardson, Huntsman 1949-1988 and his successor Barry Todhunter, who has carried the horn since 1988. Note how the clouds have descended on the fells where hounds were to hunt.

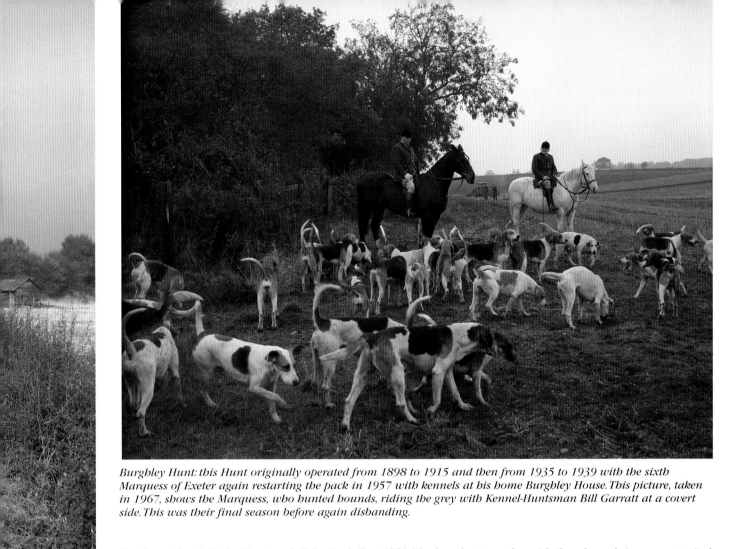

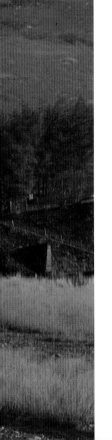

Burghley Hunt: this Hunt originally operated from 1898 to 1915 and then from 1935 to 1939 with the sixth Marquess of Exeter again restarting the pack in 1957 with kennels at his home Burghley House. This picture, taken in 1967, shows the Marquess, who hunted hounds, riding the grey with Kennel-Huntsman Bill Garratt at a covert side. This was their final season before again disbanding.

Garth and South Berks Hunt: on St Valentine's Day 1980 I had my best ever day with these hounds in very untypical country, including running along the famous 'Ridgeway Path' an ancient track across the Berkshire Downs. Huntsman Ian Langrish (1971–1995) here leading hounds had his pack in top form, catching a brace of foxes and covering many miles which had me puffing and blowing!

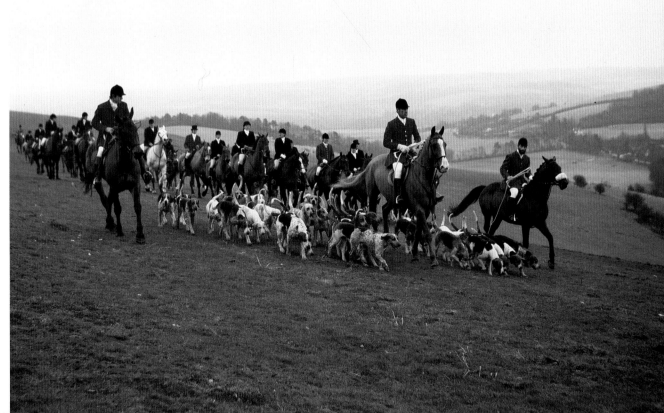

Sir Watkin Williams-Wynn's: I feel that this picture of Neil Ewart MFH and Huntsman 1983–1991 surrounded by steaming Old English Foxhounds at the end of a good hunt really captures the atmosphere of the early morning cub-hunting we so love.

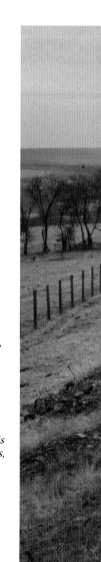

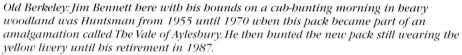

Old Berkeley: Jim Bennett here with his hounds on a cub-hunting morning in heavy woodland was Huntsman from 1955 until 1970 when this pack became part of an amalgamation called The Vale of Aylesbury. He then hunted the new pack still wearing the yellow livery until his retirement in 1987.

Berkeley: this is where the famous yellow livery originated with hounds being kept at Berkeley Castle for hundreds of years. Pictured here with this good looking pack which incidentally are never shown are Major John Berkeley MFH 1960–1984 who owns the hounds, Tim Langley, Huntsman 1967 to 1981 and (right) Barclay Watson MFH 1971–1978.

Morpeth: hacking home at the end of the day against a backcloth of Northumberland grass are the remnants of a large field, which had begun this hunt, in 1966. Leading hounds is Whipper-In Rodney Ellis, followed by Huntsman Charlie Appleyard and the Senior Joint Master, Lt Col John Cookson.

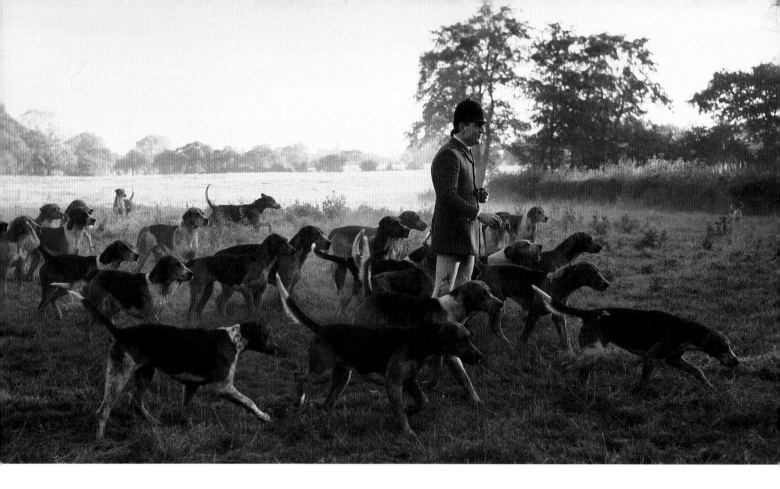

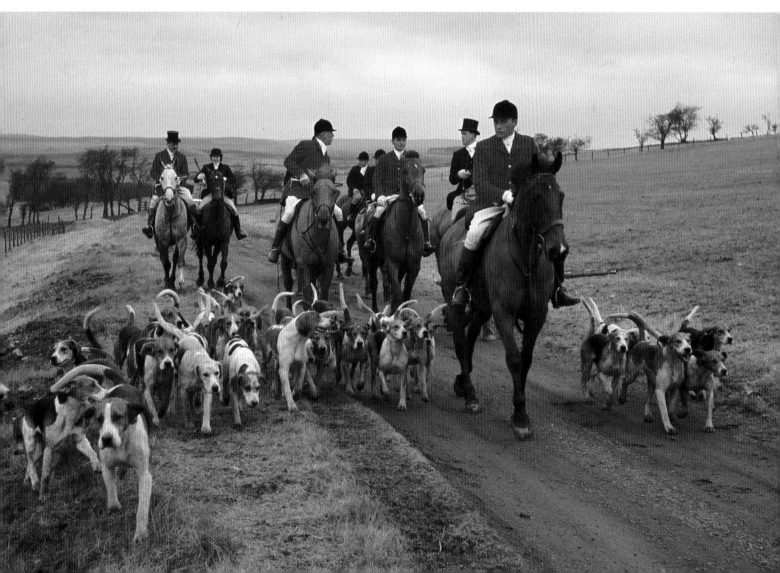

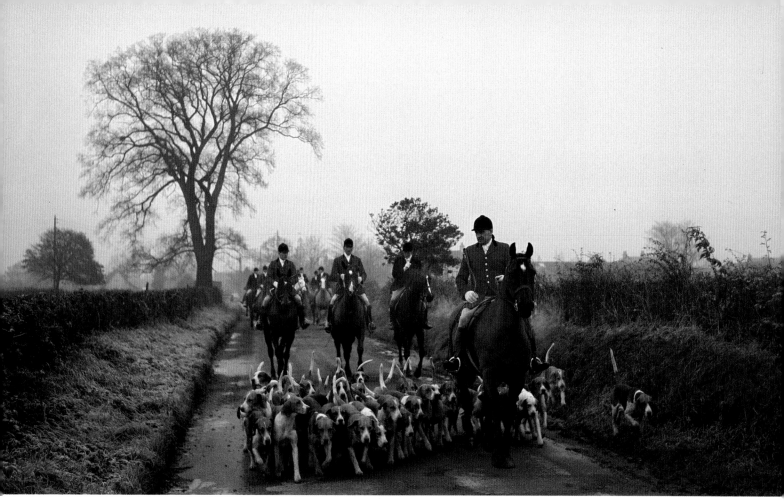

Bedale: on a bitterly cold and frosty morning in North Yorkshire long serving Kennel-Huntsman Frank Ingram, leads hounds to draw, followed by Joint Master and Huntsman Major John Howie (centre) 1960-1969.

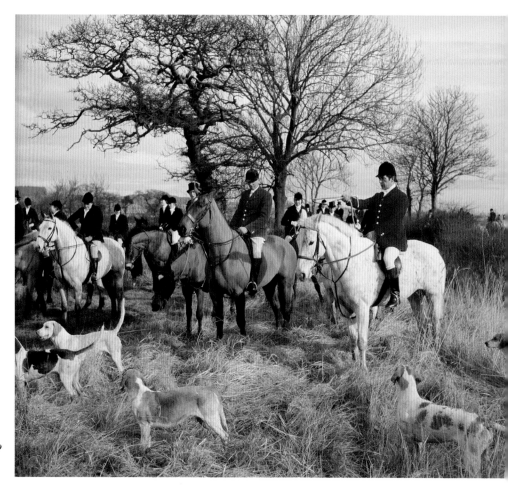

Middleton: together at the successful conclusion of a hunt in East Yorkshire on a bright sunny winter's day are Col The Hon Nick Crossley MFH 1971-1976 and 1980-1997 pointing out a hound to The Earl of Halifax MFH 1946-1980.

Blankney: with much of their hunt country being in Lincolnshire there is lots of arable land, divided by often deep ditches. Here Huntsman from 1978-1993 Tony Wing and his hounds pick their way across a typical area of Blankney plough as they leave a covert.

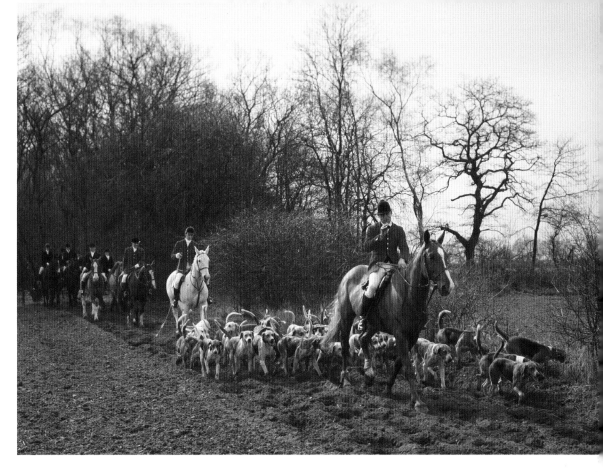

Talybont: with his green coat showing the pack's beginning as harriers, Master and Huntsman from 1980 to 1983 David Parker taking his hounds to a holloa along the banks of the River Usk. The Talybont combined with the Brecon Hunt in May 1996, using the Brecon kennels.

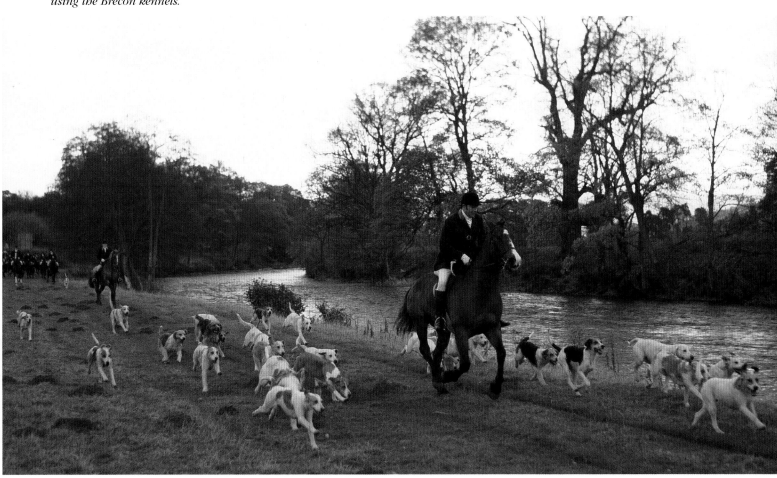

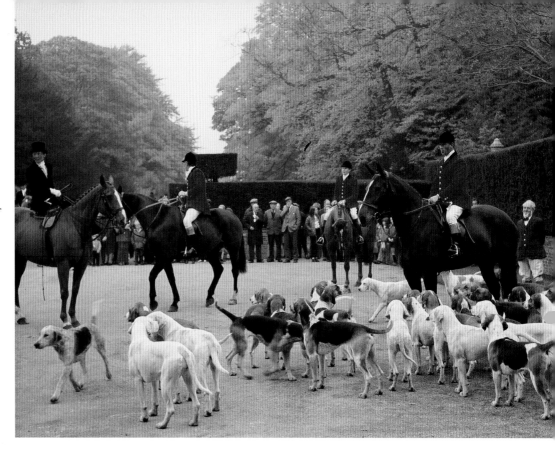

Warwickshire: what a crowd gathered at Upton House, home of former Master Viscount Bearsted, for the 1973 opening meet. With hounds on the gravel forecourt are Clarence Webster, Huntsman 1958-1982 and to the left Miss Boultbee-Brooks side saddle Joint Master 1968-1975. In the blue coat of the Staffordshire Beagles is the well known hunting journalist and character always known as 'Loppylugs'.

Whaddon Chase: this spectacularly colourful picture shows the whole hunt on Opening Meet Day, having met by tradition at Stewkley crossroads en route to the first draw of the new season High Havens. This was during the reign of Dorian Williams MFH 1954-1980 and his Huntsman Albert Buckle. Note the number of top hats, including one worn by Mrs Stoddart riding side saddle.

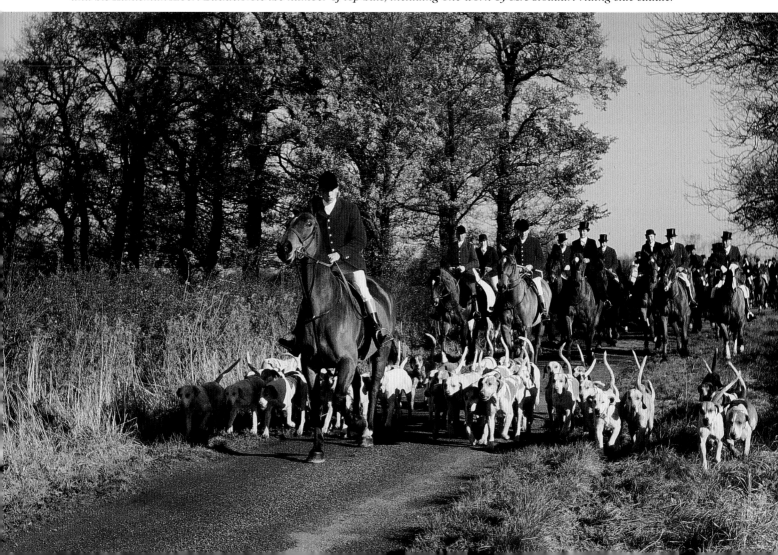

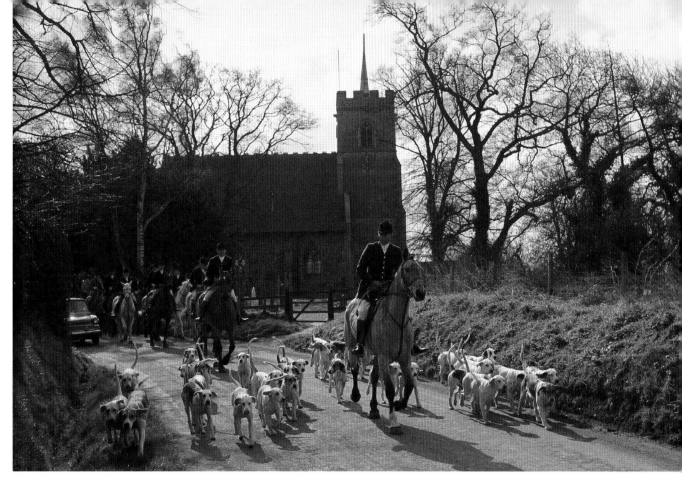

*Heythrop: hounds led by
Kennel-Huntsman Bill
Lander and Joint Master
and Huntsman Captain
Ronnie Wallace hacking
past Brent Pelham Church
during a visit to the
Puckeridge hunt country
in Hertfordshire with its
heavy plough land.*

*East Sussex and Romney
Marsh: truly a timeless
setting, as Huntsman Goff
Berry leads hounds away
from a meet at Old
Romney accompanied by
two energetic school boys
and followed by a large
mounted field all eagerly
looking forward to a day's
hunting on the unique
Romney Marsh in 1980.*

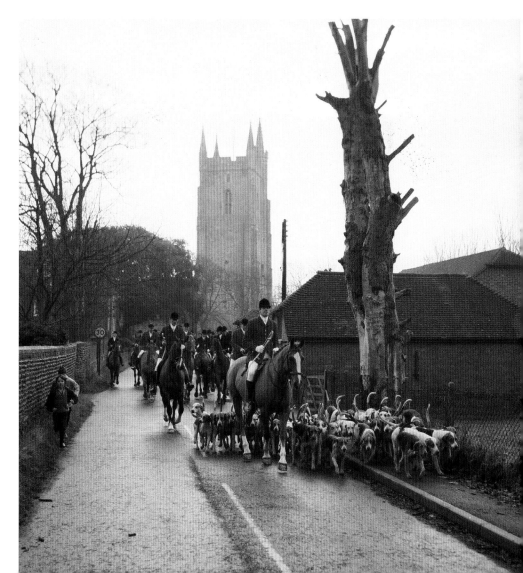

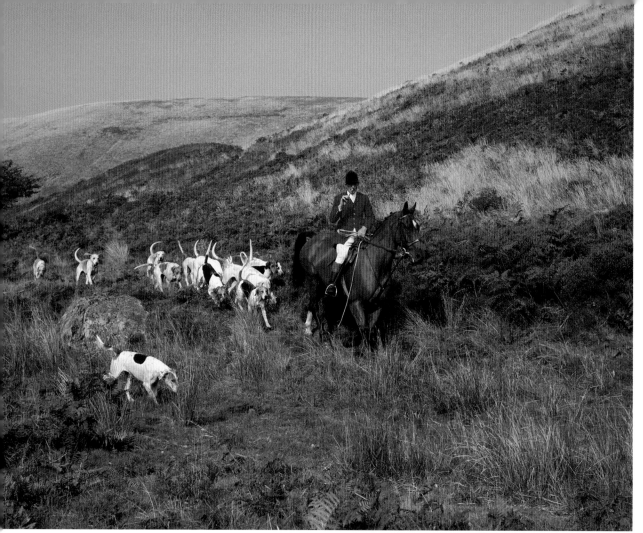

Devon and Somerset Staghounds: backing hounds home across the myriad colours and contours of Exmoor after taking their stag in Badgworthy, is Dennis Boyles, Huntsman 1971–1991.

Cattistock: against a background of glorious Dorset grassland Major Mike McEwan Joint Master and Huntsman 1965–1975 leads hounds away to draw again after catching a fox in the deep valley, just visible, to the left.

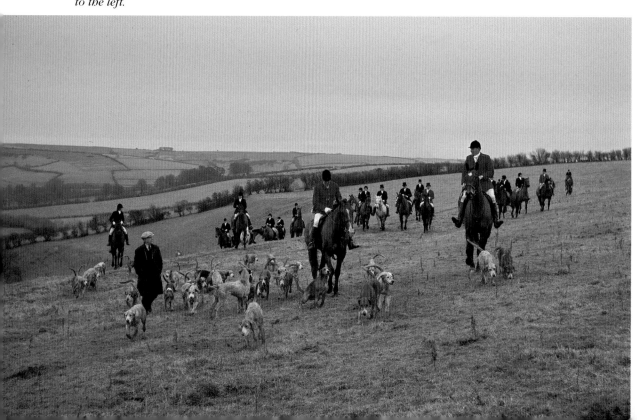

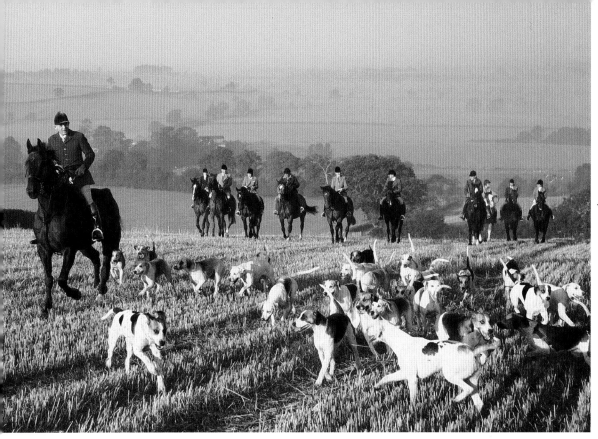

Grafton: what a lovely autumn morning to be out cub-hunting. Tom Normington, who was Huntsman or Kennel-Huntsman 1972–1995, moves across corn stubble with hounds and followed by a correctly dressed mounted field heading to the next draw.

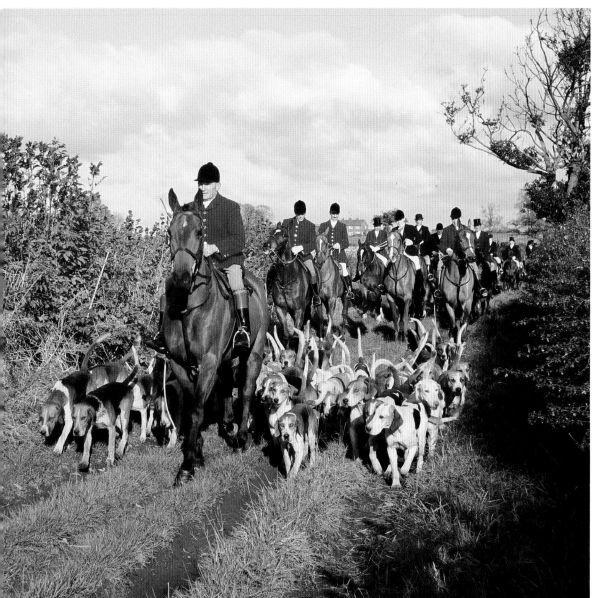

Brambam Moor: 6 November 1971 with the country still very green as Huntsman from 1954 to 1976 Tom Cody and followed by his successor Stuart Blackburn move along a narrow Yorkshire lane ahead of a big field.

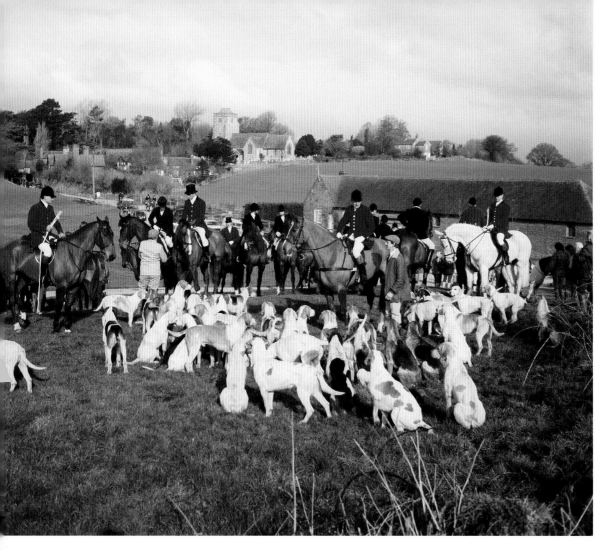

Crawley and Horsham: Huntsman Cliff Standing has his pack of light coloured hounds well grouped around him, as the field arrive at the meet at Thakeham Place in Sussex on 16 February 1987 from where an excellent day's hunting followed, with a kill at dusk.

Essex Farmers and Union: these two packs combined in 1984 with Terry Badger hunting hounds and here in their first season Masters and staff pose for a picture.

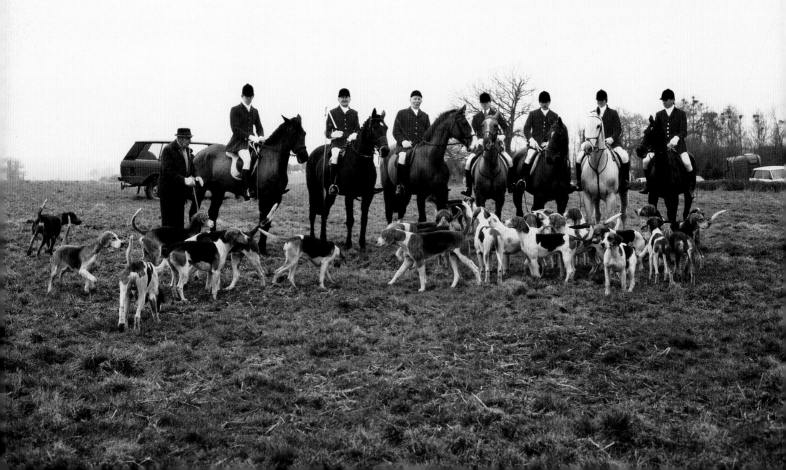

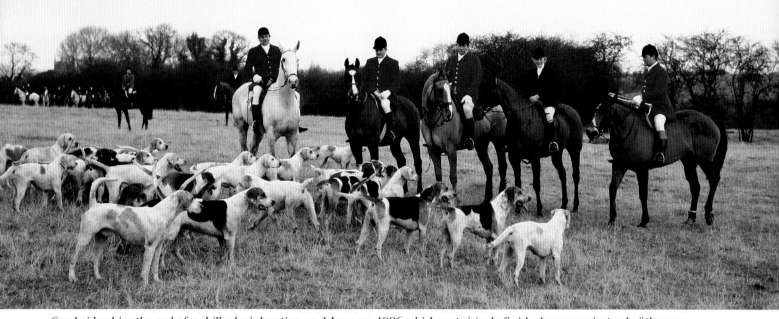

Cambridgeshire: the end of a chilly day's hunting on 3 January 1986 which surprisingly finished on grass instead of the more usual plough land. With hounds as they wait for their trailers to take them home are (left to right) David Parrish MFH, Peter Thelwall MFH, Huntsman Tony Ball, Lady Crossman MFH and Ray Moore MFH.

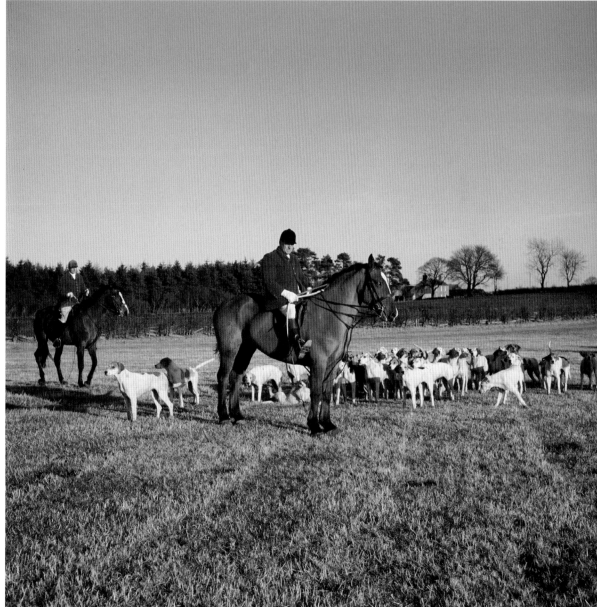

Milvain (Percy): pictured with his hounds in Northumberland on a bright December day in 1972 is Sam Gray, who was First Whipper-In and Kennel-Huntsman from 1950 to 1977. One of Sam's sons, Johnny, whipped-in to his father for a while but has been hunting the Hillsboro Hounds in Tennessee, since 1980.

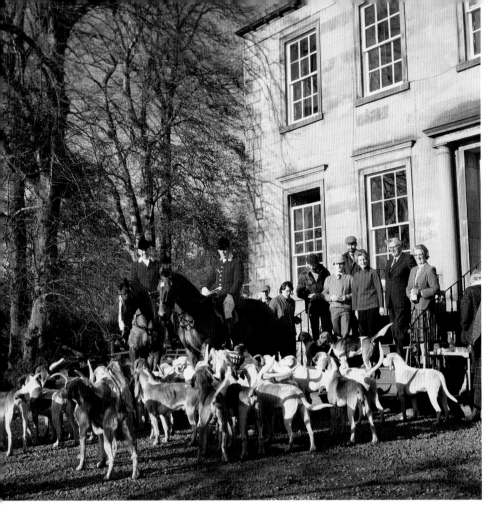

Linlithgow and Stirlingshire: Huntsman Tom Potts and the Master Thomas Boland pictured with hounds at a lawn meet in November 1982. This Hunt with a history going back to the eighteenth century was disbanded in 1991 because of urbanisation around Edinburgh, Scotland.

Isle of Wight: leading hounds to draw is Kennel-Huntsman Nigel Cox followed by Joint Master and Huntsman 1983–1995 Michael Poland on the grey. Although the island is small it has a variety of country, including woods, grassy hills and moor land.

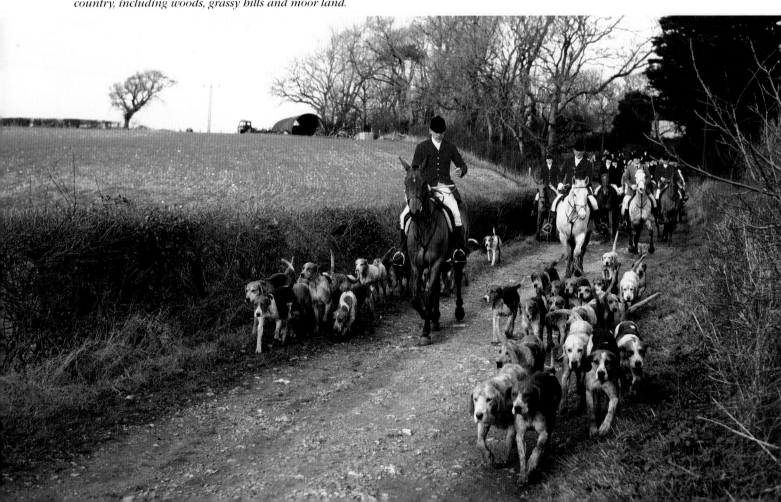

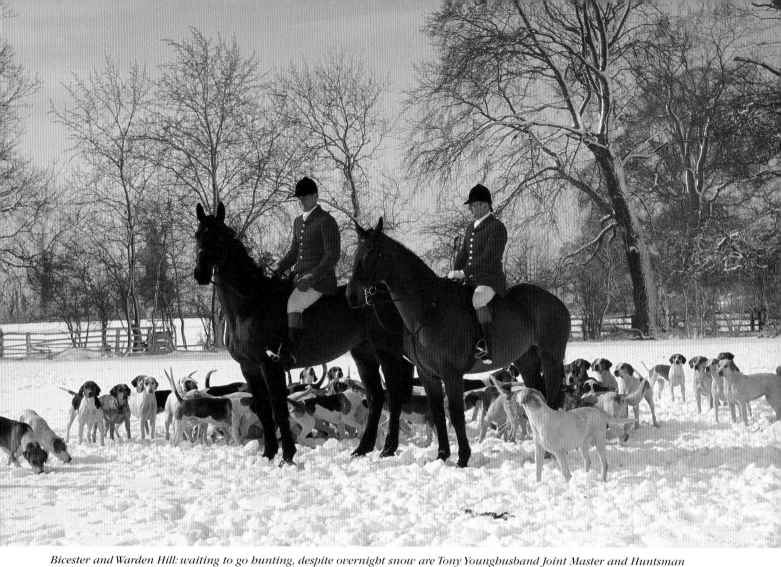

Bicester and Warden Hill: waiting to go hunting, despite overnight snow are Tony Younghusband Joint Master and Huntsman from 1968 to 1973 and long time Kennel-Huntsman or Huntsman Brian Pheasey. Tony Younghusband was a hard man to follow across country and 'Bicester Thursdays' had an awesome reputation for hard riding!

Braes of Derwent: with lovely Northumberland stone walls and undulating countryside in the background Tony Cowen, Joint Master and Huntsman from 1945 to 1968 leads hounds to a fresh covert, in 1966.

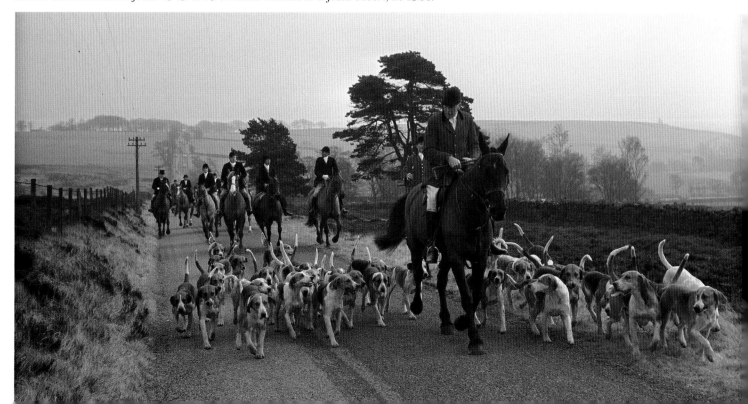

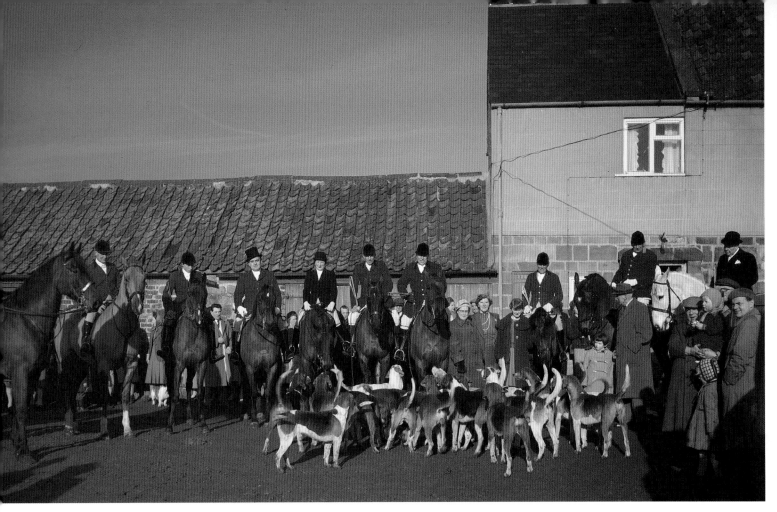

A meet of the Cleveland Hounds at their Guisborough Kennels in North Yorkshire in 1957. In the centre with hounds are the Master, Major Leslie Petch and his Huntsman Bob Champion, whose son Bob won the Grand National on Aldaniti *after beating cancer.*

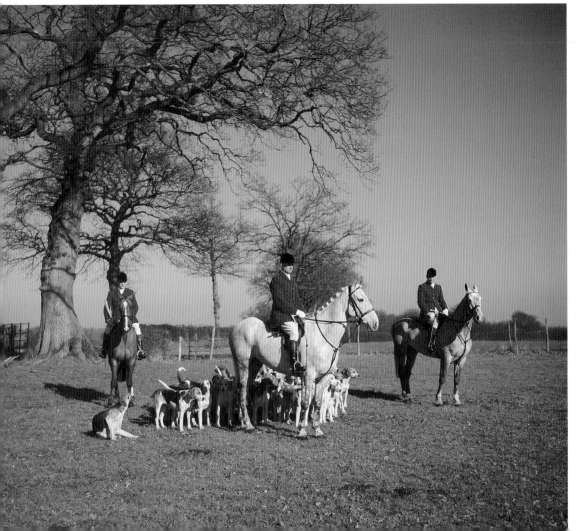

The Southdown Hounds with Huntsman Fred Cockerill, First Whipper-In Roy Goddard and Second Whipper-In David Bland pose for a picture close to the Ringmer Kennels near Lewes in Sussex during 1958.

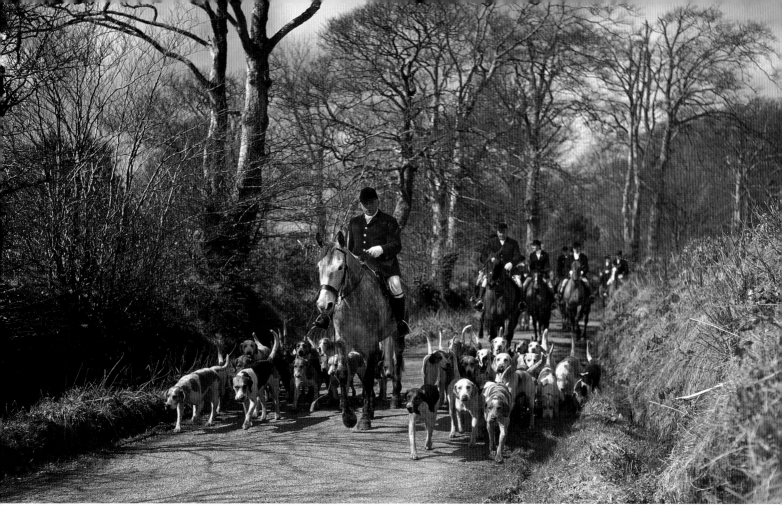

What a tranquil and timeless setting in beautiful Devon countryside as Tetcott Huntsman Tom Swain leads his hounds from a meet in 1962. Two years later this picture won a silver medal at the New York World's Fair in a competition where the theme was 'The World and its People'.

With steam rising from hounds which had just finished a fast hunt during cub hunting in 1963 Huntsman Albert Harris leads the South Devon pack to another draw. Heading the small field is his son Claude Harris who is still in hunt service with the Taunton Vale Harriers.

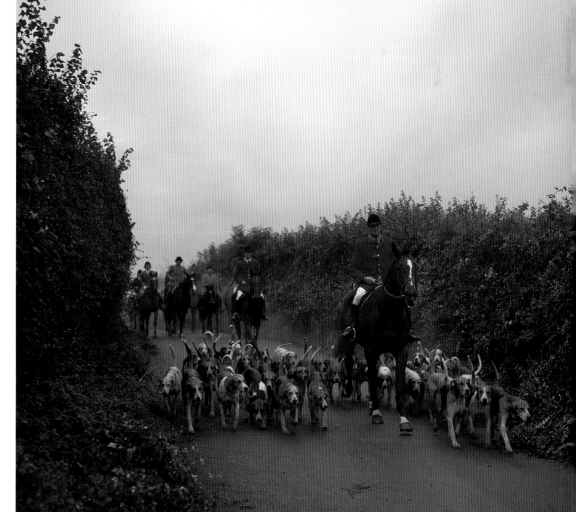

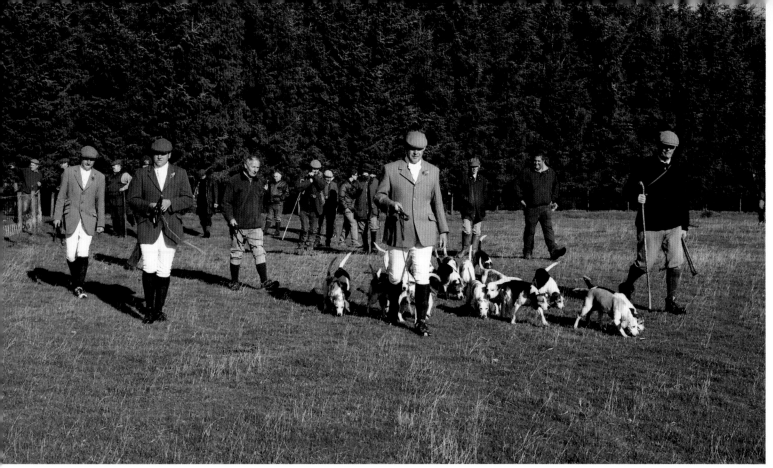

Oakley Foot Beagles

With the hunt staff wearing their pre-opening meet uniform and followed by an informally dressed field, hounds move off from a sunny meet at the start of the day. Joint Master and Huntsman Marcus Wright leads the way flanked by Whippers-In Jack and Ashley Doherty and right Robin Ingall.

Watching hounds which he had just cast after a check on a grassy hillside is David Manning, Joint Master and Huntsman since 1987. David is unusual in that he was also a Joint Master of the Cottesmore Foxhounds 2002–2004, since when he has held a similar post, with the South Notts Foxhounds.

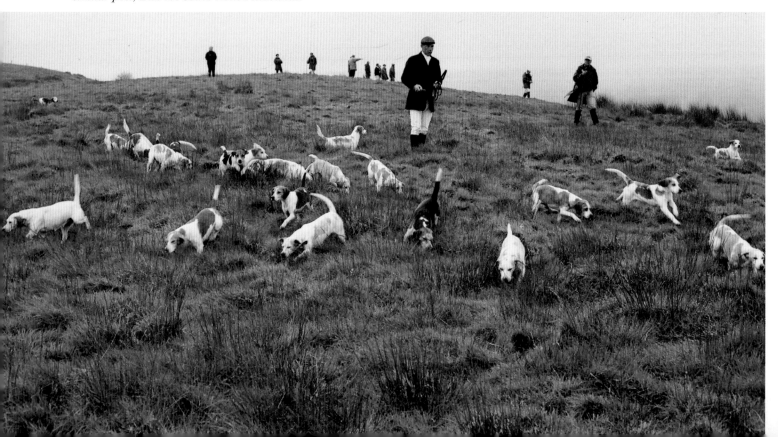

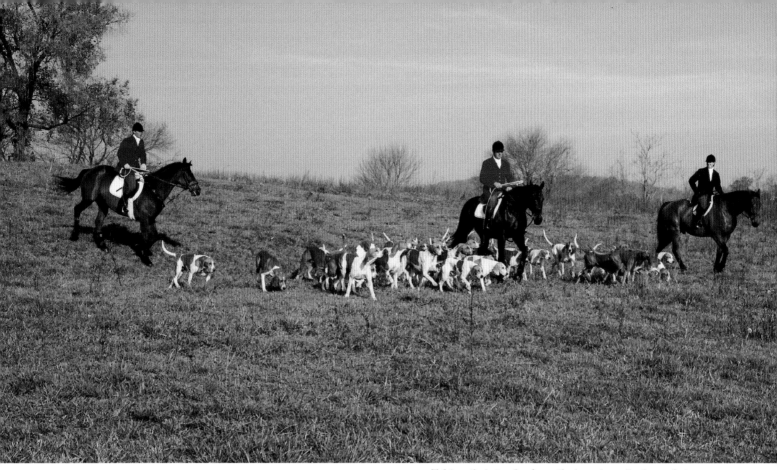

Old Dominion Hounds,
Virginia, USA

Taking their pack of mostly American Foxhounds to draw is Huntsman Gerald Keal, flanked by Whippers-In Clare Palmer and Vanessa Keal Gerrish. Note they are all wearing the Hunt's distinctive brick coloured breeches. It was the late Bill Brainard MFH who bred the well known Old Dominion 'Gorgeous' which was transferred to Capt Ronnie Wallace MFH in England many years ago.

Joint Master Gus Forbush heading the field in marvellous open rolling grass country in the foothills of the Blue Ridge Mountains. The Hunt obviously attracts many young riders some of whom are seen here riding alongside the Master.

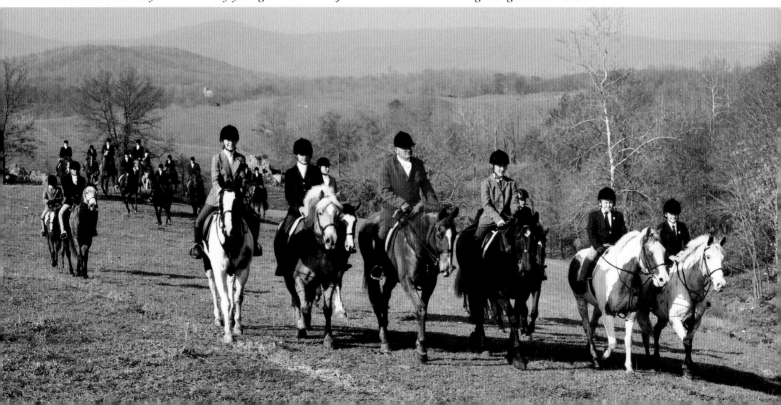

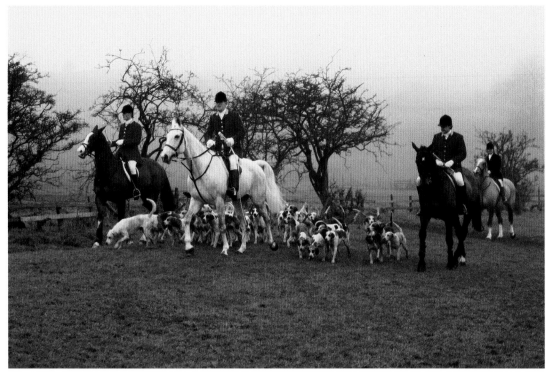

With this good-looking pack of stud book harriers as they move across their lovely grass country in Lancashire and North Yorkshire is Huntsman Richard Lloyd flanked by Joint Master Tom Bannister and Mark Smith.

Pendle Forest and Craven Harriers

With fog and low cloud limiting visibility Joint Master and Field Master since 1977 Michael Bannister had his work cut out to avoid the large mounted field from being 'left' when hounds found.

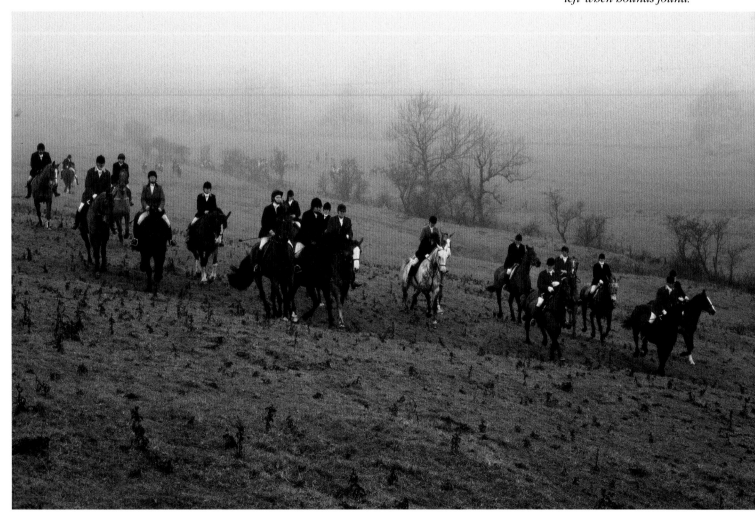

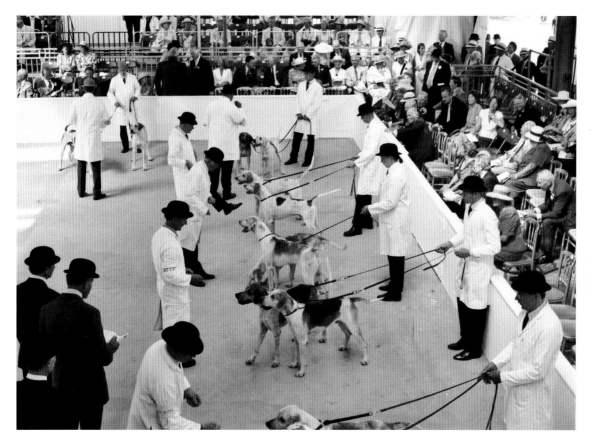

The 2006 Show was special, not just because it was the sixtieth one I had attended but because, for the first time since 1947 (yes, I was there) hunt staff were requested to wear white kennel coats and not full hunt uniform. This was due to the intense heat, which was reported to have reached 95°Fahrenheit. However, the Judges, Nigel Peel MFH and Edward Foster MFH were immaculate in dark suits, ties and bowler hats as tradition decrees.

Peterborough Royal Foxhound Show

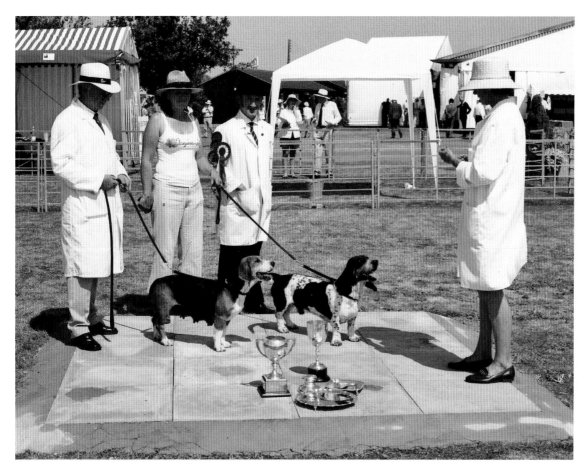

Nowadays the Show is entitled 'A Festival of Hunting' as it includes many other breeds, including harriers, beagles and bassets. One basset pack which will never forget the 2006 show and not just because of the heat, on their outdoor ring was the De Burgh and North Essex Harehounds. They won both Championships with 'Tasmin and Orion', seen here being shown by Edna Philp MH and Huntsman since 1997 and held by Roy Matthews and Julia Reed while Matthew Lee MH has the rosettes!

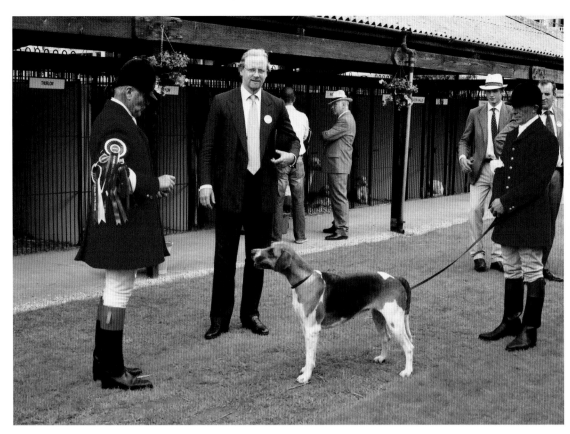

In 2007, which was the 119th Annual show the Brocklesby won both Old English Championships. Here Brocklesby Master, The Earl of Yarborough MFH admires his 'Tendril', shown by Huntsman John Goode and held by Whipper-In Mark Bennison.

President for the year, Simon Hart, presents Countess Suzie Goess-Saurau MFH Vale of White Horse, with the cup for the best two couple of entered doghounds, 'Aintree-Artist-Aztec-Guardsman'. These are being shown by Huntsman Phillip Hague and held by Whipper-In James Bradley.

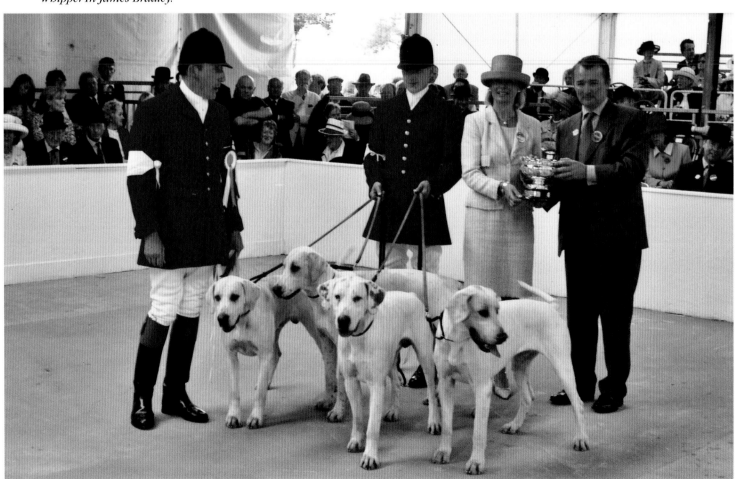

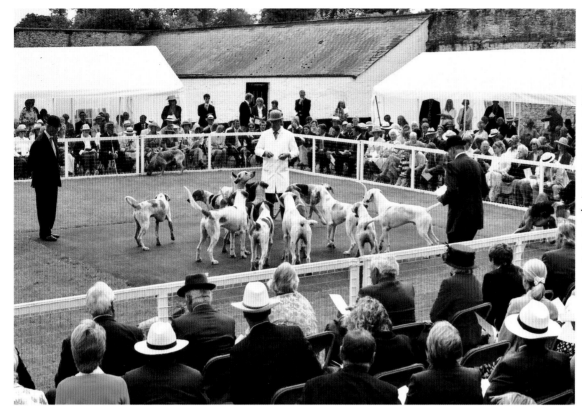

Probably the biggest puppy show in England, is the Duke of Beaufort's held at their kennels close to Badminton House. Here kennel Huntsman Tony Holdsworth shows the young doghounds to the Judges, Capt Brian Fanshawe and Martin Scott, while a large crowd of foxhunters watch intently.

Puppy Shows

Nancy Dougherty MFH Lewisville Hunt in Pennsylvania, had come a very long way to judge the David Davies young entry! Here, on a lovely summer's evening, she is inspecting the Champion dog 'Bristol', shown by Gareth Davis, while to the left is the Champion bitch and overall Champion 'Beatrice' shown by Lorna Davies.

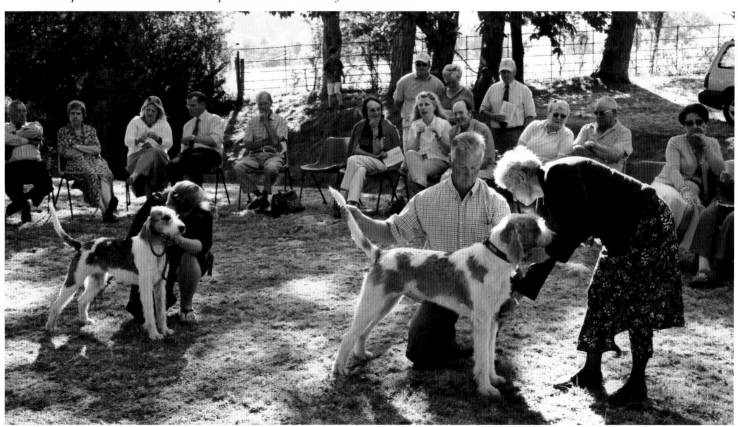

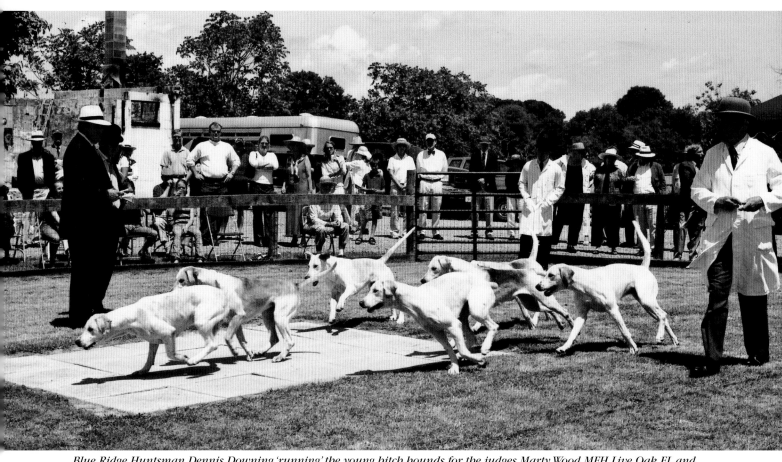

Blue Ridge Huntsman Dennis Downing 'running' the young bitch hounds for the judges Marty Wood MFH Live Oak FL and Ledbury UK Huntsman John Holliday. This show is always held at their kennels on the day after the Virginia Hound show and has a very English atmosphere.

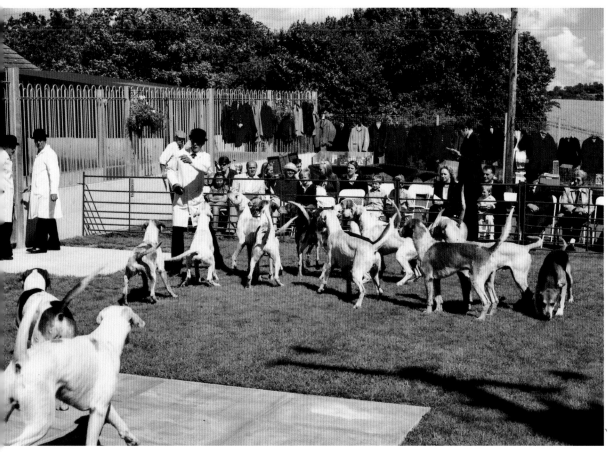

Kennel-Huntsman to the South Shropshire Shane Francis showing hounds at their Puppy Show held at the refurbished kennels at Annscroft. In the ring is Joint Master and Huntsman Otis Ferry, behind whom can be seen a splendid display of colourful hunt coats, which added to the interest of the day.

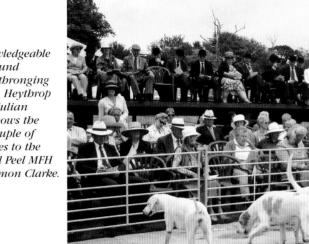

With a knowledgeable crowd of hound enthusiasts thronging the ringside, Heythrop Huntsman Julian Barnfield shows the last three couple of young bitches to the judges, Nigel Peel MFH and Capt Simon Clarke.

Long serving Kennel-Huntsman Bert Loud, who has been with Sir Watkin Williams-Wynn's hounds since 1980 showing their dark coloured young bitches to the judges, Robin Gundry and Andrew Osborne MFH. Admiring these almost 'Old English' type hounds is Richard Tyacke MFH and Huntsman since 2004, prior to which he had been with the Tynedale Hunt.

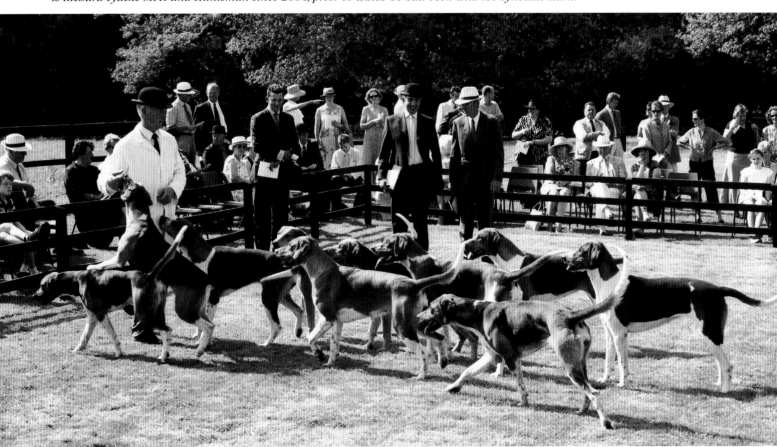

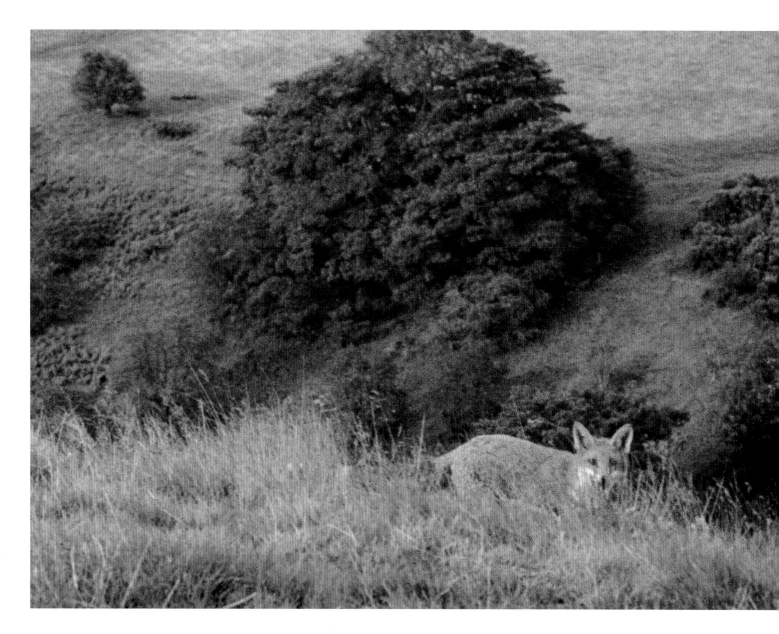

Quarry

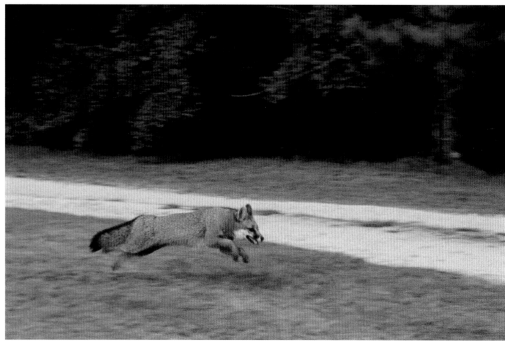

With all four feet off the ground, this pretty, red sided grey fox was running flat out and who wouldn't with the Live Oak Hounds only thirty seconds behind! However, he survived by finding an open earth minutes later, where he was left.

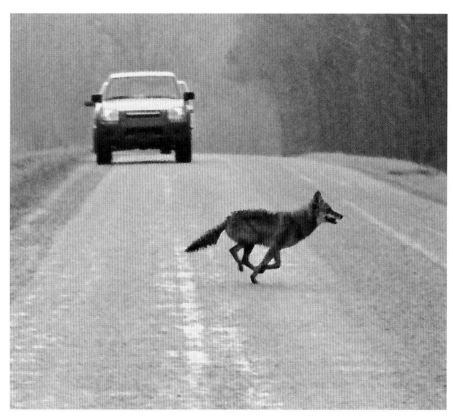

What amazing critters coyotes are! This one was pictured on a very wet day with the Mooreland Hounds in Alabama, when it gave a 16 mile hunt in 2¼ hours and escaped!

This lovely red fox looks amazed to meet a photographer in the middle of nowhere during a morning's cub-hunting with the United Hounds on the English-Welsh border, the year before 'the ban'. He was hunted, but made good his escape!

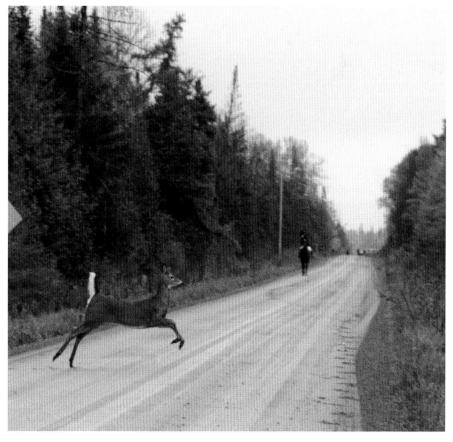

Riot! One of the major forms of Riot in North America comes with white-tailed deer, which seem to be everywhere. This one, crossing a dirt road in the Eglinton and Caledon Hunt Country in Canada was ignored by Huntsman Steve Clifton's Hounds!

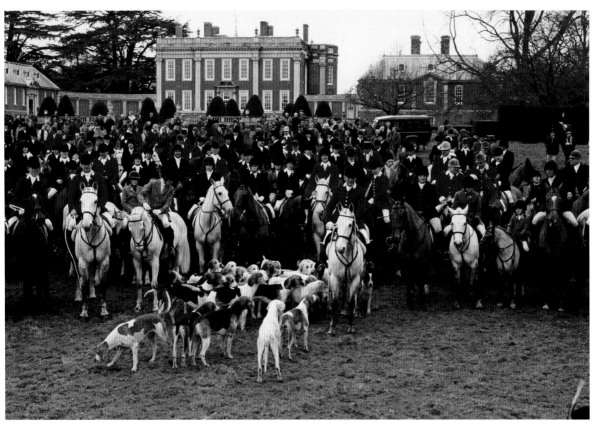

Cottesbrooke Hall, home of the Macdonald-Buchanan family, provides a magnificent setting for the retirement meet of Peter Jones, Huntsman from 1971–2005. Peter, in the centre with his hounds, is the longest serving Huntsman in the history of the Pytchley Hunt, which goes back to at least 1756.

Retirement

Leading the Pytchley Hounds away to draw for the last time after carrying the horn for thirty-four seasons is Peter Jones. His friends and supporters, which included a mounted field of more than two hundred had formed a guard of honour, along which Peter and his hounds moved off to draw. The date was Wednesday 16 February 2005, two days later the ban on hunting with dogs came into force.

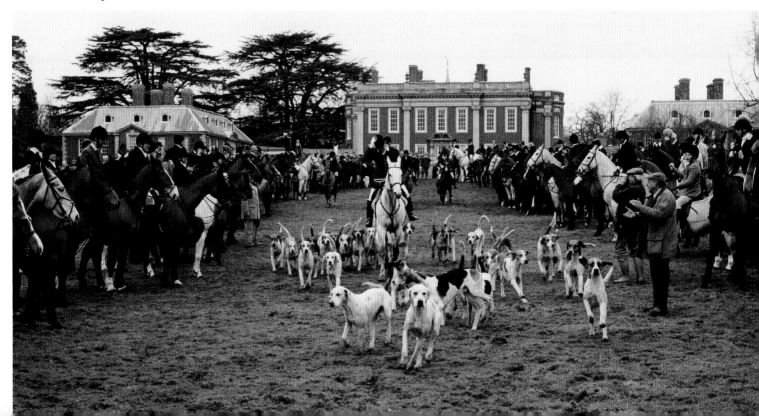

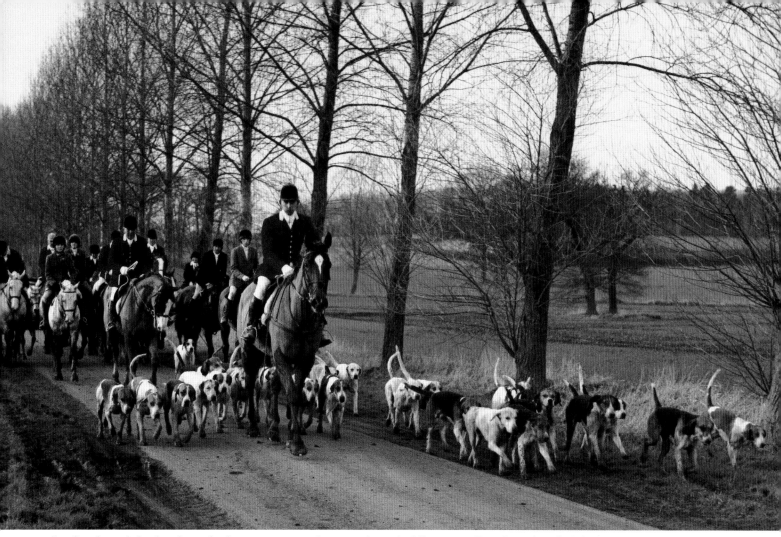

Leading hounds back to kennels along an avenue of trees at the end of Huntsman Peter Jones last day's hunting is Whipper-In David Parker. Peter is just behind hounds, heading what remained of the two hundred strong mounted field, which were at the meet.

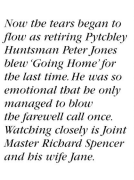

Now the tears began to flow as retiring Pytchley Huntsman Peter Jones blew 'Going Home' for the last time. He was so emotional that he only managed to blow the farewell call once. Watching closely is Joint Master Richard Spencer and his wife Jane.

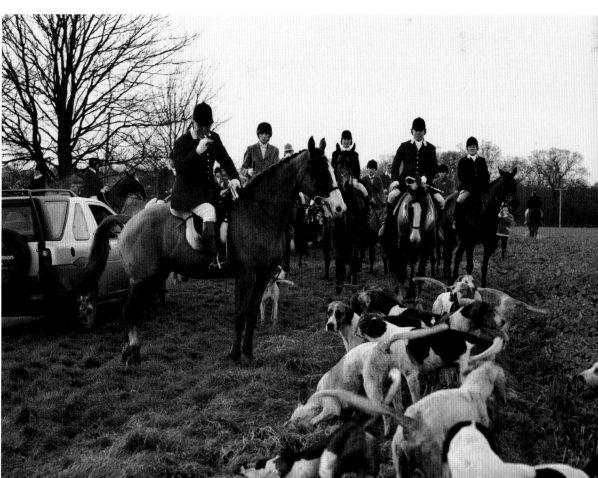

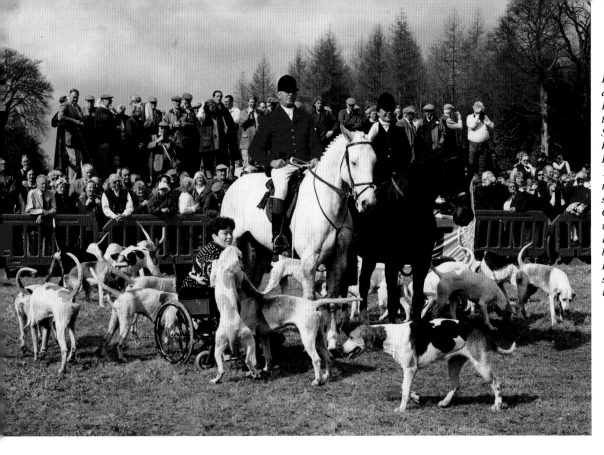

Five weeks later saw another very senior Huntsman retiring. This time it was the turn of Sidney Bailey, who had hunted the Vale of White Horse Hounds since 1966, to call it a day. He is pictured here in a special enclosure in Cirencester Park with his wife Carol and daughter Karen. On the wagon behind are some of the Hunt's personalities and speech makers, who wished Sidney well.

Sidney Bailey, leading his Vale of White Horse Hounds away from a meet for the very last time, on 26 March 2005. Flanking him is Whipper-In Richard Markham, while following along Ten rides in Cirencester Park, is a mounted field which numbered close to three hundred.

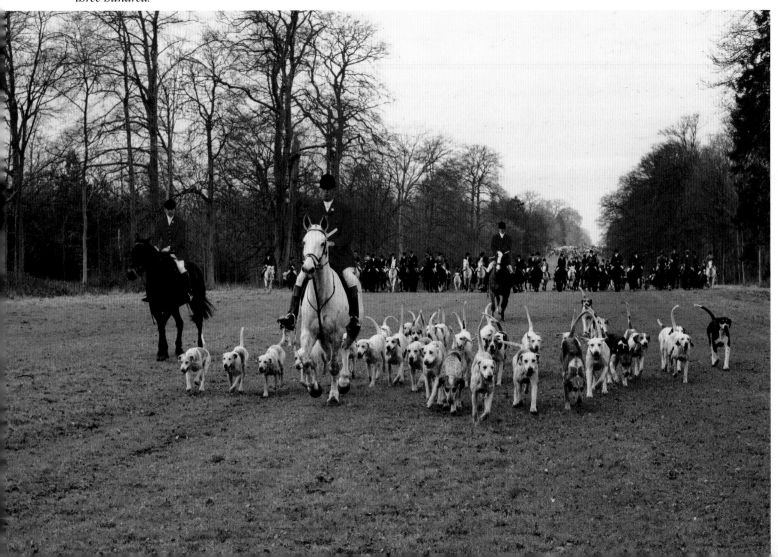

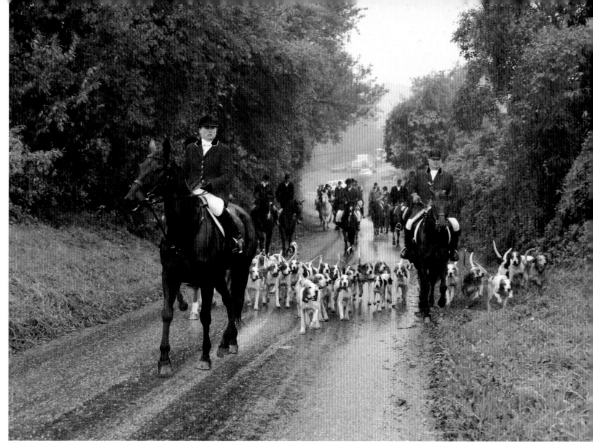

This day's foxhunting was as wet as it looks in this picture! The Rose Tree were honoured by having the MFHA Directors' Meeting in their country, thus giving all these top visitors the chance to see this excellent pack of Penn-Marydel hounds in action. Leading the way from the meet is Whipper-In Missie Murtagh, while her Father Jody Murtagh MFH and Huntsman rides with his hounds.

Rose Tree Foxhunting Club, *Pennsylvania, USA*

The hard riding field on steaming horses, pause on a country lane, after a fast hunt on a fox, while hounds draw a covert for another fox. Many of those who ended the day wet through are visiting Directors of the MFHA who had attended the Fall Meeting in Pennsylvania.

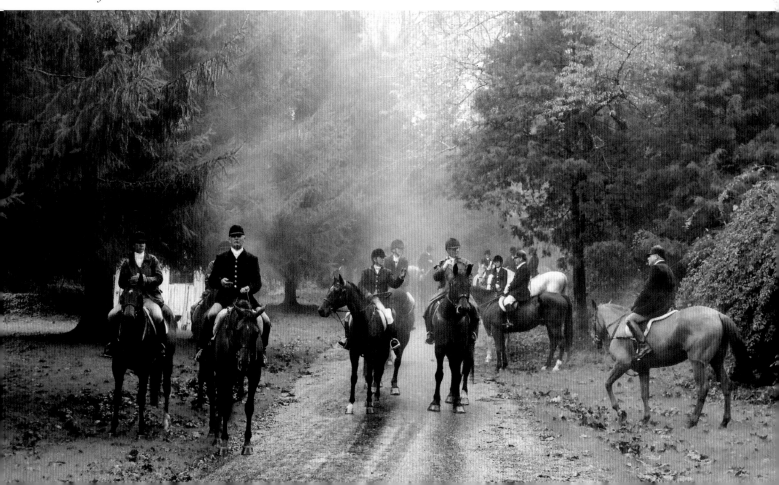

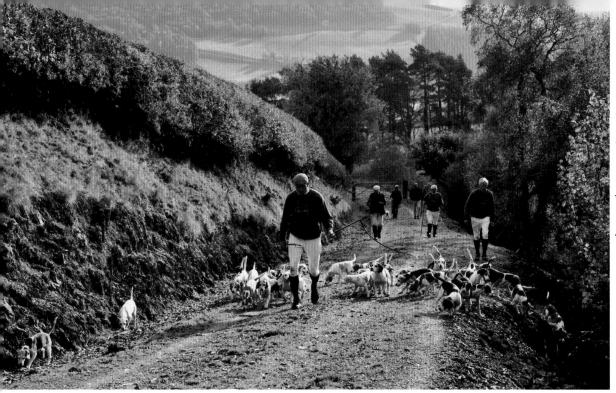

This pack was formed in 1989 when the Aldershot and the Sandhurst Beagle packs amalgamated. Both have military connections with the Aldershot being formed in 1870 and the Sandhurst in 1935. Here Mark Jackson leads hounds away to draw, from an early season meet in Mid-Wales.

Sandhurst and Aldershot Beagles

Huntsman Mark Jackson blowing for hounds, during a hunt in wonderful open and wild country in the Welsh hills. For many years Mark's father Michael Jackson was Kennel-Huntsman to the Sandhurst Pack when they were kennelled at the Royal Military Academy, Sandhurst.

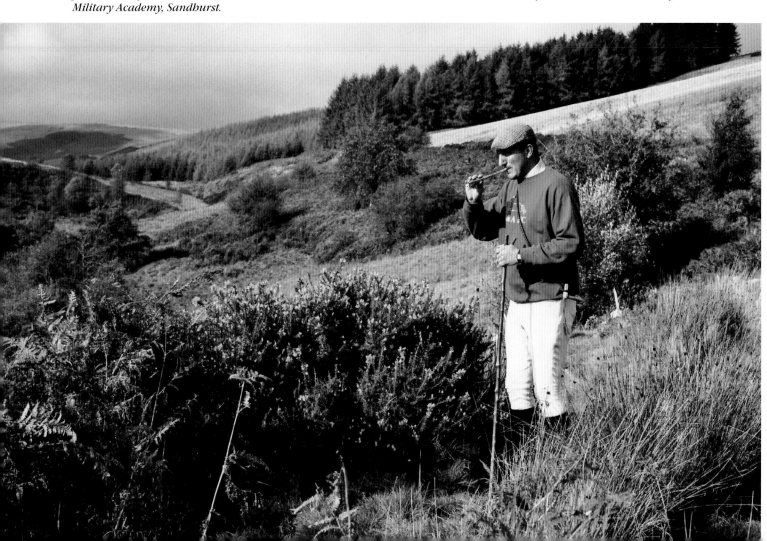

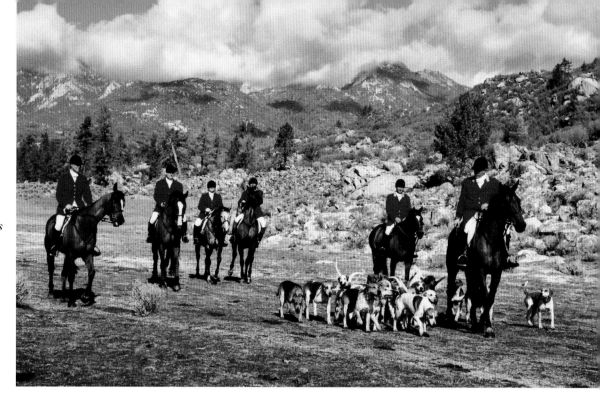

With kennels and hunt country between Los Angeles and San Diego, many types of terrain are encountered. Here Master and Huntsman since 1990, Terry Paine, leads hounds and hunt staff to a meet on high ground, amidst the most spectacular scenery. Lack of rainfall in recent years has seen former grasslands turn brown.

Santa Fe Hunt, California, USA

The pack of English and crossbred foxhounds really having to use their noses, as they hunt slowly across an arid landscape some 5,000 feet above sea level. Master and Huntsman Terry Paine is ready to help if needed, but the coyote escaped into the distant mountains, where it is impossible for horses to go.

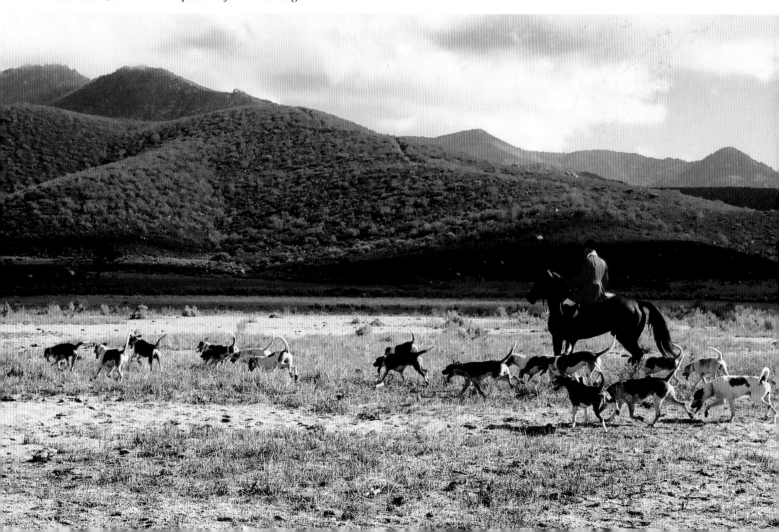

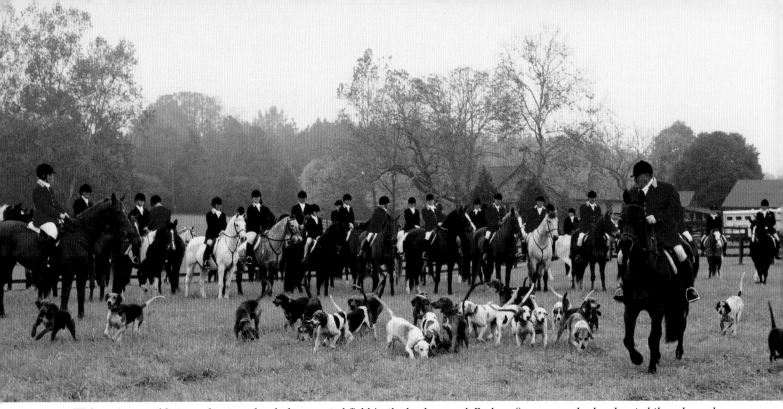

With an impeccably turned out, and orderly mounted field in the background, Rodney Swanson, who has hunted these hounds for twenty years, leads his pack of Penn-Marydel and crossbred hounds away to draw. A grey fox and a coyote were hunted during this day before the weather became too hot to continue.

Shakerag Hounds, *Georgia, USA*

With hounds at the end of a hot day, during which they provided an excellent fast run on a strong coyote, are Huntsman Rodney Swanson and the two Joint Masters, Sally Rasmussen and Dick Washburn – now for a hunt breakfast!

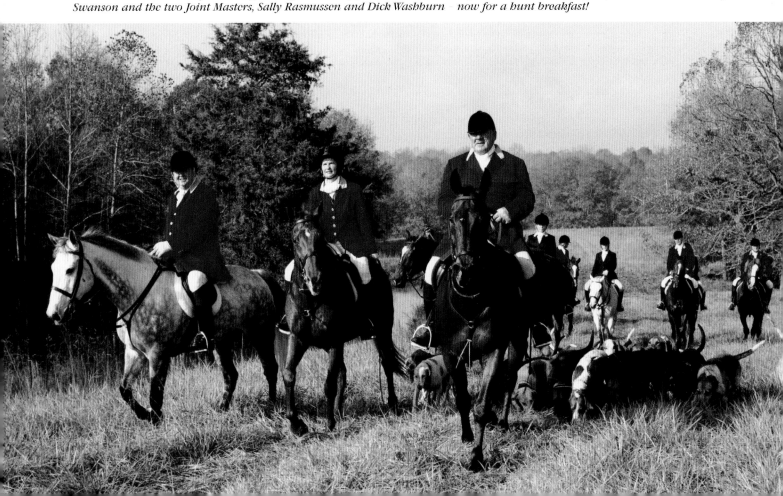

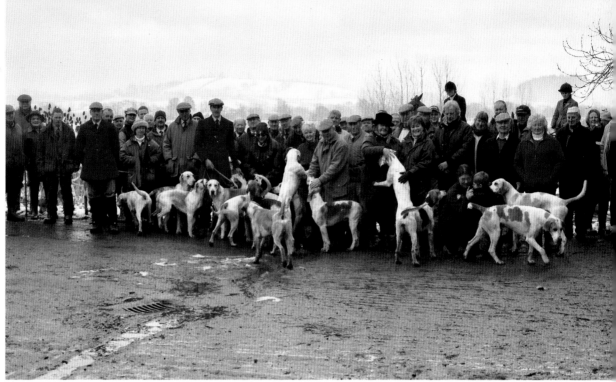

With conditions under foot making things totally unsafe for horses, the South Shropshire Hunt turned out on foot and were rewarded by a big turnout of supporters keen to hunt. It is interesting to note the number of flat caps being worn, to keep out the cold!

Snow

Leading the South Shropshire Hounds away from a foot meet at Bodynfoel Hall are Joint Master and Huntsman Otis Ferry and Kennel-Huntsman Graeme Wright, followed by members of the field. However, there was only a small number of us, who climbed to the tops of the snow-clad hills, thus keeping in touch with hounds!

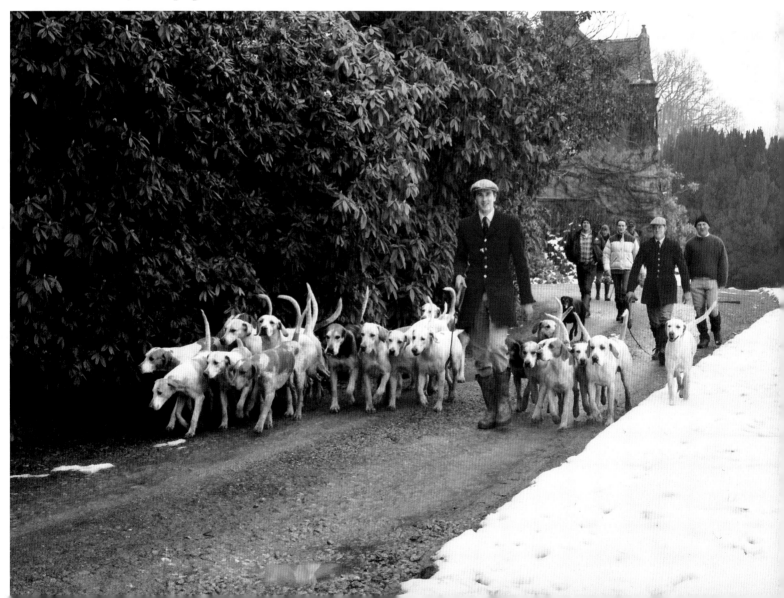

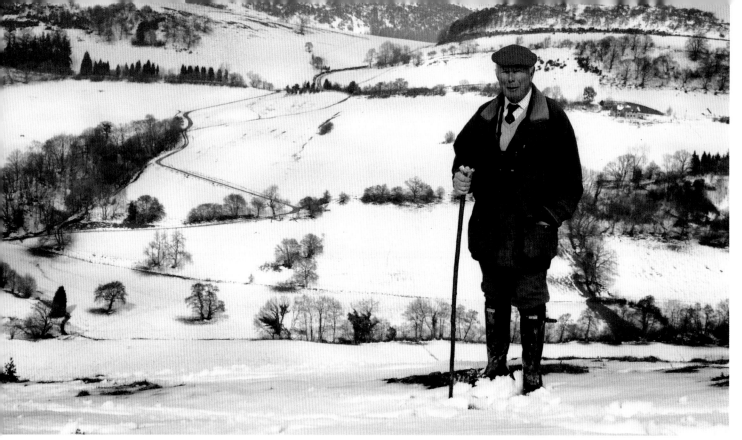

To find a view like this whilst out foxhunting makes all the hard work involved in scaling the heights well worthwhile. Here, former South Shropshire Joint Master Richard Tanner takes a breather and admires the scenery.

The Middleton Hunt, field watching hounds at work from an exposed snow covered hillside. From the look of the sky, another squall was imminent! Note the flock of sheep on the horizon.

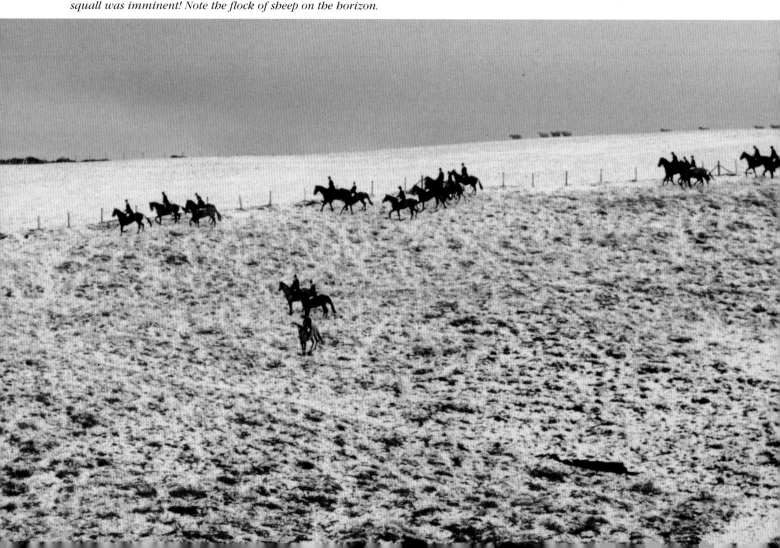

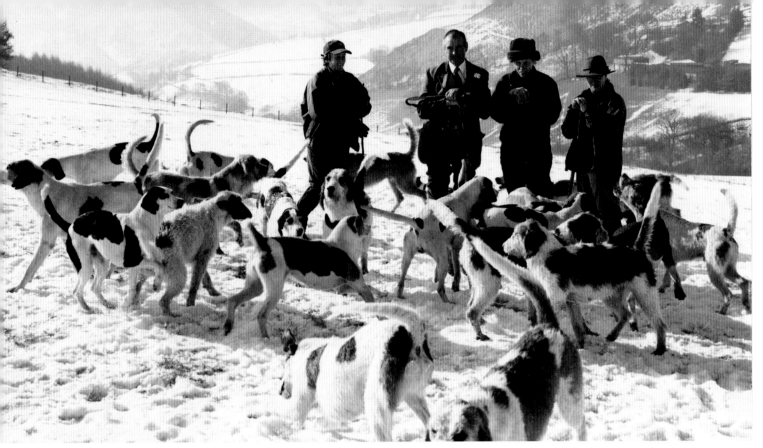

When a group of American Masters phoned David Davies Huntsman David Jones to arrange a visit he readily agreed, even though it snowed heavily that night hounds still met in an isolated place near to Pantydwr. Here, with hounds are David Jones with Sherry Buttrick MH Farmington Beagles, Jeep Cochran MH, Calf Pasture Bassets and Betsy Park MH Sandanona Harehounds.

Later that same day and having followed the David Davies Foxhounds across country for several miles the three American Masters pause to regroup, in scenery more like Switzerland than Wales. Sherry Buttrick MH Farmington Beagles VA, Betsy Park MH Sandanona Harehounds NY, Jeep Cochran MH Calf Pasture Bassets MD.

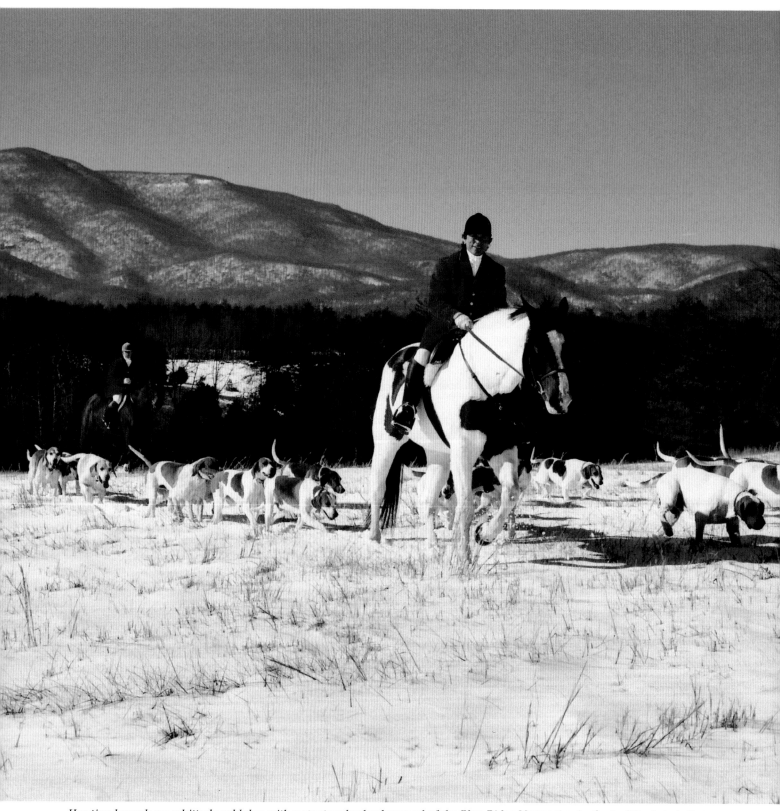

Hunting bounds on a bitterly cold day with a spectacular background of the Blue Ridge Mountains in Central Virginia is Oak Ridge Joint Master and Huntsman Rita Mae Brown, who is also a bestselling author.

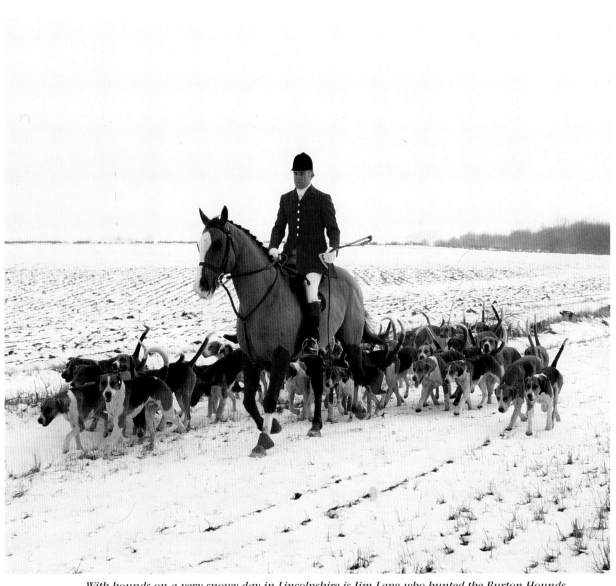

With hounds on a very snowy day in Lincolnshire is Jim Lang who hunted the Burton Hounds from 1967 to 2008 when he retired.

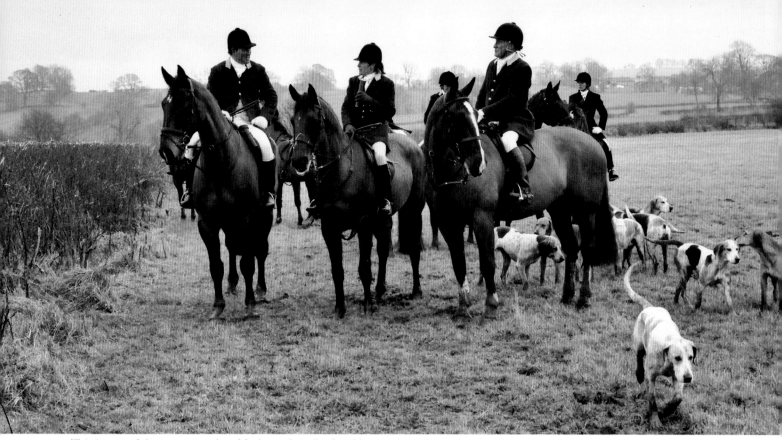

This is one of the newest packs of foxhounds in England having been formed as harriers in 1980 changing to foxhounds and becoming a private pack in 1993. Here, discussing where to draw next is Huntsman Elaine Barker MFH flanked by Joint Master Gerald de Ville and Field Master David Machin. During the day stonewalls and thorn hedges were jumped and all on grass.

Staffordshire Moorland Hunt

Coming in at the end of a busy day in marvellous countryside but with fog coming and going hounds are under the control of huntsman Elaine Barker MFH and Joint Master Gerald de Ville. Note the green moss growing on the stonewalls bordering this narrow lane in England's Peak District.

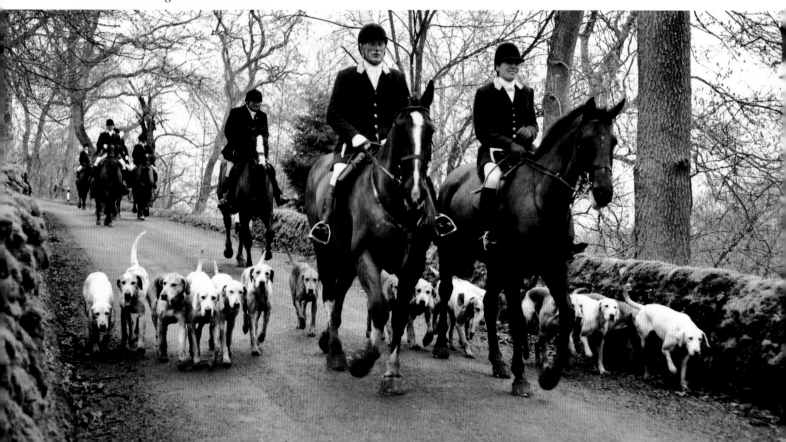

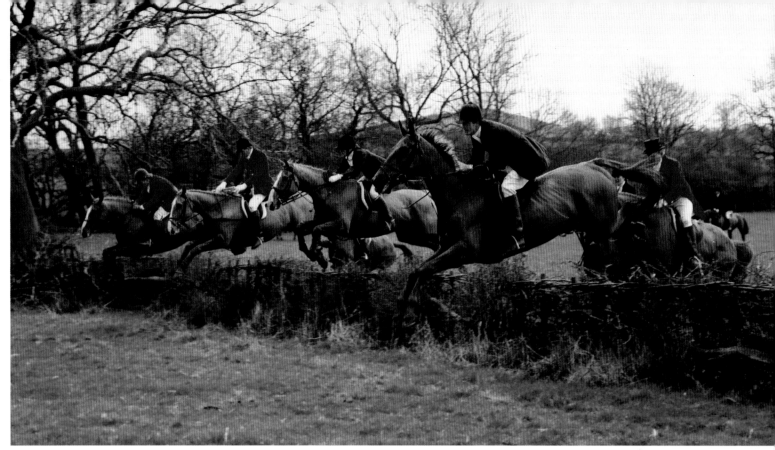

Quite a rare sight, except in paintings, showing four riders going flat out over a neat, cut and laid hedge in the Quorn country of High Leicestershire. Notice how many other riders are close to the leaders, as nobody wants to be 'left'!

Synchronised Jumping

Together over a timber fence close to Unionville, Pennsylvania, in the renowned Mr Stewart's Cheshire foxhound country are Jock Hannum, whose mother Nancy was MFH 1945-2003 and Joint Master Russell Jones. It is interesting to note the unusual pre-opening meet clothes being worn.

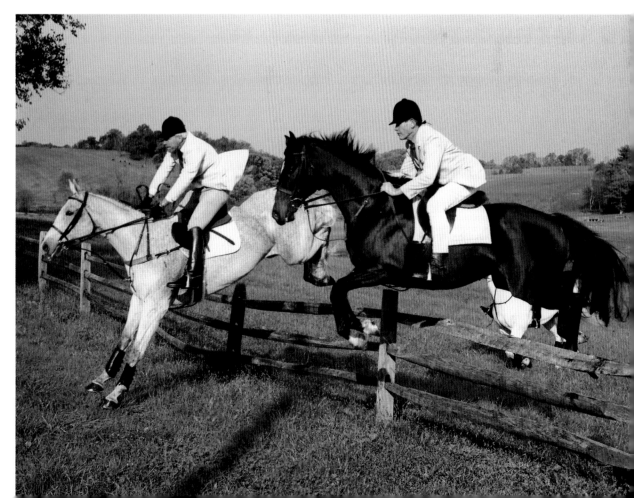

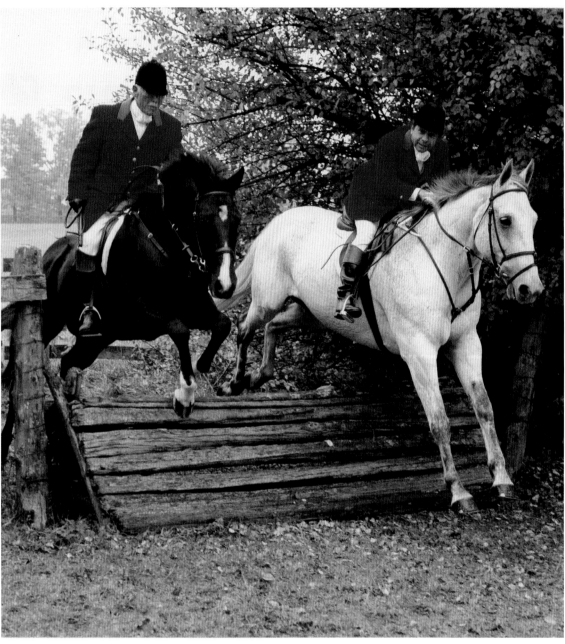

Leading the Eglinton and Caledon Hunt field over a coop during a hunt in Canada are two former Joint Masters. On the black horse is Gus Schickedanz while on the grey, previously a top class show jumper, is Frank Merrill.

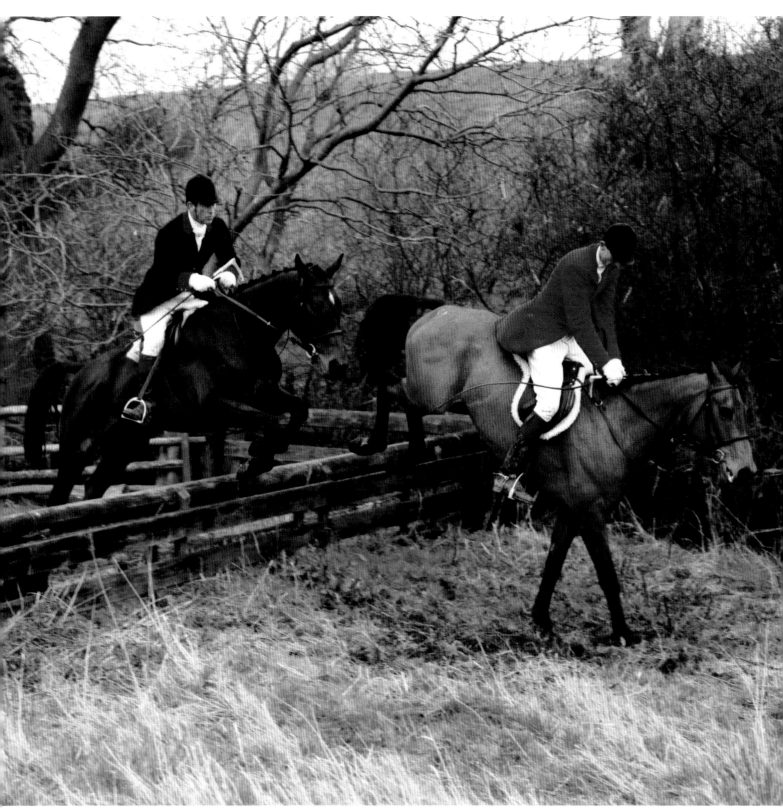

HRH Prince Charles, in his distinctive Windsor Livery Hunt coat with Jos Hanbury MFH Quorn. Jos has also been a Joint Master of the Cottesmore Hunt, Field Mastering big fields on many occasions with both hunts. He is also a winner of the Melton Hunt Club Cross-Country ride.

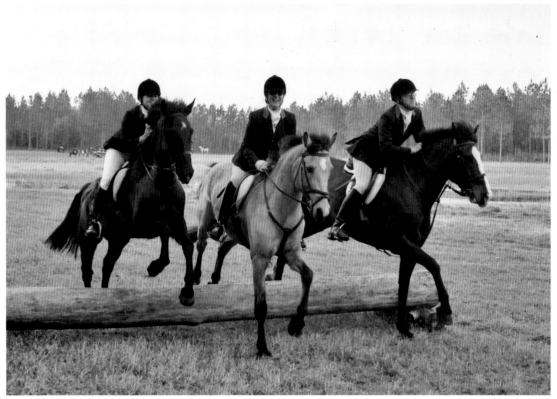

It's not often that I'm able to picture a landowner in action on their own property during a hunt, but on this occasion I did! The Misty Morning Hounds had met on Nancy Hardt's Alma Del Zorro Ranch, in Florida and here Nancy is in action, flanked by her children Will and Katie.

A nice pair of greys in perfect harmony as they take a stonewall in the Shamrock Hunt country in Georgia, USA. The riders are Rachel Ochoa and Momo Wetherby, while close behind is yet another grey about to jump.

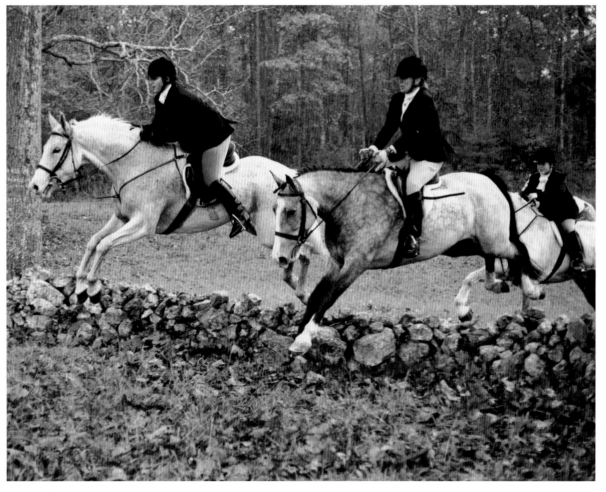

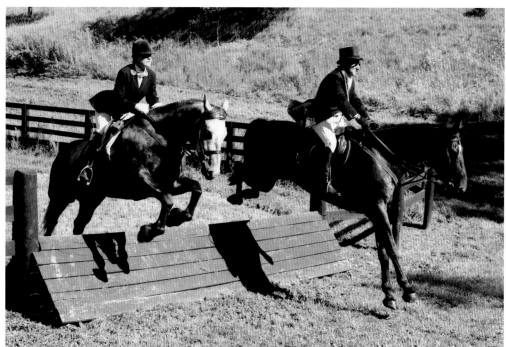

Another rarity is to photograph a husband and wife airborne together over a coop. This was during a hunt on John Greene's land with the Fox River Valley Hounds in Illinois; the couple concerned are Herb and Debra Lamee who also ride with the Arapahoe Hunt in Colorado.

Another 'family affair' as Staffordshire Moorland Field Master David Machin and his son Andrew clear an imposing stonewall in the Peak District of England. The wonderful scenery is just beginning to appear as the early morning fog clears.

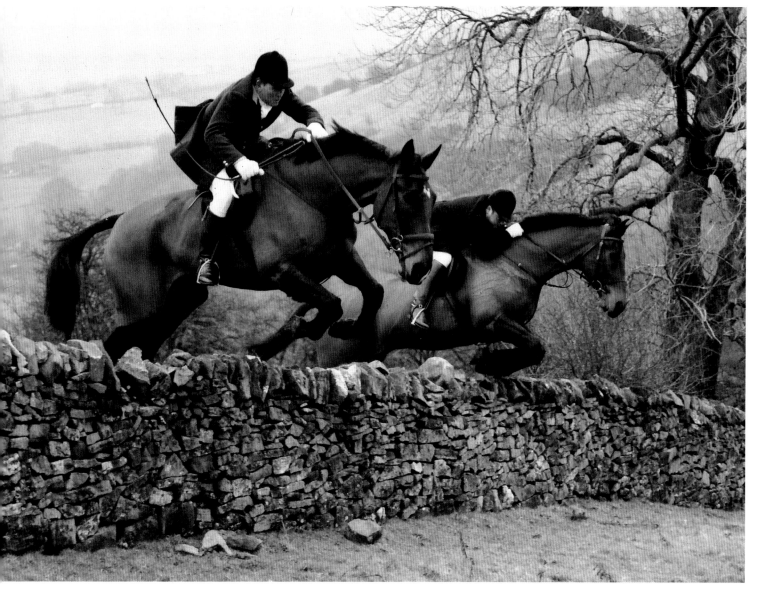

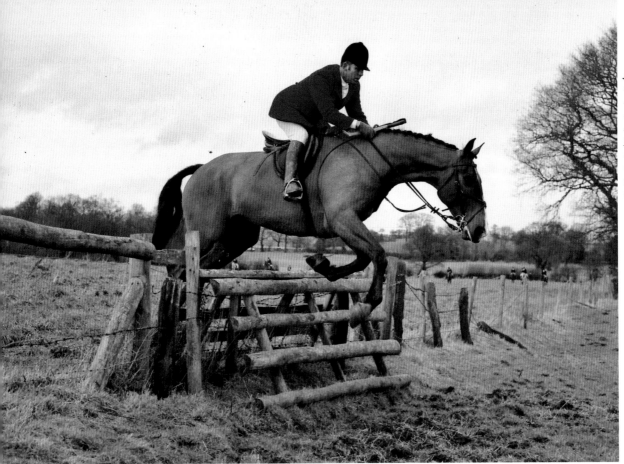

Joint Master and Field Master of the North Staffordshire Hounds, Mark Allman setting the pace with the field strung out behind during a fast hunt in this mostly grass country.

Timber

How good it was to see Neil Beaton out with the Pytchley Hounds elegantly attired in a scarlet cut away coat and silk top hat, despite the muddy conditions.

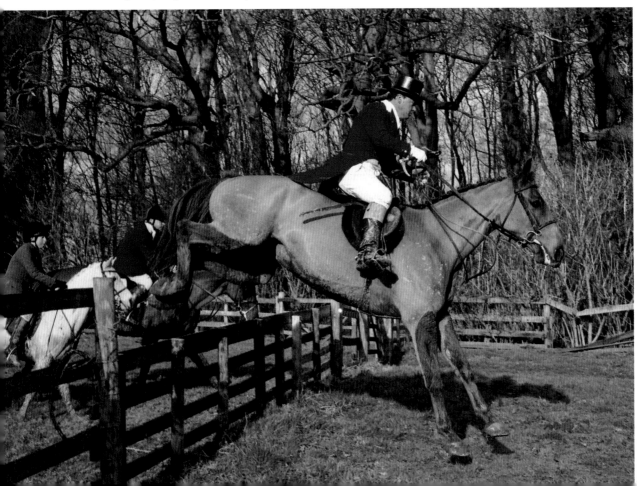

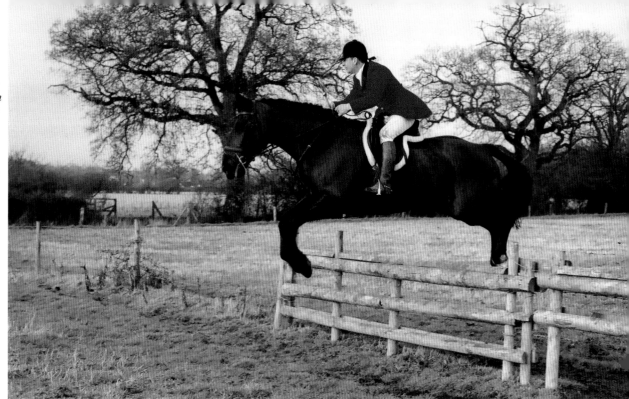

Smartly turned out amateur Whipper-In to the Four Burrow Hunt since 1990, Paul Bowden keeps his eyes on hounds as they leave a covert in pursuit of a fox.

Enjoying a late afternoon hunt with the Four Burrow Hounds is Nikki Hancock, who helps whip-in to her father Paul Hancock MFH, who hunts the hounds.

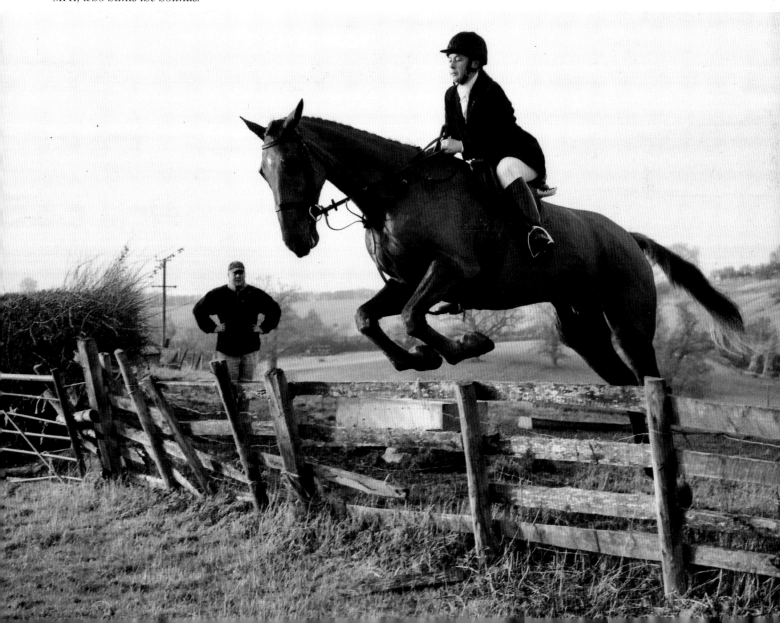

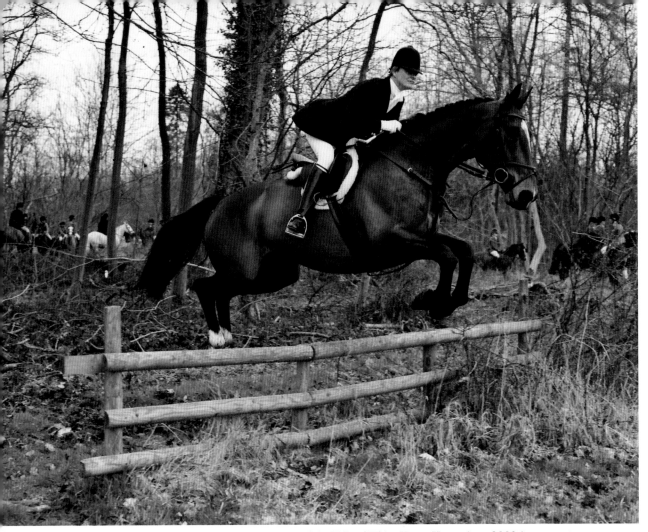

Countess Suzie Goess-Saurau, a Joint Master of the Vale of White Horse Hunt since 2003 jumps out of a covert at the start of a hunt with some of the large mounted field in the background.

Nicely turned out and with her good chestnut hunter's mane well plaited Jane Clark 'pings' this jump, during a day with the United Pack in wonderful open country.

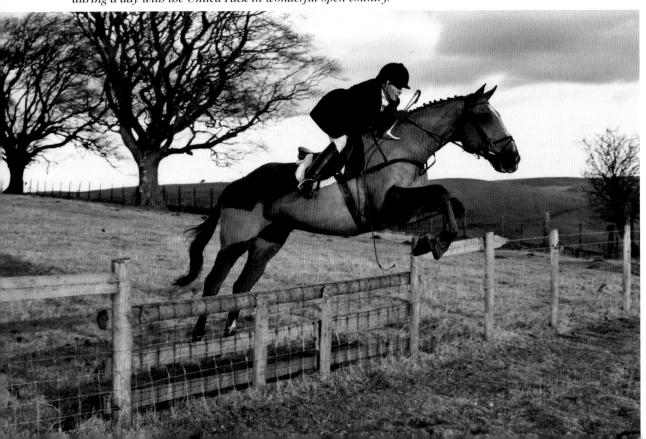

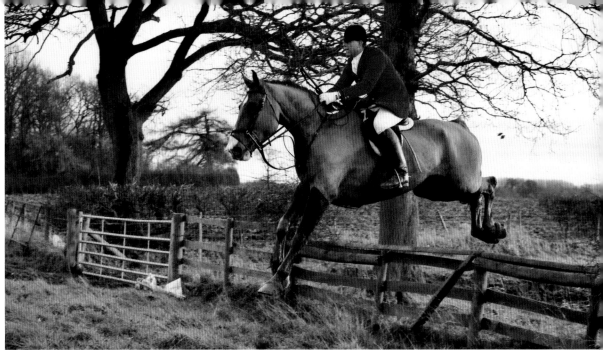

Giving this jump plenty of air is Chris Mellard MFH North Staffordshire Hunt, whose history extends back to 1845.

Wendy Watts sees a good stride at this upright fence in the Ledbury country and sails effortlessly over onto a trail through a covert.

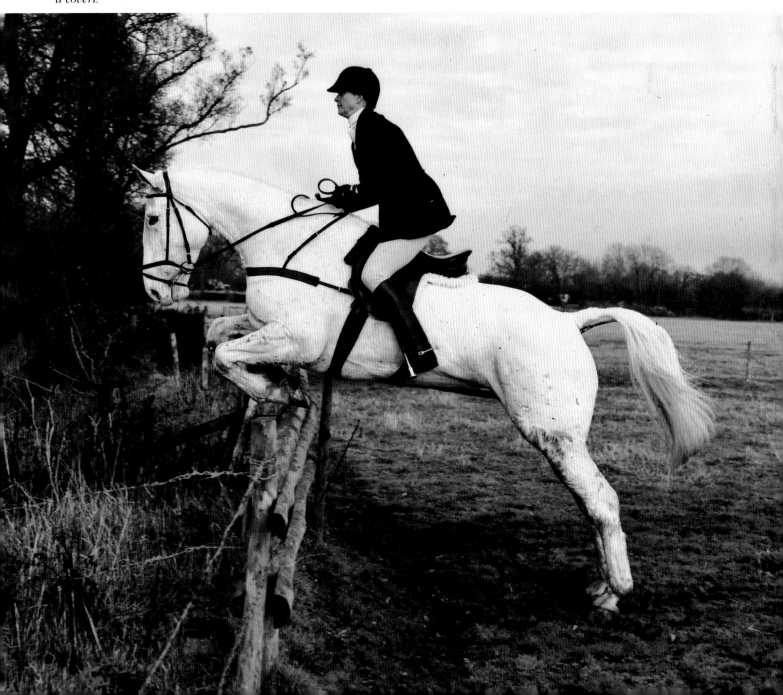

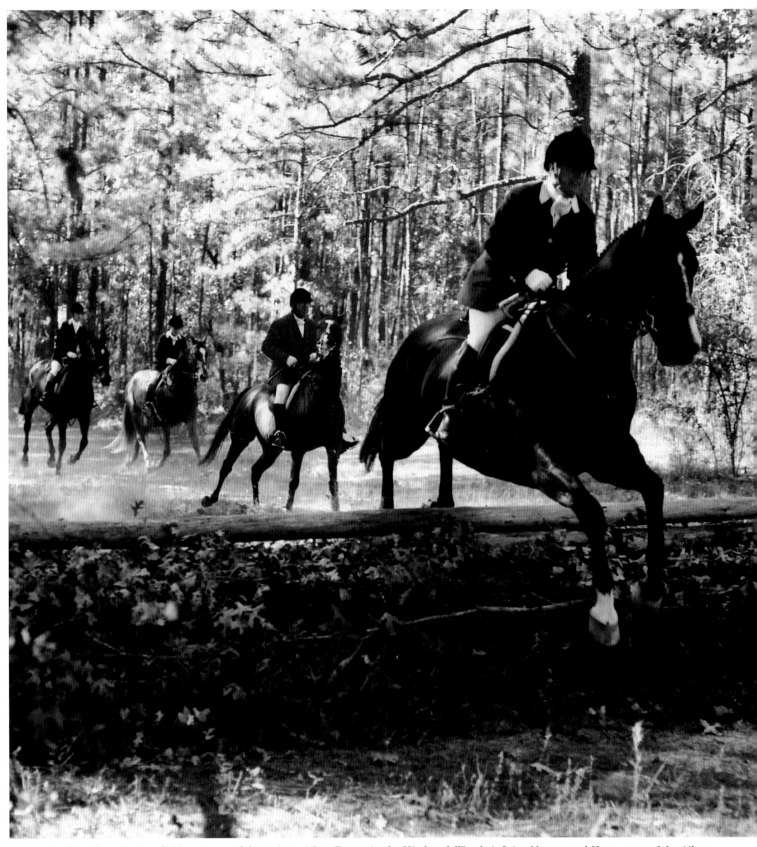

Leading the galloping field over one of the unique Aiken Fences in the Hitchcock Woods is Joint Master and Huntsman of the Aiken Hounds, Linda Knox McLean whose hunt country is in South Carolina.

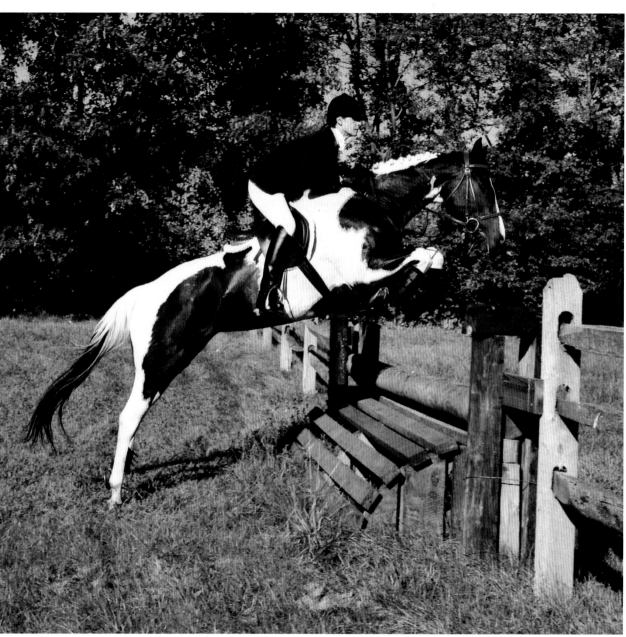

All sorts of jumps are encountered when hunting with the Myopia Hounds in Massachusetts, but Francois Martinolle and her good coloured horse took them all in their stride.

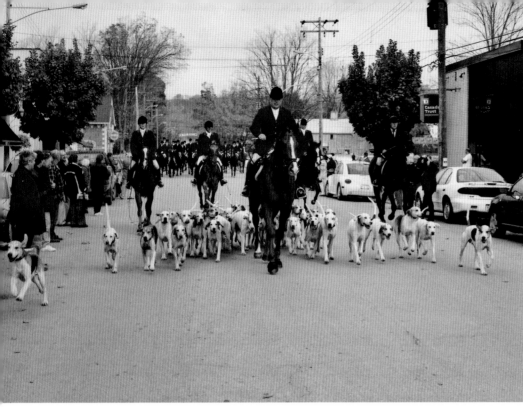

Moving along this spectacularly beautiful valley close to the new hunt kennels the first field lead the way, with the 'Hilltoppers' following behind. Each group has its own Field Master, so that hopefully nobody gets lost!

Following the annual blessing of the hounds in Creemore, Welsh born Huntsman Mark Powell and his wife Emma parade their good looking pack of modern English foxhounds along the main street at the beginning of a day's hunting.

Toronto and North York Hunt, Canada

Heading the galloping field after a Centennial Joint Meet at Grand View Farms are the two Joint Masters, Wolf Von Teichman who hosted the meet with his wife Gill and on the grey, Michael Belcourt. During the day hounds ran across both Masters' property.

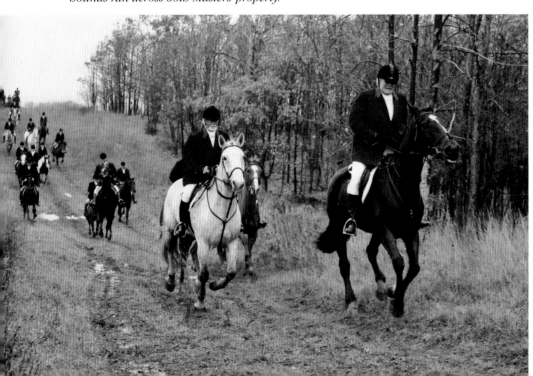

Huntsman Mark Powell with support from Rodney Barton hacking hounds back to kennels at the end of the day with the trees showing many of the full colours of the Fall.

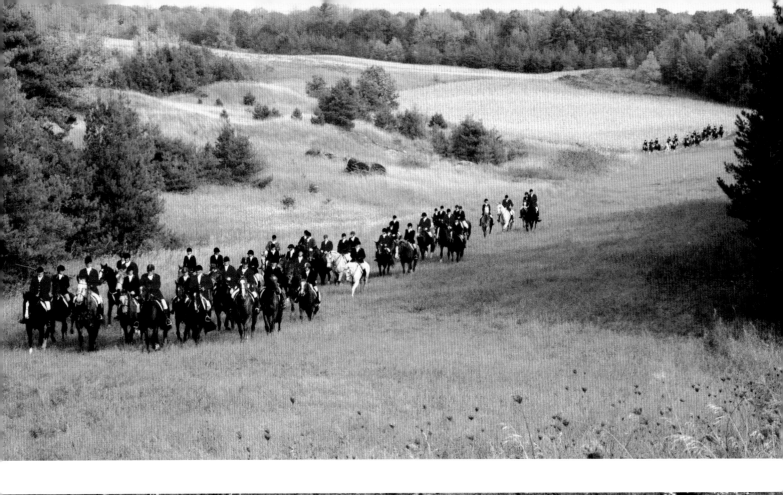

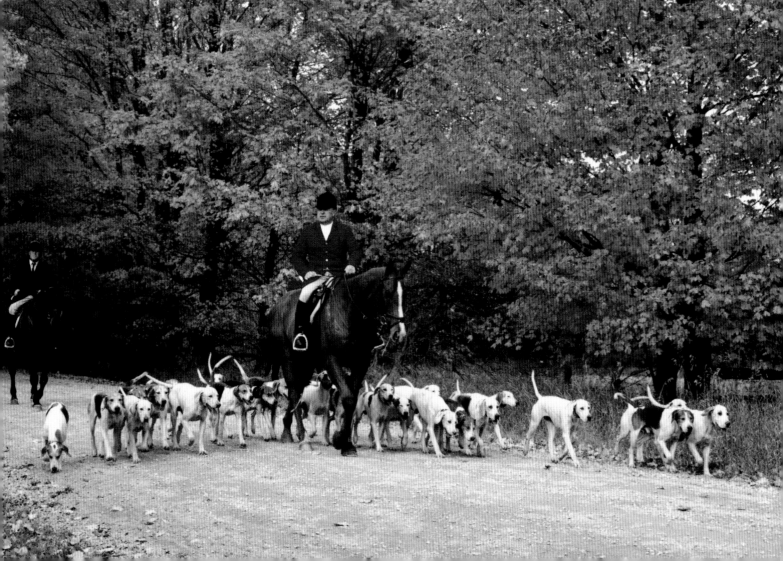

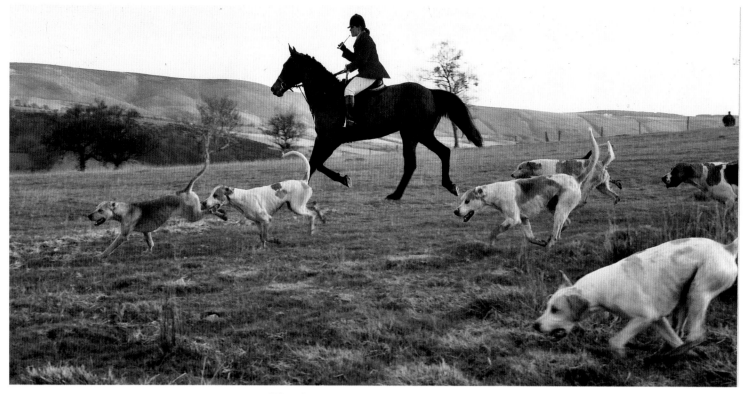

United Pack

When Joint Master and Huntsman Oliver Hill was injured they did not have a Whipper-In capable of hunting hounds. However, help was at hand for living close by was Diana Rowson, who had been a professional Whipper-In in England, Australia and Georgia USA, while her father Michael hunted the South Shropshire Hounds for many years. Diana proved an able deputy wearing the coat she had worn when with Ben Hardaway's Midland Foxhounds in Georgia and Alabama!

With Joint Master Robert George leading this group of riders during a hunt, it is possible to see what a marvellous grass and hill country this pack hunts over, where roads are few and far between.

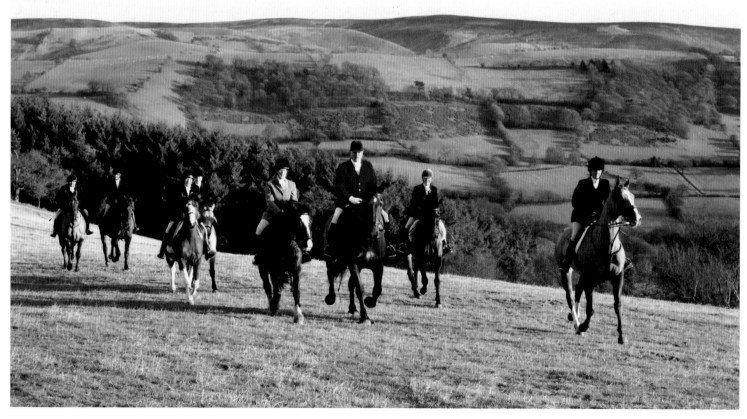

Showing just how much fun they have in Florida with the Misty Morning Hounds, Field Secretary Ann Scott on her extrovert grey hunter 'Reilly' highly placed in one of the Centennial Field Hunter Competitions, salutes the camera!

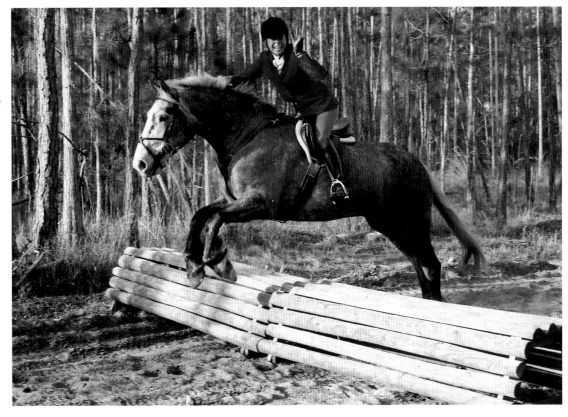

Unusual

When Marvin Beeman MFH (Arapahoe Hunt) and first Vice-President of the American MFHA was enjoying a Directors' Hunt with Mr Stewart's Cheshire Hounds, the hunted fox ran onto a cross-country racecourse ready flagged for race day so it was natural for the field to jump the fences!

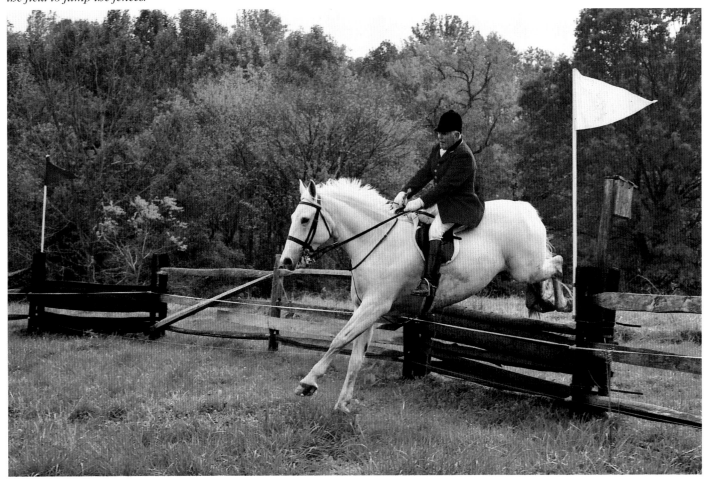

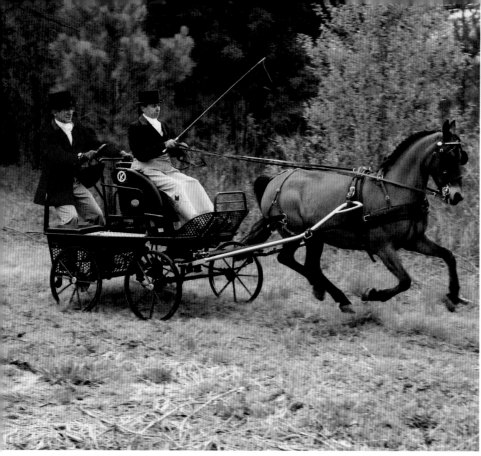

What's unusual about this picture of the Shamrock Hounds, moving off from a meet in Georgia? Two of the Joint Masters, Barry Henderson and Al Barron are on each side of the front rank, while between them are Huntsman Stephen Farrin and his father Michael Farrin who hunted the Quorn Hounds brilliantly from 1968 to 1998.

Ken Linthacum, who is a pilot and his wife Diane, regularly follow the Live Oak Hounds across country in their purpose built carriage often at the gallop as shown here, in their efforts to keep up with the action. Notice that both are wearing full hunt uniform.

Fred Hart, Joint Master and Huntsman of the Tanatside Hounds looking round for danger when winning the Donkey Derby at a fund raising event in the rain. For many years, Fred was a professional Whipper-In, Kennel-Huntsman or Huntsman with various packs before coming out of retirement to become an MFH!

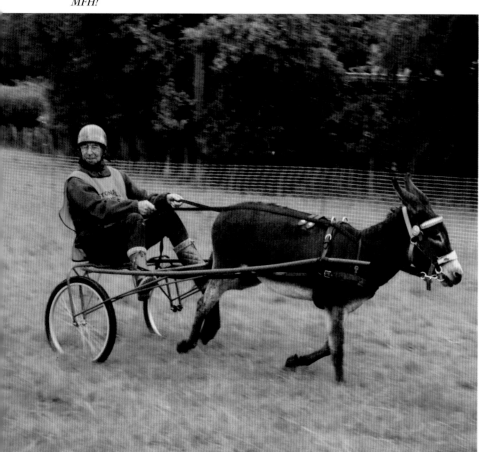

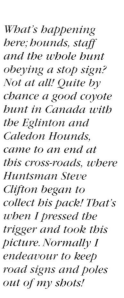

What's happening here; hounds, staff and the whole hunt obeying a stop sign? Not at all! Quite by chance a good coyote hunt in Canada with the Eglinton and Caledon Hounds, came to an end at this cross-roads, where Huntsman Steve Clifton began to collect his pack! That's when I pressed the trigger and took this picture. Normally I endeavour to keep road signs and poles out of my shots!

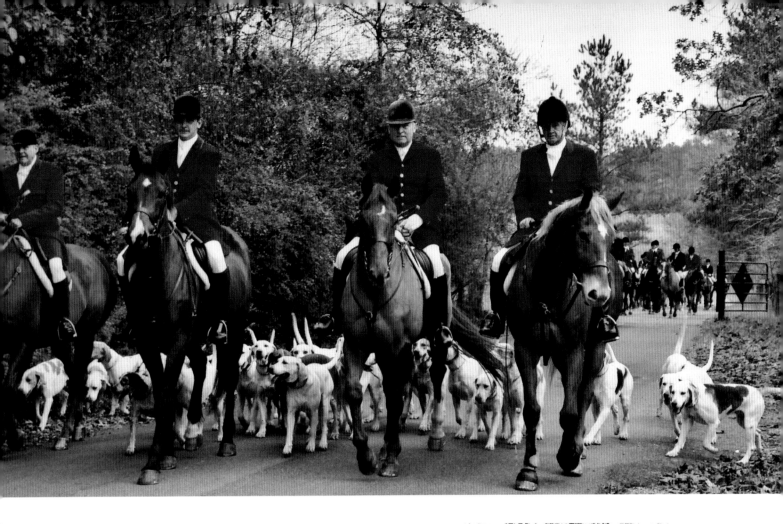
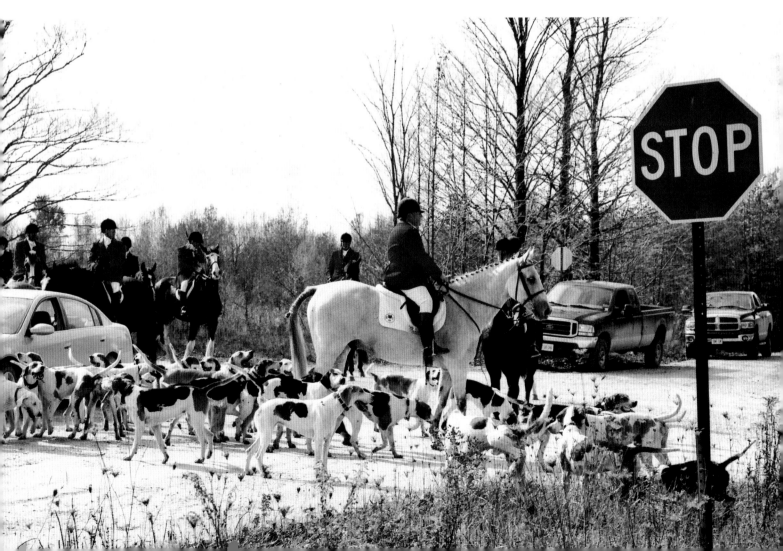

When the Mooreland Hunt in Alabama finished earlier than expected, after hounds had crossed the dangerous Big Nance creek, which was unsafe for horses, the riders returned to the trailers for the hunt breakfast. To while away time until hounds returned, Mitzi McDonell produced a portable table, and proceeded to give comforting massages. Here, Robin Leberte gets the treatment.

When Mason Lampton MFH (Midland) and President of the American MFHA won a race at the North American Point to Point Championships at Morven Park he was greeted by Liz McKnight MFH (Elkridge-Harford) with a bucket of water not realising that he had already changed clothes! Oh Dear!! Mason's wife Mary-Lu, looks on aghast!

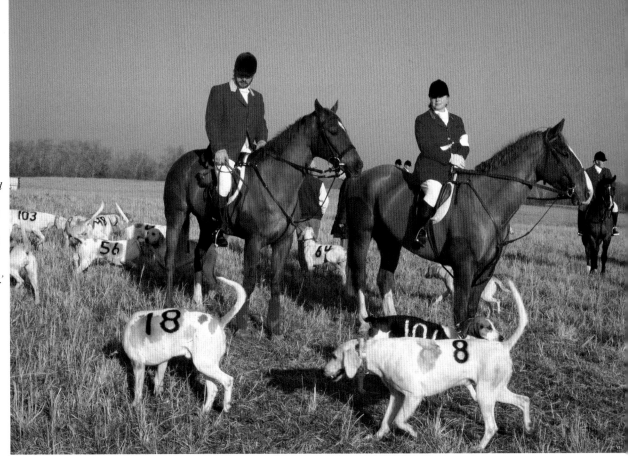

Pictured here with numbered hounds at a Performance Trial is Dina Del Guercio, Master and Huntsman of the Misty River Hounds in Arkansas who hunts hounds using a curved cow horn. With her is one of her Whippers-In 'L.D.' Lewis.

Following a Countryside Alliance Joint Meet in Wales Huntsman Will Jones MFH Irfon and Towy and Roy Savage from the Teme Valley Hunt both blowing for hounds at the same time!

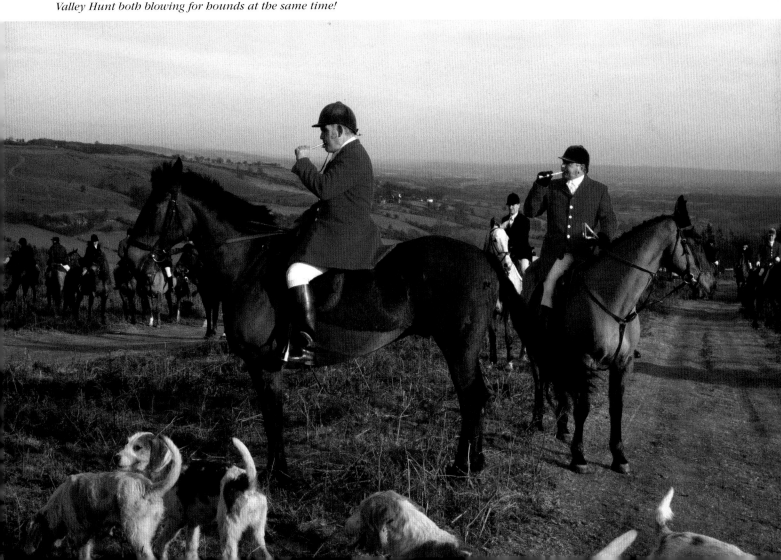

Masters, staff and members of the Staffordshire Moorland Foxhounds, all aboard a pick-up truck taking them to tea, at the end of the day! Normally in the UK hounds hunt until dark, when most people go home.

The Belle Meade Hunt in Georgia under the leadership of 'Epp' Wilson MFH hold the most amazing opening meet I've ever seen! Not only do they have a mounted field of around 130 riders but also, upwards of 750 people on 'Tallyho' wagons, while bringing up the rear is a wagon containing twelve mobile toilets, pictured here! Seems they are much in demand!

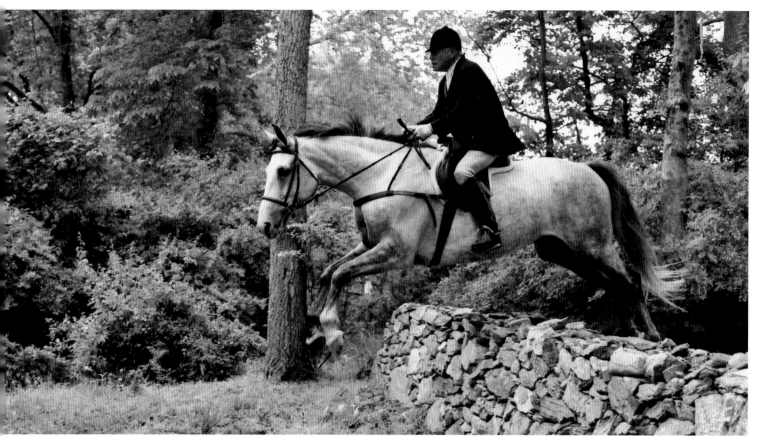

Walls

Executive Director of the American MFHA, Lt Col Dennis Foster who does an amazing job in anticipating and dealing with any anti-hunting threat in the USA, pictured here, in action in the Blue Ridge Hunt Country in Virginia.

Field Master to the Tanatside Hunt, Marnie Davies on her useful grey hunter leading the way after the opening meet at Bodynfoel Hall, the home of former master and Huntsman, Major Edward Bonnor Maurice 1971–2001.

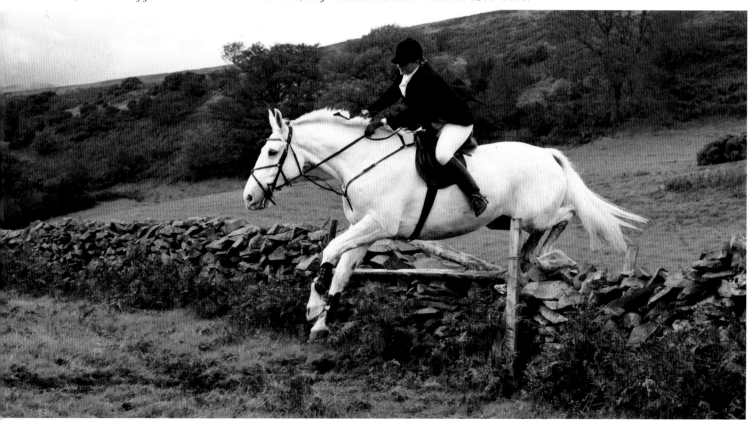

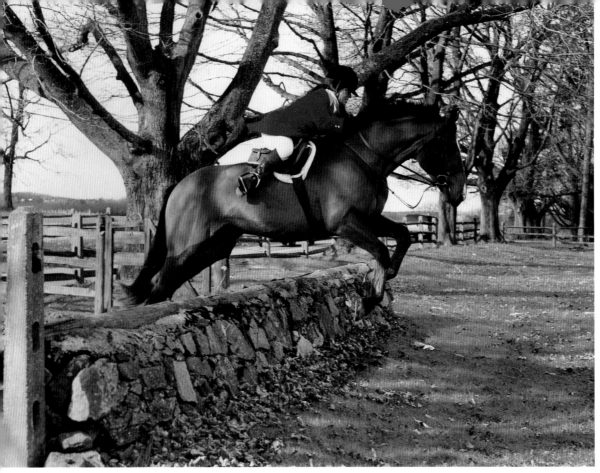

Sue Jones and her coloured hunter accurately clear a stonewall with a drop, high in the hills while following the Tanatside Hounds in their mostly grass country.

Field Master to the Radnor Hunt in Pennsylvania, Esther Gansky in action during a hunt from their kennels at Malvern. Later in the day we endured a snow squall!

With mud divots flying, Zara Owen shows good style during a hunt with the Tanatside in lovely wild hill country.

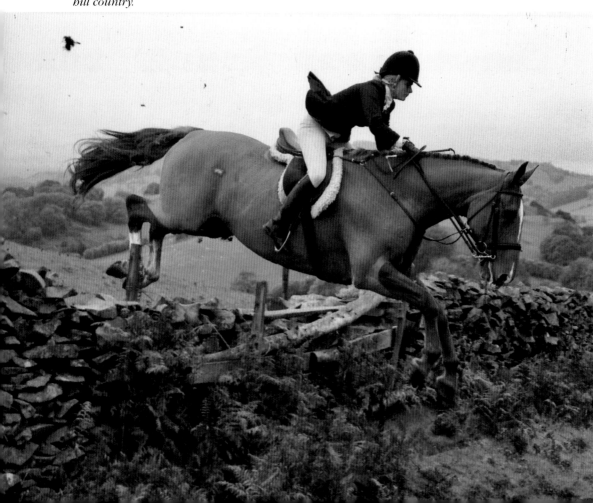

Mo de Ville, wife of the Joint Master of the Staffordshire Moorland Hounds in action on a day almost ruined by fog.

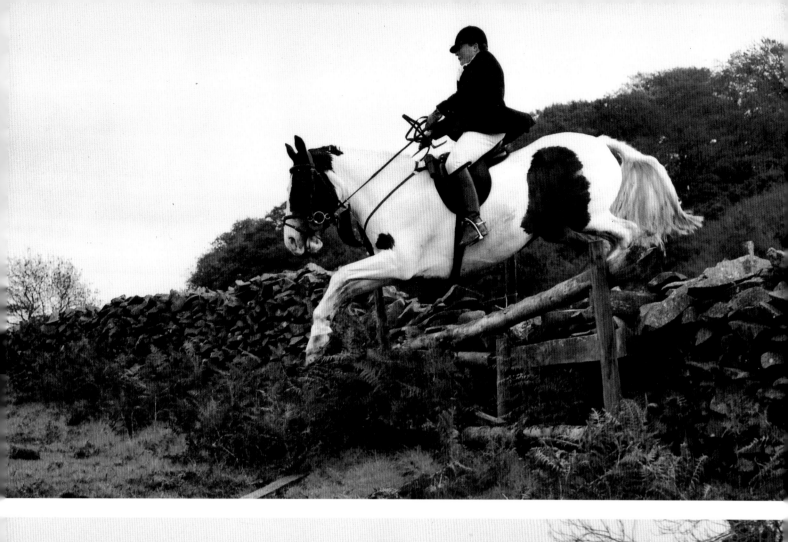

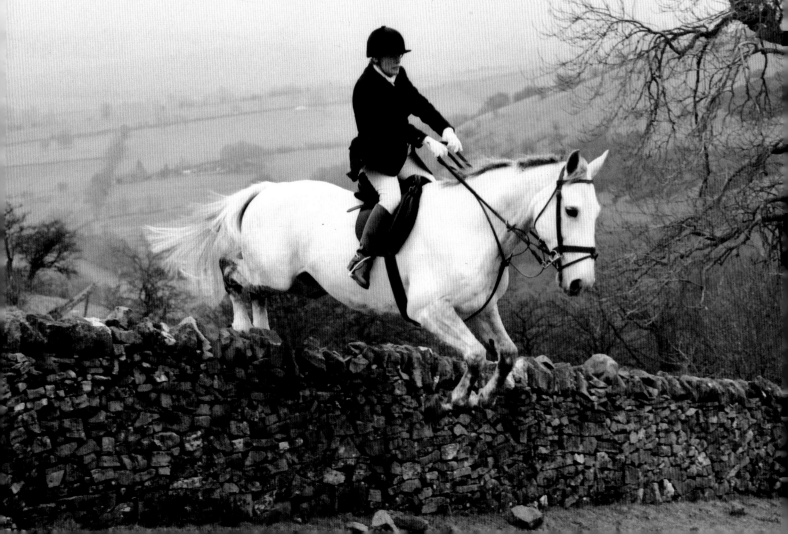

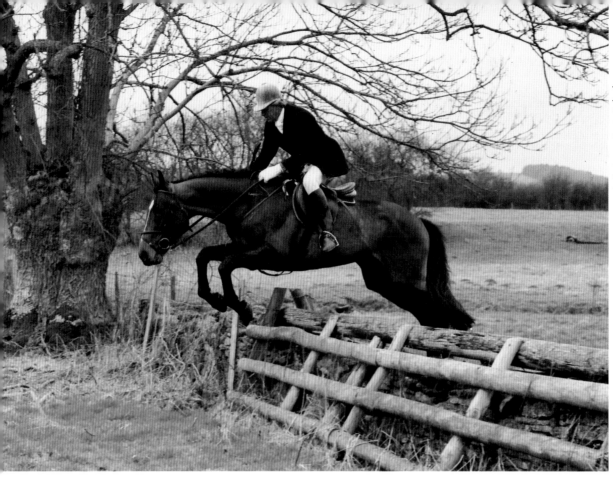

Jumping this unusual framework placed over a stone wall, in the Cotswold Hunt Country is David Guilding; it prevents the wall from being damaged by cattle, as well as horses.

Santa Ynez Valley Hounds Joint Master Paul McEnroe, in full flight over a well-built stone wall in California on the 'Kick-On' Ranch home of his Joint Master, Steve Lyons in office since 1989.

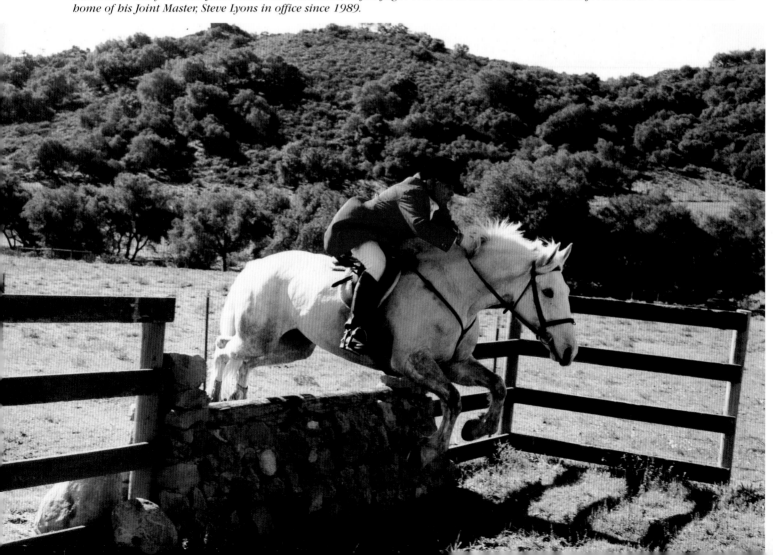

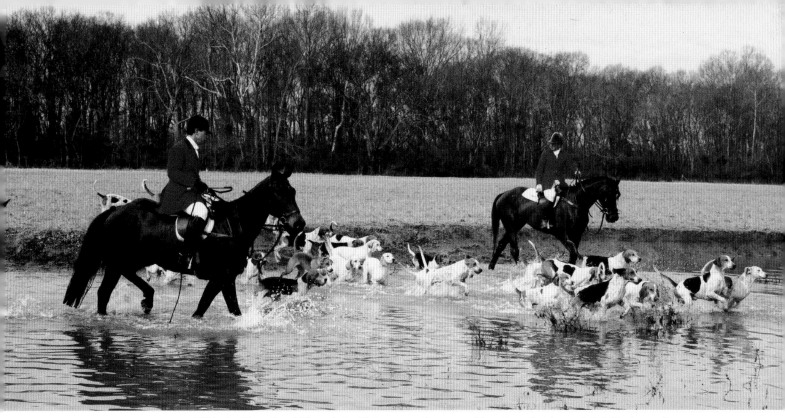

With the Mooreland Hounds in Alabama as they cross Limestone Creek, are Joint Master and Huntsman Randy Waterman and his Kennel Huntsman Jimmy Boyle who comes from Scotland.

Water

Rain-soaked riders follow Rose Tree Hunt Field Master Kerrie Hayes across a creek during a Director's Hunt in Pennsylvania. The pack's Penn-Marydel hounds and their Huntsman Jody Murtagh put on an excellent show, despite the heavy rain.

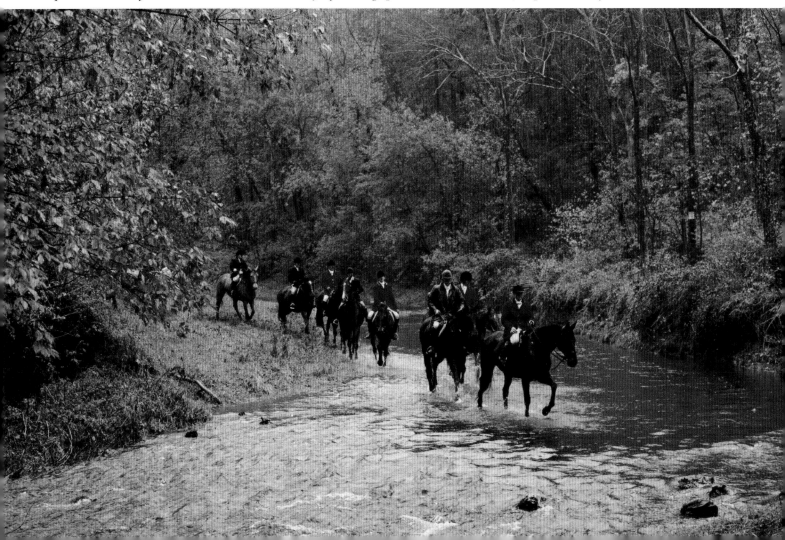

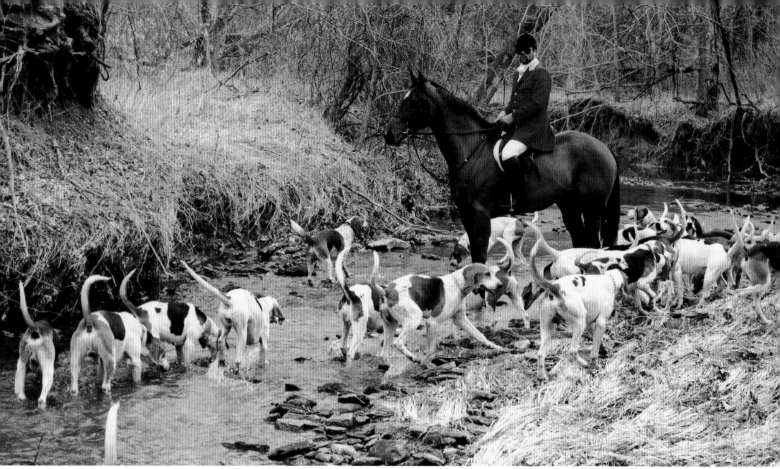

Camargo Huntsman Danny Kerr with hounds as they check in a creek during a hunt in Ohio. As part of the Centennial celebrations Danny took his hounds to Michigan for joint meets with the Metamora Hounds.

Casanova Hunt Joint Master Joyce Fendley riding with Courtney Ball MFH Camargo Hunt, leads the way through a creek during a hunt with the Casanova Hounds in Virginia, when they entertained numerous visitors.

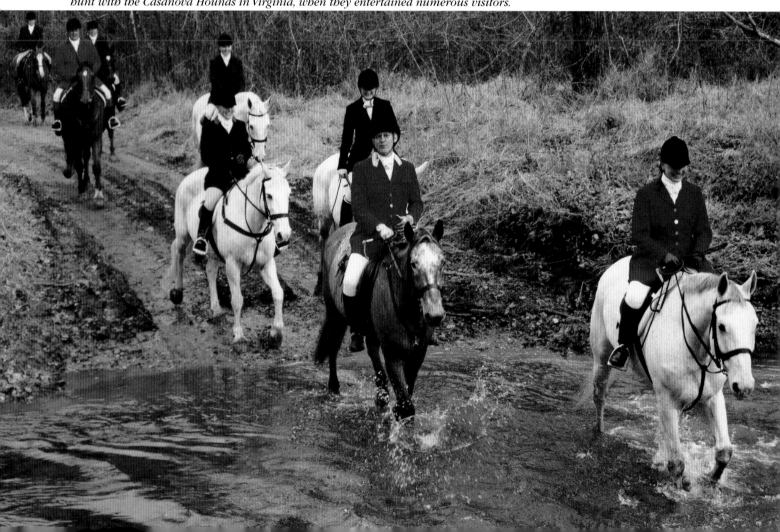

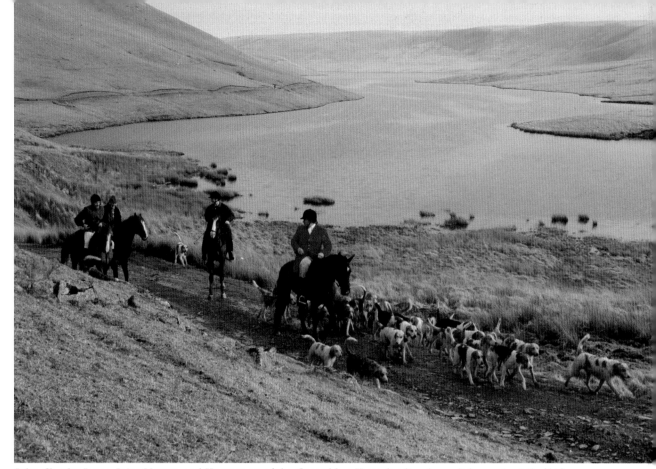

John Charles Jones, Joint Master and Huntsman of the Gogerddan Hunt, leading hounds home, past the Teifi Pools in an isolated area of Mid-Wales close to Ffair-Rhos.

Leading his hounds through a creek in Pennsylvania is Radnor Huntsman Noel Ryan during a hunt from the kennels. Noel now holds a similar post with the Loudon Hunt in Virginia.

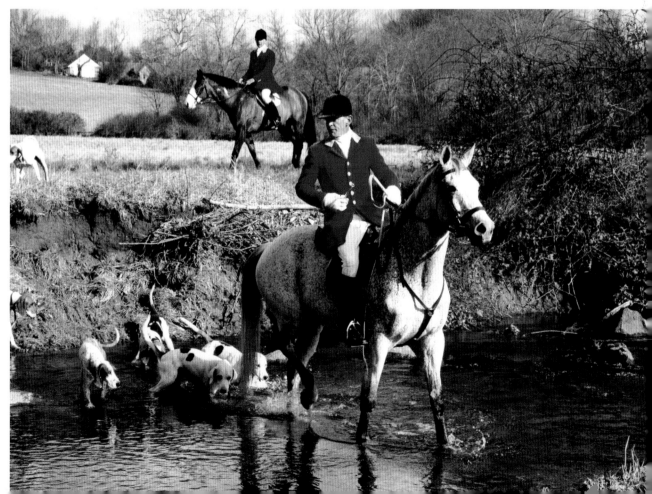

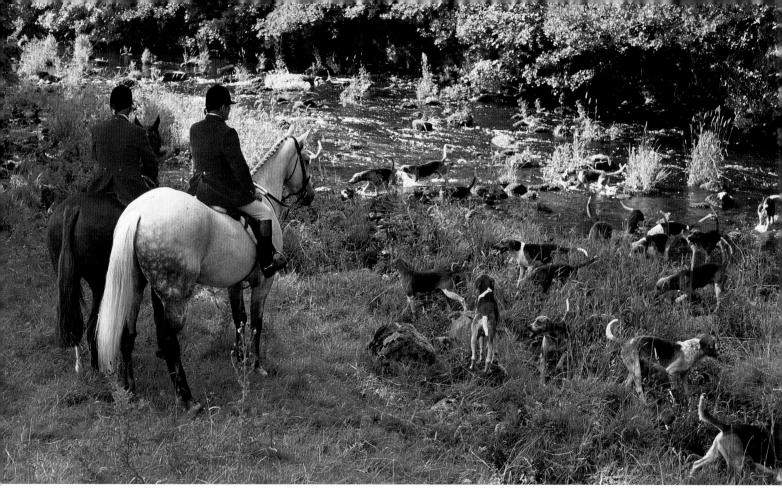

Hurworth Huntsman Joe Townsend gives his hounds the chance to cool off in the River Lowther after taking part in the Hound Parade at the end of Lowther Show on a hot August afternoon.

High on the slopes of Snowdon which peaks at 3,560 feet the Eryri Hounds with their founder Master and Huntsman Pyrs Williams make their way across a Roman bridge spanning a rocky mountain stream during autumn hunting.

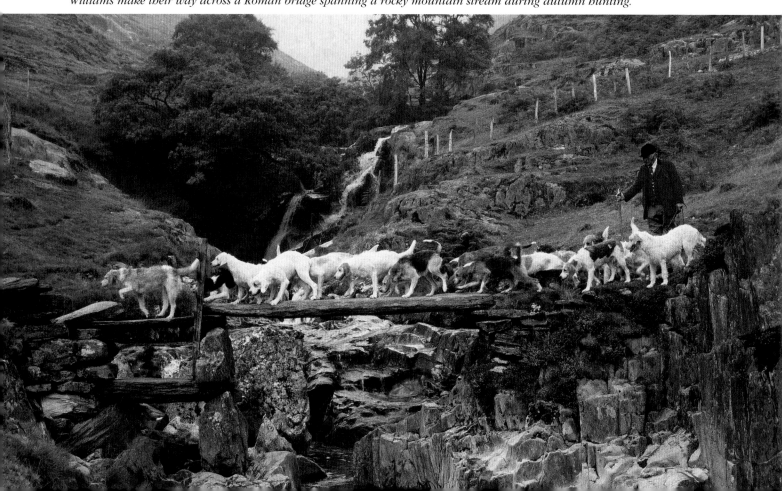

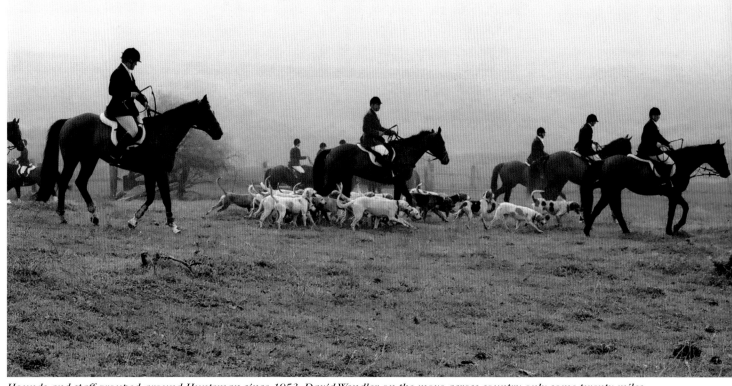

Hounds and staff grouped around Huntsman since 1953, David Wendler on the move across country only some twenty miles North West of Los Angeles in early morning fog which soon cleared.

West Hill Hounds, *California, USA*

In solitary splendour as he watches for a coyote to break cover from the scrub-land below is Mitch Jacobs MFH since 1997. He is also MFHA Director for the Pacific district having taken over from Terry Paine MFH in 2006.

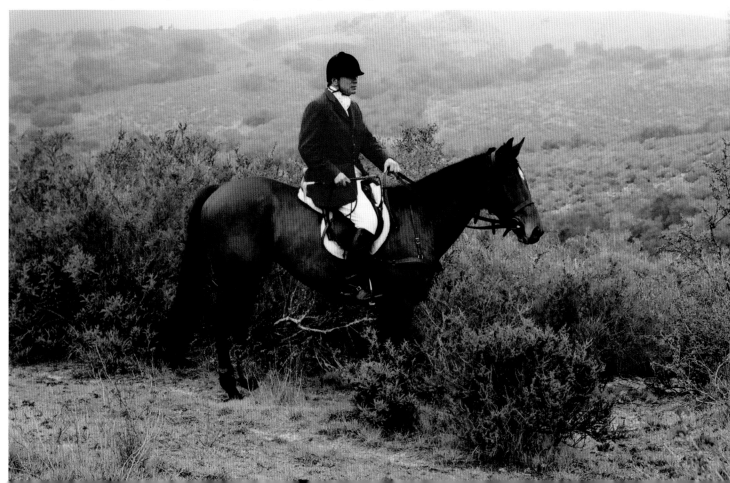

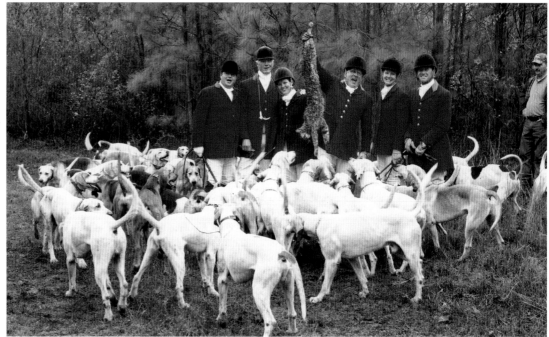

The end of an excellent bobcat hunt when the Midland Hounds visited the Mooreland Hunt Country in Alabama. Pictured are Masters of both packs Dr Jon Moody MFH, Dr Jack Sewell MFH, Evie Van Sant Mauldin MFH, Mason Lampton MFH (Huntsman), Leslie Rhett Crosby MFH, John Flournoy MFH.

Whooo-Whooop!

Following a splendid ten mile 'race', this big coyote was caught by the Live Oak Hounds, during a Centennial Joint Meet in Florida. (left to right) Daphne Wood MFH, Piper Parrish Whipper-in, Charles Montgomery Huntsman, Geoff Hyde (Elkridge-Harford) Huntsman and Marty Wood MFH.

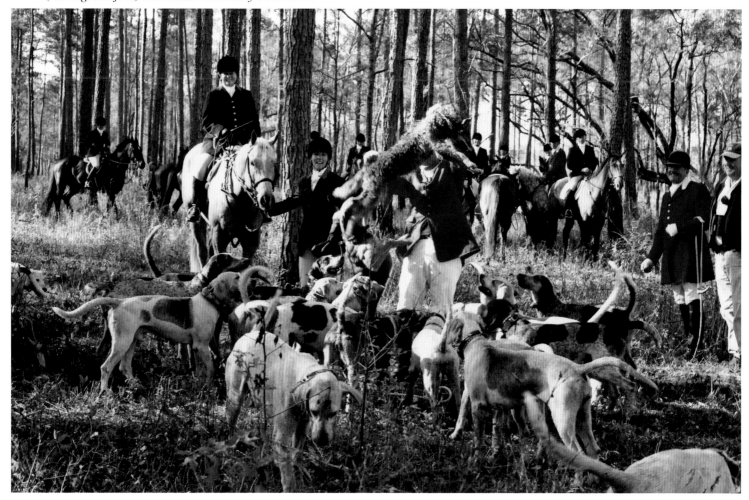

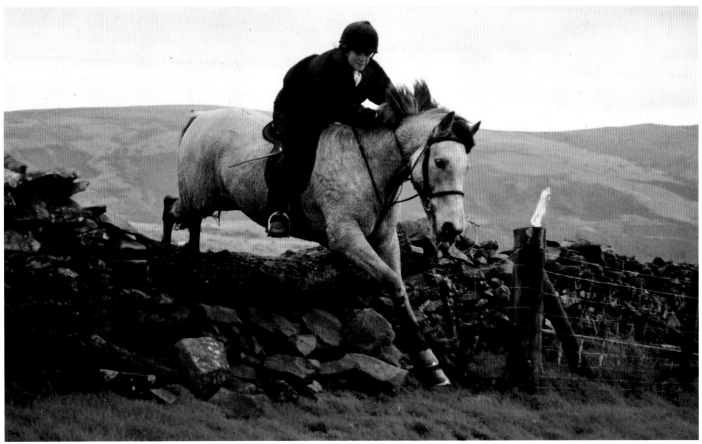

Showing good style after a wet opening meet of the David Davies Hounds is Jemma Gilligan, pictured high in the hills of mid-Wales.

Young Riders

Going well over a big black coop in the Bear Creek Hunt Country in Georgia is Sophie David. Her mother Heather is Hunt Secretary while her step-father Guy Cooper is Professional Huntsman.

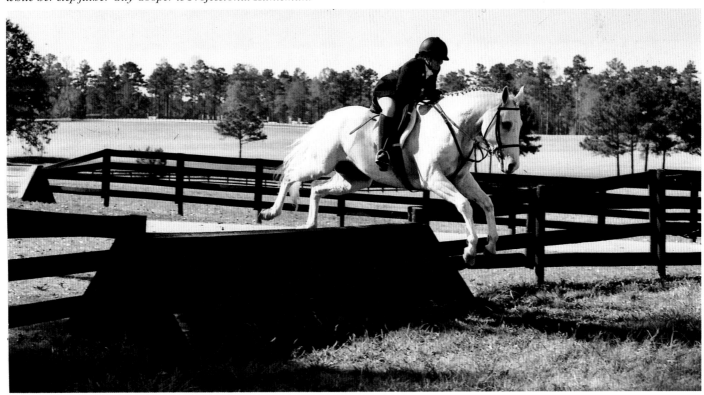

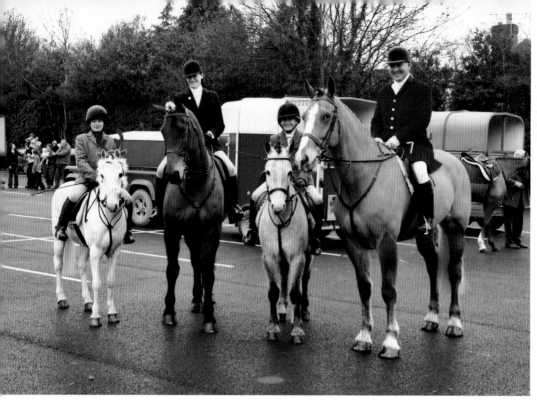

With their ponies and horses decorated for the Tanatside Hunt's Boxing Day meet are Joint Master Ian Coe, his wife Vicky and their children Hannah and George.

Flora Rigby and Claerwen Maclean were so keen to hunt with the South Shropshire Hounds despite overnight snow that they struggled to the meet. Sadly they hadn't called the kennel hotline where the message said 'Today's hunting will be on foot'! Still, they had showed their enthusiasm for hunting!

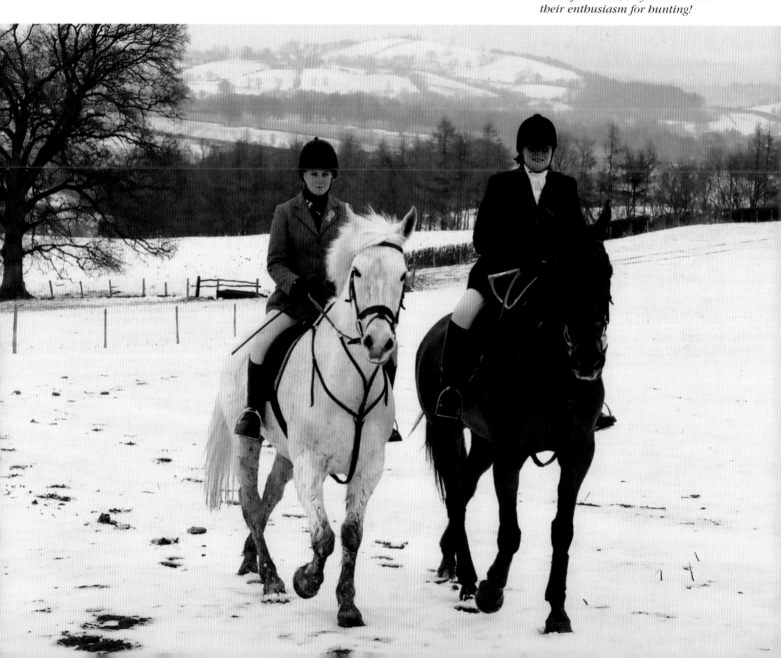

Carrying on the family tradition with the Mooreland Hunt in Alabama is Hattie Crosby, seen here with her father Moss. Hattie's grandfather Harry Rhett founded the hunt in 1961 and his daughter Leslie is Hattie's mother!

Under the gaze of people on a tally-ho wagon and other interested spectators Will Roboski and Zoey Craig fearlessly leap into the water jump during a fun day with the Misty Morning Hounds in Florida.

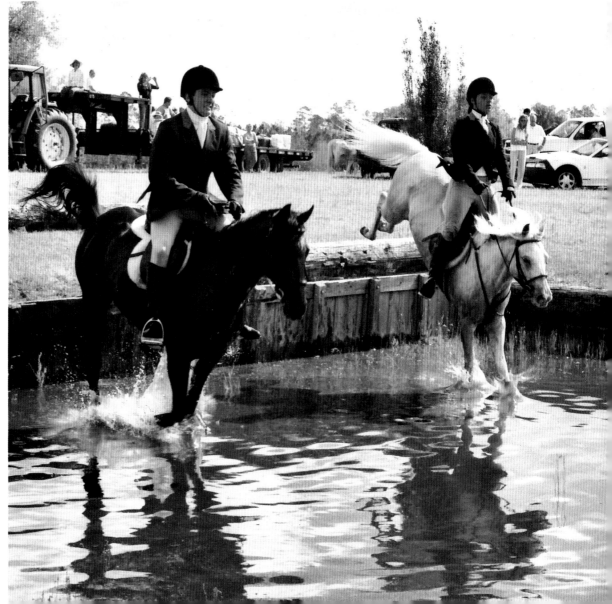

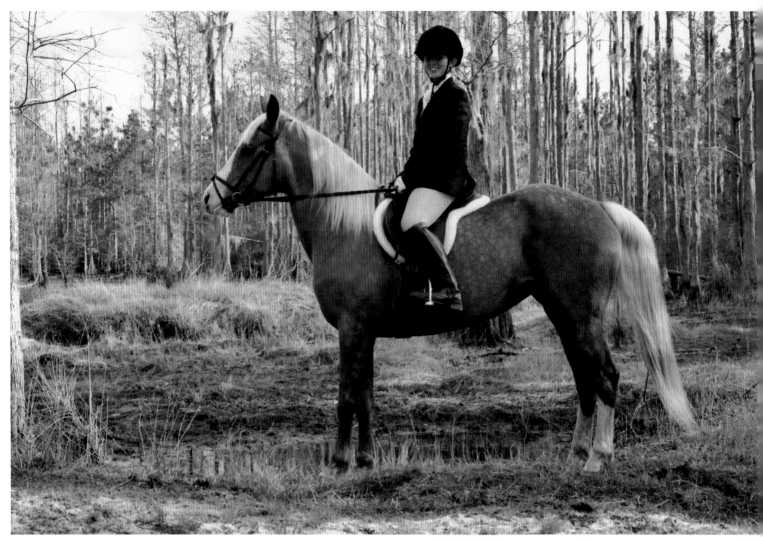

This young rider with the happy smile is fifteen year-old Simone Faas, who shared this Palomino mare 'Miss Mae' with her mother Carol. Simone is a keen member of the Pony Club and wants to learn all she can about hunting. She assures me that in due course, she will come to England to hunt, but I told her she won't find any picturesque cypress swamps as in this background in Florida!

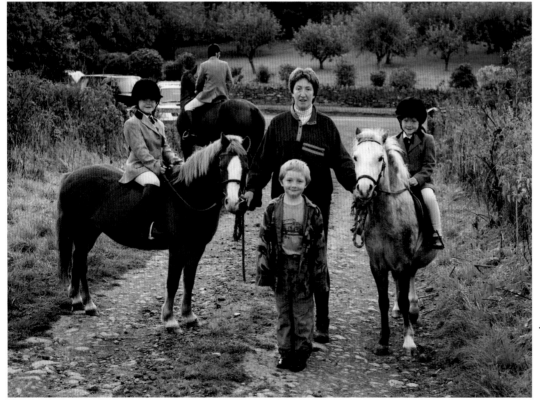

Joint Master of the Golden Valley Hunt, Annette Greenow at an early morning cub hunting meet with her twin daughters Poppy and Rosie and son Huw.

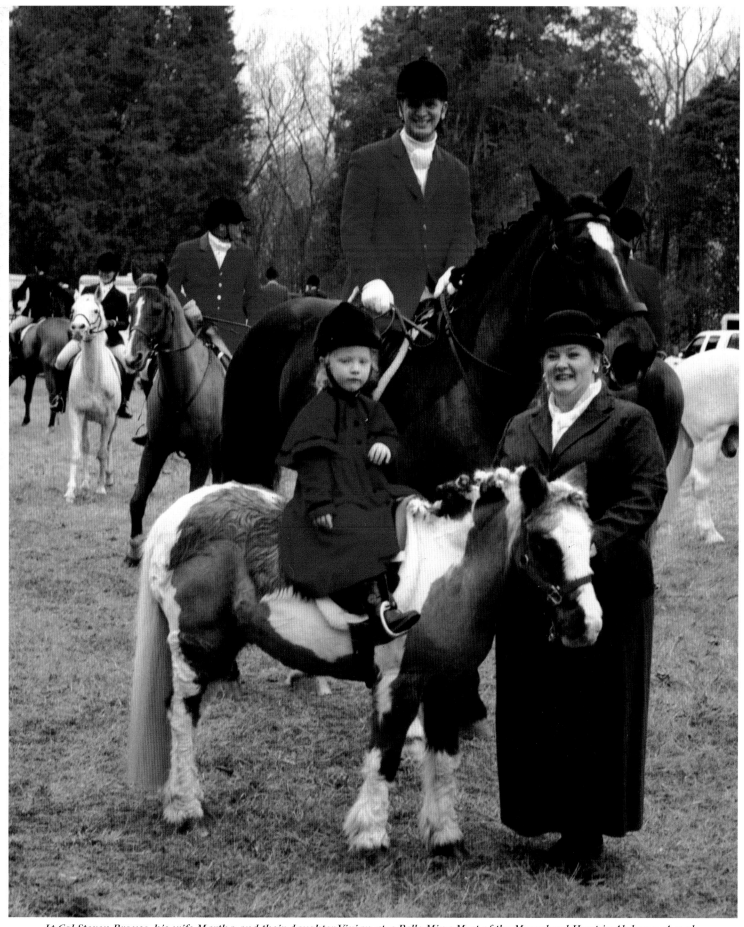

Lt Col Steven Brouse, his wife Martha and their daughter Vivian at a Belle Mina Meet of the Mooreland Hunt in Alabama. A real family outing!

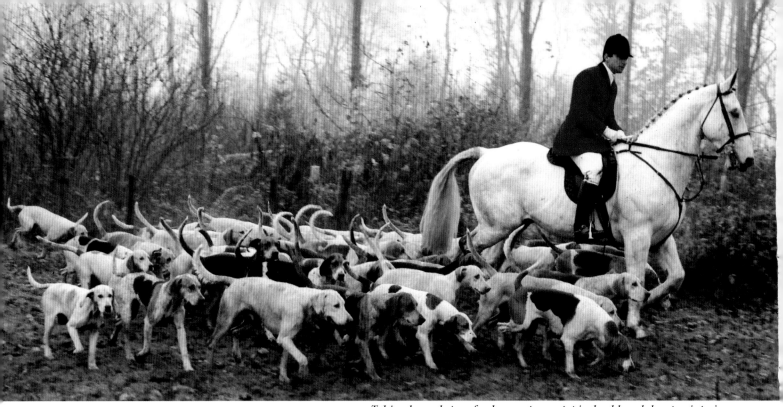

Zetland Hunt

Taking hounds to a fresh covert on a typical cold and damp winter's day in North Yorkshire is Huntsman since 1996, David Jukes, riding a very smart grey hunter nicely plaited.

At the head of the hard riding field is Field Master Paul Morrison MFH, flanked by Peter Hill-Walker and (right) Chris Dawson on a day stolen from dense fog.

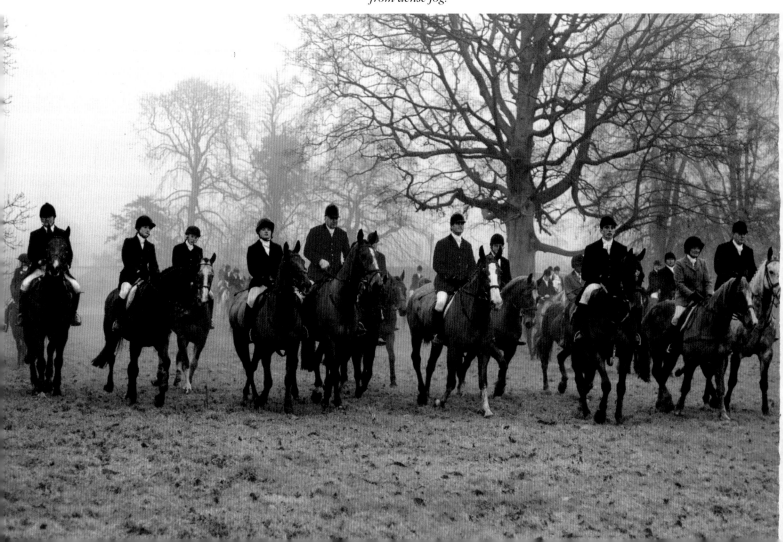

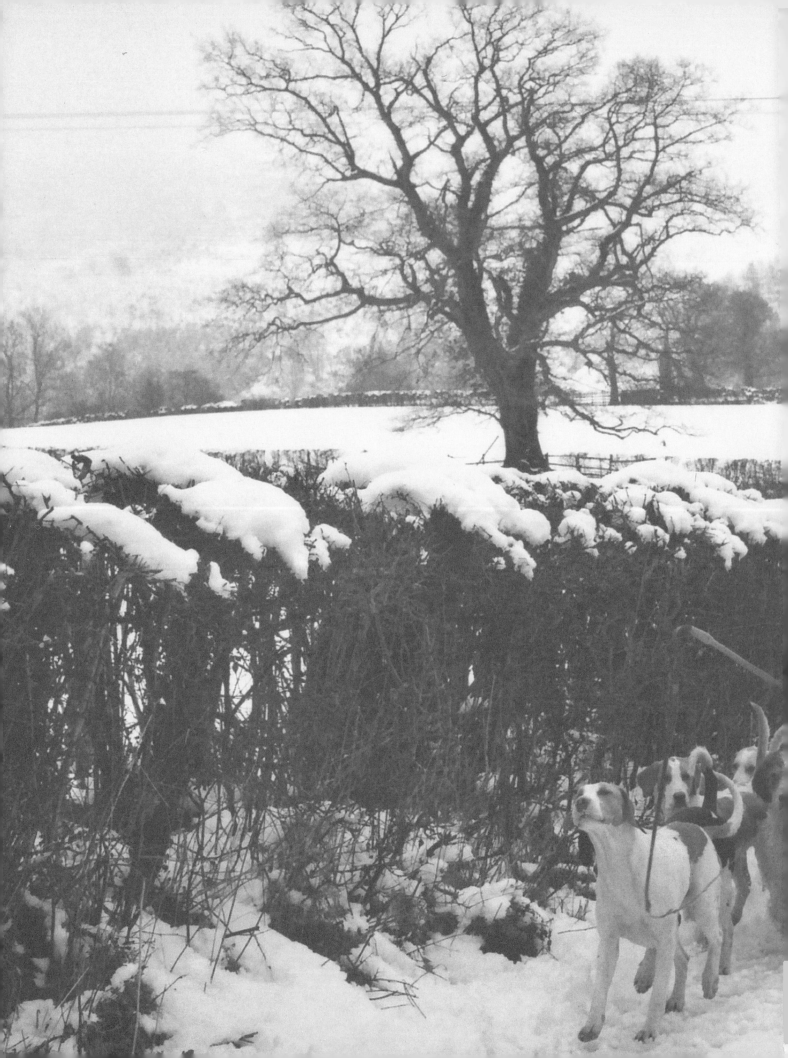